London's Burning

LONDON'S BURNING

Life, Death and Art in the Second World War

❘❖❘❖❘❖❘

Peter Stansky and William Abrahams

Stanford University Press
Stanford, California
1994

Stanford University Press
Stanford, California
© 1994 Peter Stansky and William Abrahams
Originating publisher, Constable and Company
 Limited
First published in the U.S.A. by
 Stanford University Press
Printed in Great Britain
ISBN 0-8047-2340-0
LC 93-86764
This book is printed on acid-free paper

FOR ALICE ADAMS

CONTENTS
|❖|❖|❖|

ILLUSTRATIONS
| ❖ | ❖ | ❖ |

ix

Portrait of Graham Sutherland 1943 (© *Lee Miller Archives*)
Graham Sutherland, Henry Moore and Myfanwy Piper picnicking on the train to
 Leeds *(Henry Moore Foundation)*
Henry Moore in his studio at Much Hadham during filming of 'Out of Chaos',
 1943 (© *Lee Miller Archives*)
The Northampton Madonna and Child *(Henry Moore Foundation)*
The Northampton Madonna and Child *(Henry Moore Foundation)*
The Northampton Madonna and Child *(Henry Moore Foundation)*

between pages 110 and 111

Myra Hess playing at a concert before the Queen in the National Gallery, from
 'Listen to Britain' directed by Humphrey Jennings *(BFI Stills, Posters and
 Designs Crown Copyright)*
Queen Elizabeth and Kenneth Clark at the Myra Hess concert, from 'Listen to
 Britain' directed by Humphrey Jennings *(Crown Copyright)*
Humphrey Jennings directing 'Fires Were Started' *(BFI Stills, Posters and Designs
 Crown Copyright)*
Fires Were Started, Barrage Balloon *(Crown Copyright)*
Barrett and Jacko at docks *(Crown Copyright)*
Barrett and Jacko at docks looking at the freighter *(Crown Copyright)*
Barrett playing 'One Man went to Mow' at the piano *(Crown Copyright)*
Jacko and Rumbold on the roof *(Crown Copyright)*
Burning warehouse *(Crown Copyright)*
Control. Bomb falls. Girl's forehead is bleeding *(Crown Copyright)*
Jacko's grave with helmet *(Crown Copyright)*
Freighter pulling out *(Crown Copyright)*

between pages 162 and 163

Auden and Britten, New York 1941, at the time of rehearsals for Paul Bunyan
 (The Britten–Pears Library)
Pears and Britten, Stanton Cottage December 1941 *(Photo Lotte Jacobi © University
 of New Hampshire)*
Britten with Serge Koussevitzky, Boston 1942 *(The Britten–Pears Library)*
Montagu Slater *(© B. Kitley)*
Britten and Pears at Old Mill, Snape *(The Britten–Pears Library)*
Britten with Eric Crozier *(Hulton-Deutsch Collection)*
Britten, Montagu Slater and Eric Crozier with a model of part of the set for Peter
 Grimes *(Hulton-Deutsch Collection)*
Britten working on Peter Grimes *(Hulton-Deutsch Collection)*

ACKNOWLEDGEMENTS
|❖|❖|❖|

MANY people, libraries and institutions have assisted us in the making of this book. We are grateful to Ann Garrould who arranged for us to visit Henry Moore at Much Hadham; to Angela Dyer of the Henry Moore Foundation for reading the section on Moore, and to the Foundation for providing illustrations and for granting permission to reproduce them as well as quotations. We are also grateful to Clare Colvin of the Paul Nash Trust and for the assistance of Janet Todd of the Design and Artists Copyright Society in relation to Graham Sutherland. The Tate Gallery and the Imperial War Museum have been helpful in regard to manuscripts in their possession. At the Imperial War Museum, we are particularly grateful to Angela Weight and Michael Moody. We wish to thank for permission to quote from the work of Kenneth Clark his literary agent, Margaret Hanbury, London.

This study is in no sense authorized, yet we are deeply beholden for the permission given, the assistance rendered, and the reading of the relevant section by Mary-Lou Jennings, Humphrey Jennings' daughter.

Donald Mitchell, the great musical scholar, and a member of the Britten Trust, gave permission for quotations. He meticulously read the pages on Britten with a keen eye both for detail and larger considerations. Throughout we have been the beneficiaries of his unrivalled knowledge of Britten's life and work. It is a further pleasure to acknowledge the kindness of Donald and Kathleen Mitchell both in London and Aldeburgh, enabling us to meet Sir Peter Pears, and to work in the Britten-Pears Library where we were assisted so ably by Paul Wilson.

Many others have helped us along the way, most recently our publishers, Benjamin Glazebrook, Shane Weller, and Jenny Speller at Constable, and Norris Pope at the Stanford University Press. Peter Stansky wishes to acknowledge support from the staff of the History Department of Stanford University, the National Endowment for the Humanities, St Catherine's College, Oxford and the Center for the Advanced Study of the Behavioral Sciences.

INTRODUCTION
| ❖ | ❖ | ❖ |

O UR theme is the relation between art and war, or war and art – the question of precedence is not negligible. We shall be looking for evidence of that relationship in certain works of art that came into being in England during the years of the Second World War. Our exploration begins with the shelter drawings by Henry Moore, extends to some paintings by Paul Nash and Graham Sutherland, continues with a film by Humphrey Jennings, *Fires Were Started*, and ends in 1945 with *Peter Grimes*, Benjamin Britten's first opera.

Now, half a century later, those works transcend their national boundaries and historical circumstances: they have become part of twentieth-century Western culture. As much may be claimed for a number of other 'civilian' works that belong to the war years in England and reflect their influence – to name only a few: Virginia Woolf's novel *Between the Acts*; the last three of T. S. Eliot's *Four Quartets*; Evelyn Waugh's satirical comedy of the phoney, or 'great bore', war, *Put Out More Flags*; Laurence Olivier's film *Henry V*; some of the poems in *Deaths and Entrances* by Dylan Thomas; and the stories by Elizabeth Bowen collected in *Ivy Gripped the Steps*.

If we have decided against an encyclopaedic survey and chosen to limit ourselves principally, though not strictly, to the 'biographies' of one group of drawings, some paintings, a film and an opera, it is in the expectation that, by studying them in close-up rather than in a grand perspective, we shall see more clearly the enigmas and affirmations they encompass. Our hope is that an account of the particulars of these individual achievements will allow us to generalize more freely about our theme than would otherwise be the case. And if not, we shall have had, at the least, stories to tell.

This outpouring of art in England during the years 1939–45 would have been notable at any time; that it should have occurred in wartime, in a

country engaged in a struggle that threatened its very existence, is extraordinary. Nothing on so comprehensive and diversified a scale, in quality and quantity, had happened during the First World War; in the post-war aftermath, in the disillusioned 1920s and the embittered 1930s, the notion that war might lead, however inadvertently, to an enrichment of culture would have seemed a far-fetched paradox. Yet what took place in London in the period between 1939 and 1945 was precisely that: a linkage, a connection, a cause and effect relation between war and art.

There appears to have been, from the first, a determination by such public figures as John Maynard Keynes and Kenneth Clark, by editors such as John Lehmann of *Penguin New Writing* and Cyril Connolly of *Horizon*, and senior authors such as E. M. Forster and Osbert Sitwell that 'culture' should not be put aside for the duration: in the act of fighting to save England, English culture must not be sacrificed. However half-heartedly and confusingly, the commitment of the government to art in all its manifestations was established as a principle. The War Artists' Advisory Committee, under Clark, and the Council for the Encouragement of Music and the Arts, under Keynes, were formed early, and would have a significant effect in bringing art to the people of England even as the Blitz brought the war itself literally into their lives. The Home Front, so cosy-sounding, was anything but cosy when the Blitz began and the bombs fell on London, Manchester, Coventry and elsewhere. Life in those wartime siege years went on at something like battle pitch, a level at which it proved, unexpectedly, possible for many artists, composers and writers to create works of art – not as a way of escape but as a way of expressing the tension under which they lived.

PART 1
❖ | ❖ | ❖

Henry Moore, Paul Nash & Graham Sutherland

|❖| 1 |❖|

O N 1 September 1939 the German army invaded Poland: in effect, if
not yet officially, the Second World War had begun. That date – 1
September 1939 – was fixed as a title to a poem by W. H. Auden,
who had emigrated to America in January of that year with the intention of
becoming a citizen of the United States. The poem begins:

> I sit in one of the dives
> On Fifty-second Street
> Uncertain and afraid
> As the clever hopes expire
> Of a low dishonest decade . . .

One of those hopes, more delusory than clever, was that a *second* world war
would never happen. Another hope, equally strongly felt, often by the very
people who were anti-war, was that Nazism and Fascism might be
contained, defanged, somehow made to disappear. The date 1 September
1939 made it clear that the two hopes were irreconcilable, that to be against
war and against Fascism was a contradiction too deep to be papered over
by rhetoric or wishful thinking.

|❖| 2 |❖|

At ten o'clock on the morning of 3 September 1939 at Monk's House, their
home in Rodmell, Sussex, half an hour's drive from the English Channel,
Leonard and Virginia Woolf were waiting for the Prime Minister, Neville

Chamberlain, to speak to the nation. In the previous October he had spoken to the nation upon his return from a meeting with Hitler in Munich. He was, he had said, bringing 'peace with honour' – he had the assurances of Herr Hitler that this was so. Now, at ten o'clock in the morning, Virginia Woolf, who let hardly a day pass without writing in her diary, took it up and wrote:

> This is I suppose certainly the last hour of peace. The time limit is out at 11. P[rime] M[inister] to broadcast at 11.15. L[eonard] & I "stood by" 10 minutes ago. . . . We argued. L. said Greenwood was right – forcing the PM in the House last night. I argued its 'they' as usual who did this. We as usual remain outside. If we win, then what? L. said its better to win, because the Germans . . . are what they are. . . . All the formulae are now a mere surface for gangsters. So we chopped words. I suppose the bombs are falling on rooms like this in Warsaw. A fine sunny morning here; apples shining . . .*

The mood at Monk's House was a compound of resignation, acceptance and weariness. In her diary Woolf notes that she was 'Sewing [black-out] curtains. . . . An anodyne. Pleasant to do something; but so tepid & insipid.' That mood was not peculiar to the Woolfs; something comparable was pretty general throughout England. When the Prime Minister broadcast at 11.15 a.m., he was pained, resigned and woefully incapable of striking the heroic note. The mood in 1939 was not that of 1914; there were none of the confident high spirits that had marked the onset of that earlier conflict.

|❖| 3 |❖|

It is hard to believe that the prevailing mood on 3 September was any more cheerful at the small house in Kent where Henry Moore and his wife, Irina,

*Anne Olivier Bell (ed.), *The Diary of Virginia Woolf*, v. *1936–1941* (London, 1984), p. 233. Bell's footnote reads: 'Arthur Greenwood (1880–1954), Deputy Leader of the Labour Party, urged to 'speak for England', insisted that the time for compromise was past and that England's duty was to honour her guarantee of aid to Poland.'

lived when not in London. If there is no documentation, such as a diary entry, to confirm the point, there is the evidence of a drawing, done in pencil, pen and ink, chalk, crayon and water-colour, signed and dated with unusual emphasis, 'Moore Sept 3rd / 1939.' (Usually he signed his drawings simply with 'Moore' and the year.) Odd, enigmatic and surrealistic, this drawing of 3 September offers a degree of literary content and particularity of detail that make it very different from most of Moore's 'Ideas for Sculpture' and his other drawings of the period. It challenges us to decipher its meaning. What we see, beginning at the lower part of the drawing, are eight women bathing in a sea the colour of diluted blood, submerged to their breasts, their heads confined in what appear to be gas masks or, possibly, divers' helmets. Behind them is a strip of empty beach. Filling the upper half of the drawing, a great wash of dark, blood-red cliffs encloses the scene, with only a marginal glimpse of empty sky above. The effect is alarmingly claustrophobic, as though these women with their strange headgear have been dropped down in the sea – who are they? where have they come from? and why? – with no way out (not a footprint on the beach, not a path or stairway up the cliffs) from the predicament imposed upon them.

When the drawing was included years later in a comprehensive international exhibition, 'The Drawings of Henry Moore', Alan Wilkinson, who wrote the catalogue, provided this explanatory note:

> On 3 September, the day war was declared, the Moores were bathing off the Shakespeare Cliffs at Dover. He remembers hearing an air raid siren, an ominous prelude to the day and night warnings in London a year later during the Blitz. In this recreated scene of bathers with the cliffs in the background, the strange heads of the figures, evoking the world of science fiction, were probably suggested by the familiar form of gas masks. Standing chest high in the water, these forbidding women, alert and watchful, look across the Channel towards the French coast.[1]

Wilkinson's explication is clearly helpful; but since an enigma never admits of a final answer, it seems permissible to suggest that the scene is more likely to have been created than re-created, and that the figures who populate it were almost certainly drawn from the artist's unconscious. France would have deep, latent memories for Moore. So too the gas masks

worn by the women in the drawing – in the year preceding the outbreak of war gas masks were already being distributed in London by the authorities, who feared a gas attack from the air. Moore himself had been a volunteer soldier in France during the First World War; he had worn a gas mask and had been under a gas attack on the Western Front. So one may legitimately wonder if the drawing is not a kind of symbolic recognition – or precognition – of the changes that war might lead to for him as an artist. That, of course, the First World War had not done, for he was not then an artist at all, although he wanted to be.

|❖| 4 |❖|

Henry Moore, the seventh of eight children of Raymond and Mary Moore, was born in 1898 in Castleford near Leeds in Yorkshire, where his father was a coal miner and later a mining engineer. (Moore himself did not go down a mine until he did his drawings of miners during the Second World War.) Moore's father encouraged his youngest son in his studies, hoping that he would grow up to become a teacher, as an older brother and sister were to do. Henry went first to the local elementary school and, perhaps more importantly for his ultimate vocation, to the local Sunday school. For it was there, when he was 10, that he decided he would become a great sculptor:

> Our Sunday School teacher told us how, when Michelangelo was carving his Head of a Faun, someone said, 'But that's an old faun; surely an old faun would have lost some of his teeth?' Michelangelo took up his chisel and knocked two of the teeth out. 'There you are', our teacher said. 'There's the greatest sculptor in the world ready to take advice.' What went click in my mind was not the moral but the fact that this was the greatest sculptor who ever lived. I'd always liked our drawing classes, and I'd carved bits of wood and stone. Now, instead of saying I wanted to be an engine driver, I said I wanted to be a sculptor.

The poet Donald Hall, who reported this story in 1966, went on to comment, 'He is still competing with Michelangelo.'[2]

Two years later, at the age of 12, Henry won a scholarship to Castleford Grammar School. There he received particular encouragement from the art teacher, Alice Gostick, the first of the decisive figures to recognize his potential gift very early. Away from school there were other significant awakenings in the Castleford years: he enjoyed going into churches and looking at the statues of saints, angels and funeral effigies – that was sculpture. Wandering about in the countryside beyond the town, he was fascinated by stones, pebbles, tree trunks, twigs and branches, the natural forms that foreshadowed and determined so much of his sculpture throughout his life.

If his father's plan had been fulfilled he would have gone on from grammar school to a teacher-training college, but the war intervened. In February 1917, when he was 18, Moore went into the army, enlisting in the Civil Service Rifles. He was sent for training to a unit near Winchester, where he stayed until mid-summer. On day leaves he was able to go up to London where he paid his first visits to the National Gallery and the British Museum. In August his unit was sent to France, at first to a quiet sector, then at the end of September to the Front. There he experienced 'the full-scale horror of a major German assault' and was gassed at Bourlon Wood (near Cambrai) at the end of November. His biographer sums up: 'That was the end of Henry Moore's active war service, a brief but grim experience.'[3] One can accept as characteristic understatement Moore's cheerful remark forty-four years later that for him, the First World War 'passed in a kind of romantic haze of hoping to be a hero'.[4]

When he was finally demobilized in February 1919 Moore returned to teach at Castleford for a short time. Then, using a grant available to him as an ex-serviceman, he studied at the Leeds School of Art for two years, from 1919 to 1921, and had the more valuable experience of getting to know well the avant-garde art collection of Sir Michael Sadler, the vice-chancellor of Leeds University. In 1922 he went on from Leeds to study at the Royal College of Art in London for a further three years. During that time he became familiar with the antiquities in the British Museum that were to have a significant influence upon his development as a sculptor. Of his conventional art education, he would say: 'I'm terribly grateful that I didn't get to Leeds till I was old enough not to believe what I was told by teachers.'[5]

He did not believe all that he was told at the Royal College either.

However, he did successfully complete all that he was asked to do. In 1922 the professor of sculpture 'required him to copy a Renaissance model and he chose an Italian marble in the collection of the Victoria and Albert Museum, the *Virgin and Child with Three Cherub Heads* by Domenico Rosselli'. Moore's copy, in white marble, beautifully carved, is evidence enough to suggest that, had he wished, he might have gone on to a resplendent career as a maker of conventional images – from the Royal College to the Royal Academy, as it were. But that was not the way he chose to follow even as a student, and 'the conflict between his new interest in primitive sculpture ... and the academic teaching he received at the College ... he partly resolved by carving according to his own instincts in the vacations'.[6] Indeed, judged by the story of his life, the most enduring consequence of his time at the Royal College – first as a student, and then from 1924 to 1931 as an instructor in sculpture – was that it was there, in the autumn of 1928, that he met a young and very beautiful student painter, Irina Radetsky. The daughter of an upper-class Russian family that had been a casualty of the 1917 Revolution, she had been brought to England to live with a connection of her mother's, and had presently enrolled at the Royal College. Henry, meeting her, was dazzled. Undeterred by the complication that she was more or less engaged to someone else, he courted her assiduously, and they were married in the summer of 1929, thus beginning a life together that continued until his death fifty-seven years later.

In 1922 he went to Paris, the first of his many annual trips abroad; in 1925 he spent six months on a travelling scholarship from the Royal College. His visit to Italy that year was surely the most important part of the trip: he encountered the works of the early Renaissance painters and sculptors, Masaccio in particular, and, as one would expect, the overwhelming achievements of Michelangelo. Their influence, however, did not make itself felt for many years to come. 'Until my shelter drawings during the war I never seemed to feel free to use what I learned ... to mix the Mediterranean approach with my interest in the more elementary concept of archaic and primitive peoples.'[7] Significantly, when he came back to London from Italy he was drawn not to the paintings and sculptures of the Renaissance in the National Gallery but to the primitive and archaic collections of the British Museum: the pre-Columbian, Mexican, Egyptian, Etruscan, African and others.

From his student years on, Moore had an abiding interest in the art of nature, in stones and natural shapes, along with a belief that in sculpture there must be 'truth to materials'. Yet, at the same time, by temperament and inclination he was then, and continued to be, an artist with no wish or need to adopt the traditional realism of English art. His genius as a sculptor expressed itself first in the act of carving, in discovering the form that he wanted in the block of stone or wood, and secondly in his extraordinary gift for abstraction. Thus what emerged from the stone was not a portrait or effigy or likeness of a particular woman but, as it were, 'woman herself', one might even say 'womanness'. And the motifs that continued throughout his life were the reclining figure (virtually without exception of a woman) and the seated figure of a woman holding her child.

In his early experimental days, before he had found his true style, he had to come to terms with the great variety of influences to which he had been subject. There were the forms in nature that had fascinated him since childhood. There was the continuing tension between his admiration for the works of the Renaissance he had seen in Florence and his instinctive responsiveness to the primitive sculpture he was seeing in the British Museum. But the greatest demand that he made upon himself was to reconcile abstraction with the expression of emotion.

In his relatively late book of drawings and comments, *Heads, Figures and Ideas* (1958), Moore included a postcard photograph of an Egyptian carved head. Under it he wrote 'XVIII Dynasty Egyptian – Head of a Woman (princess?) in the Archaeological Museum, Florence. I would give everything, if I could get into my sculpture the same amount of humanity & seriousness; nobility & experience, acceptance of life, distinction, & aristocracy with absolutely no tricks no affectation no self-consciousness looking straight ahead, no movement, but more alive than a real person.'[8] This, we contend, is what he was to achieve in his work during the Second World War. He himself recognized his wartime drawings as being 'perhaps a temporary resolution of that conflict which caused those miserable first six months after I had left Masaccio behind in Florence and had once again come within the attraction of the archaic and primitive sculptures of the British Museum'.[9] In many ways, his most powerful sculptural works, once he had assimilated and surmounted his influences, were those that he carved himself in the early part of his career, especially during the 1930s, with their abstract but intuitive suggestion of fundamental forms of the

human figure. But the humanity and seriousness for which, as he said, he would give everything were still in the future.

He had his first one-man show in 1928; it contained thirty drawings and half a dozen sculptures. The young Kenneth Clark – he was then 25 – whose career would be intimately involved with Moore's, bought a drawing from the show for £1. Others who came to that first exhibition to see, to admire and even to buy included the painters Augustus John and Henry Lamb and the sculptor Jacob Epstein. Moore was launched as an artist. From that time forward he slowly yet steadily ascended to fame and recognition.

Certainly the earliest and most remarkable act of recognition came from the distinguished critic, historian and apostle of modernism Herbert Read. In 1931, in his book *The Meaning of Art*, he proclaimed the stature of Henry Moore: 'We may say without exaggeration that the art of sculpture has been dead in England for four centuries; equally without exaggeration I think we may say that it is reborn in the work of Henry Moore, [who] in virtue of his sureness and consistency, is at the head of the modern movement in England.'[10] In 1931, when Moore left the Royal College and became an instructor at the Chelsea School of Art, Read's judgement must have seemed as much a manifesto and a prophecy as it was an evaluation of Moore's achievement to date. But by the end of the decade – after one-man exhibitions in London in 1931, 1933, 1935, 1936 and 1939, to which a good deal of attention was paid – the prophecy had been fulfilled. Among discerning admirers of modern art he was acknowledged as the foremost sculptor in England.

This, however, was not an opinion shared by the far more numerous middle-brow audience who didn't know much about art but who knew what they liked – and it was not modernism. More than twenty years after the notorious exhibition that introduced Manet and the Post-Impressionists to England in November 1910, modern art was still being viewed with hostility and incomprehension. A cartoon of a sculpture in the Moore style, a reclining woman with holes punched through her, was a welcome subject for laughter in *Punch*. Although Moore had many purchasers for his work, he needed to teach to survive financially; in 1939, at the outbreak of the war, he was still on the staff at the Chelsea School of Art.

Nevertheless, his reputation grew both at home and abroad. In 1930 he was one of three British sculptors whose work was shown at the Biennale

in Venice; in succeeding years he was included in exhibitions in Brussels, Hamburg and Zurich, and at the Stedelijk Museum in Amsterdam and the Salon d'Automne in Paris. The Museum of Modern Art in New York and the Albright Knox Gallery in Buffalo bought superior examples of his work. Thus, within a decade, he was on his way to becoming one of the first English artists of the twentieth century to have a truly international fame.

Meanwhile, at home he moved easily into the modernist establishment. The English traditionally have a fondness for groups, and English artists are no exception to the generalization. In 1930 Moore was invited to join the Seven and Five Society, a moderately modernist group of sculptors and painters who by 1934 had committed themselves exclusively to abstract work. He also became a member of a still more select group, Unit One, which included the painters Paul Nash and Ben Nicholson, and Nicholson's wife, the sculptor Barbara Hepworth. For the catalogue of the Unit One exhibition in 1934 Moore contributed a statement about his work that portended much (more perhaps than he himself recognized) for his future direction: 'Abstract qualities of design are essential to the value of a work, but to me of equal importance is the psychological human element. If both abstract and human elements are welded together in a work, it must have a fuller, deeper meaning.'[11]

Separating, in so far as one can, the artist from his art, one does have a sense of Moore in the 1930s moving steadily into a position of influence, as he began to climb the first rungs of the ladder of his ultimately immense reputation. In 1934, the year of the Unit One show, he also, rather oddly, exhibited in *The Social Scene*, sponsored by the Artists International Association, politically the most left-wing artists' group of the 1930s. Given the group's heavy emphasis on social realism, it cannot have been in much aesthetic rapport with Moore, but he was obviously not someone who could be disregarded in an overview of what was going on in the London art world.

By 1936 his reputation was so well established that it was virtually a matter of course that he would serve on the organizing committee for the International Surrealist Exhibition in London, though he himself was never to be identified as a surrealist, nor as a close friend of their inner group. Like the majority of English artists, writers and musicians at the time of the Spanish Civil War, he was a strong sympathizer with the

Republic, and again it seemed entirely appropriate that he should have been a member of a proposed delegation of artists that was to visit Spain as a gesture of support. (In the end, however, because of passport difficulties, the visit was not allowed to take place.)

The risks for an artist that go with involvement in groups, cliques and coteries – politicking; time-wasting; distraction from what counts most, the work of art itself – seem never to have figured in Moore's life, even during the crowded and eventful 1930s. Nothing was allowed to deflect him from the goal he had chosen long ago as a schoolboy in Castleford.

With the coming of war, however, much would change. That he understood even in September 1939. For Moore, however, as for so many others in England, the changes came more slowly than he had anticipated. The next several months turned out to be the period of the phoney war, the 'great bore' war that Waugh satirized in *Put Out More Flags* and that came to an end only in April 1940 with Hitler's invasion of Denmark and Norway.

|❖| 5 |❖|

On Sunday, 1 October, three weeks after war broke out, Moore wrote to Kenneth Clark from his cottage in Kent:

> I'm just going on working as usual.... In the last month, because modelling is much quicker than carving, I've made some 9 or 10 lead things ... But how long it will be possible to keep enough of a tranquil state of mind for [me] to do proper work, who's to say? ... Chelsea teaching has finished, & there'll be few or no exhibitions, & so no chances of sales of any work.... But luckily for us, through you as buyer for Contemporary Arts, getting my large carving for the Tate, & although the Mayor Gallery hasn't yet been able to settle completely for the drawings sold at my show there, financially we're allright for the time being.... Of course before long, the war atmosphere might get closer, & so intense, that to keep the state of mind for working wont be possible, & so there'd be nothing for it but to seek actively a way of

taking part in it. For I hate intensely all that Fascism & Nazism stand for, & if it should win it might be the end in Europe of all the painting, sculpture, music, architecture, literature which we all believe in. . . . I hope they'll find a way of using most artists in some sort of constructive, specialist way – there must be other useful work for them as well as camouflage (which everyone I've heard of, hopes to get). If it's a war against Fascism, a war to keep democratic freedom & culture, it should not destroy or neglect some of the very things it's fighting for.[12]

It was, as the letter suggests, a time of uncertainty and inconclusiveness; in fact the Chelsea School of Art would reopen in January 1940, and he would again be teaching there twice each week. The Leicester Galleries in London, contrary to his gloomy expectation, would open a one-man show of his work in February 1940.

In December 1939 Kenneth Clark invited the Moores to stay at his house in Gloucestershire, but they saw no reason not to continue at the cottage. Increasingly, however, the war interfered with their lives. Moore found it hard to acquire the stone necessary for his work, even harder to arrange for its transport, and so he confined himself to small lead figures and drawings. They, rather than a 'full sculpture show', were what he anticipated would be exhibited in the Leicester Galleries.[13]

With the threat of invasion the area around Dover was soon to become a restricted zone, and the Moores gave up their cottage. They moved back to London, first to his studio at 11A Parkhill Road, Hampstead, and then to a larger residence nearby, 7 Mall Studios, which was being vacated by Ben Nicholson and Barbara Hepworth and their three young children. Of this period Moore would write to James Johnson Sweeney in 1943: 'Except that one was intensely concerned over the war and greatly worried about its course and eventual outcome, it had no new direct visual experiences for me which had any connection with work. But when France fell and a German invasion of England seemed more than probable, I like many others thought the only thing to do was to try to help directly.'[14]

It was then, in May 1940, casting about for a way to help directly, that Moore, along with his friend Graham Sutherland, applied to take a course in precision tool-making at the Chelsea Polytechnic. However, there were many more applications than places, and neither Moore nor Sutherland was selected, in fact they heard nothing. When early in the summer the

Chelsea School of Art removed to Northampton, Moore decided not to follow it. Expecting to be called up any day for some sort of service, he preferred to wait in London and work on drawings, which could be done in the short run. Of course he had always made drawings as part of the preparation for sculptures. His practice was to start with a more realistic version and then progressively simplify it. But now, with sculpture ruled out, drawing became an objective in itself. Later, he would diffidently explain: 'There seemed no point in starting work on a new sculpture and so I concentrated on drawings. Then came the Battle of Britain ... and the blitz began.'[15]

| ❖| 6 |❖|

Until the Blitz, Moore had not had any interest in joining the War Artists' Scheme, despite the urging of Kenneth Clark who was chairman of the War Artists' Advisory Committee. That committee was part of the Ministry of Information. Clark would describe the ministry and its role succinctly, if rather negatively, in his autobiography:

It was said to contain 999 employees.... [Its] large staff had been recruited to deal with three or four different objects. The first, and most defensible, was censorship; the second the provision of news; the third a feeble attempt at propaganda through various media; and the fourth to provide a kind of wastepaper-basket into which everyone could throw their grievances and their war-winning proposals.... We had really nothing to offer except a lot of hot air about our war aims, which after lengthy discussion, we decided should be *democracy*. In fact we were fighting to save our skins; and we very nearly lost them.[16]

The official role of war art had been, after much difficulty, established during the First World War. (In part, the idea had succeeded because the Germans had already developed such a scheme of their own, and the English felt a need to rival their enemy.) The essential purpose was that artists should provide a record of the war; and in some instances, though it

was not required or expected, they might create something beyond reportage or official portraits – works of art in their own right. This had certainly been true of such war artists as Paul Nash, Stanley Spencer and Wyndham Lewis.

No one seriously resisted the idea that something similar would happen during this war as well, presumably justified as 'propaganda through various media', but in fact serving a somewhat more exalted purpose. In August 1939 Clark proposed to the Ministry of Information that a committee be formed to deal with the question, and it met for the first time on 23 November 1939. Its stated aims were first, 'To draw up a list of artists qualified to record the War at home and abroad', and secondly, 'in co-operation with the Services Departments, and other Government Departments, as may be desirable, to advise on the selection of artists from the list for War purposes and on the arrangements for their employment'.[17]

The first Minister of Information was Lord Macmillan, a Scottish judge. Although he was extremely ineffective in most ways, it was a useful coincidence that he was much involved with the Council for the Encouragement of Music and the Arts (CEMA), financed in part by the Pilgrim Trust, and therefore that he was likely to take a benign view of questions involving art. CEMA, dedicated to the support of a broad spectrum of cultural activities during the war (and direct ancestor of the Arts Council), took as its slogan 'The Best for the Most'. These wartime steps were the first towards government support of the arts, which the Treasury expected to end when the war did. Keynes became chairman of CEMA in 1942 and strengthened its commitment to 'high art'. He also managed to get an increasingly large sum for its activities from the Treasury. As Clark noted approvingly of Keynes, 'He was not a man for wandering minstrels and amateur theatricals. He believed in excellence. In four years he transformed CEMA, the social service, into a universal provider of the arts known by the title, which I [Kenneth Clark] am said to have invented, of the Arts Council.'[18]

At the same time the armed services were interested in the arts as well, but they wanted to make arrangements themselves without the interference of the upstart Ministry of Information. An uneasy compromise was worked out: the services would employ the artists recommended by the War Artists' Advisory Committee, and representatives of the services were given places on the committee. Clark's scheme was approved by the

Treasury, and the committee got under way. That it would do important work throughout the war was largely thanks to Clark himself and to E. M. O'Rourke Dickey, its sensible and sensitive secretary, who was an artist, a former professor of fine art at Durham University, a Civil Servant, and a Board of Education Inspector for Art. Indeed, it may originally have been Dickey who presented the scheme to Clark – the latter, as the Director of the National Gallery, had the position and influence to see it through.[19]

<div align="center">

❖ 7 ❖

</div>

A few artists' organizations outside the government had already been formed in advance of the Ministry of Information's scheme, among them Paul Nash's Oxford Arts Bureau. Nash's concern was that artists might too rapidly be called up as servicemen, and he established an *ad hoc* Panel of Authorities – John Betjeman, Lord David Cecil, Lord Berners and John Piper – to compile lists of artists who might be useful for the war effort; and those lists were sent to ministries. But Nash's plans were superseded by the War Artists' Advisory Committee, empowered as it was to appoint artists in varying categories and to purchase their work.

Nash was already an established painter. He was born in 1889 in London, of a well-off family, and went to Colet Court and then on to its famous affiliated school in London, St Paul's. He also studied at the Slade School of Fine Art of the University of London. During the First World War he was both a serving officer and an artist, and, in 1915, was the first British artist to exhibit war pictures. Undoubtedly his greatest painting in that war was the ironically titled *We Are Making a New World*, a burnt-out landscape – deathscape? – showing the desolation of a battlefield after a battle, populated only by the decimated ranks of ruined trees. Almost as powerful was *Menin Road* (both paintings now hang in the Imperial War Museum).[20] Nash did not arrive in France until 1917. The experience of battle for him, as for so many others, in the Ypres Salient was devastating. He was anxious 'to rob war of the last shred of glory, the last shine of glamour. . . . The violent effect of war on nature struck and wounded [him]

deeply. He retaliated with his brush, determined to expose the waste and desolation, not only of the landscape but of the spirit.'[21]

In 1939 he was not in very good health. Much to his irritation, although he was attached to the Air Ministry he was not allowed to fly because of a bronchial condition that would eventually lead to his death in 1946. Nash was a powerful, one might almost say a wilful, organizer. He had been a major figure behind the forming of Unit One in 1934. At the time of the outbreak of war in September 1939 he and his wife, Margaret, had just moved to Oxford. Building on his experience of the First World War, Nash threw himself into the organization of his Oxford Arts Bureau, almost a single-handed attempt to make sure that all sorts of artists were both protected and put to good use in wartime, that their talents would not be wasted. He wrote to a friend:

I have been given a rather special opportunity to do something towards convincing the official mind that artists have qualifications for what I believe is called 'essential service' – apart from camouflage.... I am exploring & testing & making lists of names. You realise of course that unless architects, painters, poets, writers & so on are intelligently used they will be wasted in A.R.P. [Air Raid Precautions] & observations posts & die a lingering death from penury or rheumatism.[22]

His main task was to compile lists of those who were suitable, and he was able to make his scheme public as early as November 1939 in the *Listener*, noting that 'the Industrial Arts League, the Society of Industrial Artists, the Artists International and the National Register of Industrial Designers had all compiled lists of categories where artists might be employed, which extend beyond those of camouflage and propaganda'.[23] His own Arts Bureau, with names of artists to fit into appropriate categories and various eminent figures acting as compilers, remained in existence only until January 1940. Then Nash entrusted the lists to the Central School of Art and Design in London. In any case – at least in the case of artists, who were his major concern – the War Artists' Advisory Committee took over, in a more bureaucratic way, much of the purpose of Nash's unofficial committee.

As early as September 1939 he had been in touch with Kenneth Clark about the project, and Nash's interest may have strengthened Clark's

determination to do something for artists. Certainly he was anxious to put Nash's work to good use:

> Thank you very much for telling me about your committee; it is an excellent idea and of great value to us all. . . . My only fear is that the list of names which you draw up will never penetrate to a quarter where it can be made effective. The committees on which I serve are perhaps less well qualified to choose artists, but have the advantage of working direct for the Ministry of Labour, and the names we choose are put on the Central Register. It might help you, therefore, if I could have your list of names to bring before our committee and try to persuade them to put this list on to the Central Register. . . . There remains, however, the question of how far artists will be used in this war, as they were in the last, to record various aspects of wartime life. I believe that about 90 such artists were employed in the last occasion although the system under which they were appointed was never very carefully considered. Should the Government decide once more to employ artists in this way I think it will be necessary to evolve a new committee on broader lines than those which have hitherto worked for the Ministry of Labour. This committee should not only draw up a list of artists but also consider how they should be used, that is to say what branches of wartime activity were worth recording. The work produced could be used for propaganda as well as record.[24]

Earlier that month Clark had decried his lack of power to Betjeman, who was compiling lists of writers for Nash's Bureau: 'I do not know the origin of this deplorable idea that I have anything to do with the Ministry of Information or can get people jobs there. On the contrary I am trying hard to get a job there myself without the least success. If I get there before you do I will try and wangle you in and hope you will do the same for me. You have far more qualifications than I have and ought to get there first.'[25] Clark was not totally revealing his hand, for on the first day of the war he had gone to the Treasury and had started to put forth the scheme of the War Artists' Advisory Committee, to come under the Ministry of Information. Before long, both were sucessful in getting into the Ministry, Betjeman as a 'Specialist' in the Films Division, which Clark for a time headed. Clark later felt that his most lasting achievement in the ministry

was pointing out to Betjeman that there was a ravishing girl in the canteen called Miss Joan Hunter Dunn, the subject of Betjeman's single most famous poem.[26]

The next step for Nash's involvement in the war was his troubled employment as an official War artist by the Air Ministry. It was marked by the rather comic, if sad, story of his relations with Air Commodore Peake, a former master of foxhounds and the Air Ministry representative on the War Artists' Advisory Committee, as well as the ministry's director of public relations. A compromise arrangement had been worked out for the service ministries that wanted to deal with artists independently of the Ministry of Information. The committee would recommend artists to the appropriate services, and it was hoped the recommendation would be acceptable, as the individual from a particular ministry in charge of its artists would also be a member of the War Artists' Advisory Committee. The committee reserved to itself the right to decide who would be an official war artist, and the purchase of pictures. Nash, not unjustly, placed a high value on himself and tended to be demanding. Given Peake's rather philistine nature, the situation was set up for misunderstanding, comedy and disaster, even though the ultimate artistic result for the War Artists' Advisory Committee was considerable.

Nash's period of work as a war artist with the Air Ministry began in March 1940, at an annual salary of £650, under appointment from the Advisory Committee.[27] Nash did succeed in driving Peake and, to a lesser degree, the committee to distraction, creating quite a splendid confrontation between the artistic and the bureaucratic minds. Much to his distress, Nash learned that he was not entitled to first-class rail travel, as it was necessary to be at the salary level of £750 a year to enjoy that privilege.[28] And there was a continual hassle about whether he could reverse charges for telephone calls. Clark, who usually did his best to support Nash, recognized that this would be opening a Pandora's box. If one gave in to him, he was likely to ask for more: 'I see no reason why we should pay for Mr. Nash's long-distance telephone calls. He has a great liking for such calls and has several times rung me up from Oxford, but never on a matter of urgency. There might be an occasion when a long-distance call was necessary – e.g. if Mr. Nash were arrested for sketching, and you might be able to allow that in such cases we would refund his telephone expenses.'[29] This was quite a legitimate concern – several artists

had been arrested on suspicion of spying while sketching. Actually, Nash was doing highly satisfactory work and the committee, as early as August, was very pleased: 'Six water-colours of crashed German air-craft by Mr Paul Nash were shown to the committee, who agreed that they were the best work so far sent in by any war artist.'[30]

Nevertheless, the relations between the Air Ministry and Nash were far from good. In October Air Commodore Peake commented that 'although the work this artist has done has been much admired for its artistic merits it was not so well thought of from the Service point of view', and that there was 'a general feeling at the Air Ministry that he might be released at the end of the year'.[31] Nash was then working on a series of 'Aerial Creatures'. He complained to Dickey: 'I find Peake unhelpful & apparently indifferent to what I an trying to carry out. Is there no one else I can get going? What I feel is this: They are not making enough out of what I can do for them.'[32] Nash found 'Aerial Creatures' extremely congenial, as he wrote in a piece in *Vogue* in March 1942 on 'The Personality of Planes': 'I first became interested in the war pictorially when I realised the machines were the real protagonists.'[33]

The Air Ministry was not particularly pleased that Nash was more interested in downed German planes than in functioning British ones. As Nash wrote in 1945:

> I only know that with a few exceptions I disappointed the attitudes of the Air Ministry, and, after drawing and painting about sixty airplanes and no airmen, I gave place to an old comrade of the last war who had announced that he wanted to paint heroes. . . . I was made to feel that to make a picture of the wreck of an enemy machine on the ground was rather like shooting a sitting bird. . . . They were better pleased when I began to depict airplanes in flight, but again there was something not right.[34]

The ministry preferred, in Peake's hunting metaphor, live horses to dead foxes.[35] Peake was also irritated that Nash did not paint more subjects.[36] He was the most independent of the service representatives on the committee; perhaps the Air Force, as the newest service arm, was most anxious to assert itself. As Clark wrote to Nash in 1941: 'The Services are supposed to buy their pictures through us and have their representatives on our Committee. The only Service to break this rule is the Air Force, which

thinks that our taste is too modern and likes to go off on its own and commission a portrait by Oswald Birley.'[37]

Clark did his best to mollify Nash, recognizing that he was both a highly distinguished artist and quite a difficult man. By the summer of 1941, however, Peake was fed up. Dickey alerted Clark:

> Air Commodore Peake contends that while your Committee are prepared to encourage the production of pictures of air subjects by Mr. Paul Nash, the aeroplanes painted by this artist are not accurate representations. He would like to see more pictures of aircraft in action and on the ground which would satisfy the technical experts as being correct records of the appearance of the machines. . . . He said once more that he felt disinclined to arrange for facilities for artists recommended by your Committee when the Committee were unwilling to recommend for purchase pictures by other artists of whom he approved.[38]

It might be necessary to take strong steps against Peake, and Clark considered the possibility of enlisting the aid of Walter Monckton, director-general of the Ministry of Information.

Clark was generally willing to put up with the demands Nash made upon him, as when he asked that Clark persuade the Queen to buy one of his Dymchurch paintings. Apparently, Clark was not successful – if he broached the subject – even though he was the Keeper of the King's Pictures. Writing to Nash at the end of October about the tension between himself and Peake, Clark agreed that 'Peake, as you see, is not an amateur of the arts, but I think it would be a great pity if you were taken away from Air Ministry work. . . .' Then, in a change of subject, he added 'It is very difficult for me to persuade the Queen to buy modern pictures at the moment. . . . But if I get an opportunity I will mention your Dymchurch.'[39] (The Queen did later buy a Nash oil of 1944, *Landscape of the Vernal Equinox*.)

On 21 November Nash wrote to Clark in despair: 'I have received the incredible heartbreaking intelligence that my Air Ministry appointment is to finish with the year. Of course this is Peake's doing alone.'[40] Clark tried to reassure him: 'We have told them [the Air Ministry] how foolish they are in very strong – I might almost say insulting – terms, but I am afraid there are a certain number of them led by Peake who yearn for the Royal Academy style, and they are determined to have it. . . . You should be able

to go on painting flying subjects as much as you like, but for us rather than for your former ungrateful employers.'[41]

The ultimate solution was to remove Nash from the jurisdiction of the Air Ministry and make a special arrangement for him to be directly employed by the Ministry of Information. In effect, little had changed, but his friends tried to bolster him up from what he considered a blow to his pride. Lillian Browse wrote to him: 'I should not worry too much over the Air Ministry affair, in a way it is a compliment that the officials do not like your work – they have no imagination and are only interested in the planes as machines. You will now at least have a free hand and will probably do things more to satisfy yourself.'[42]

Nash may have derived some enjoyment out of his fight with the Air Ministry, despite his claim that it was disturbing him. He appeared not all that dissatisfied now that he was employed directly by the War Artists' Advisory Committee: 'I have ceased to work for the Air Ministry. They engaged me as an official artist but forgot to imagine that being an artist might mean more to me than being an official. I now work for the M of I and continue to do my aerial creatures & so on as if nothing had happened.'[43] Or as he wrote to the painter Richard Seddon: 'I couldn't please the Air Ministry who wanted a Royal Academical point of view. . . . I now work under the auspices of the Ministry of Information which gives me complete freedom.'[44]

Whatever the bureaucratic arrangements, Nash continued to be fascinated with aircraft and frustrated that he was not allowed to fly. He gathered photographs of aircraft, and took photographs himself, particularly of the wrecked German aeroplanes that were kept at a dump in Cowley, near Oxford, and were to prove the inspiration for *Totes Meer*.[45] Photographs were very important to him, although only a few of his own were shown during his lifetime, some at the International Surrealist Exhibition in 1936.* Nash wished to show

*There has been increasing interest in Nash's photographs recently, including an exhibition devoted to them at the Tate Gallery in 1973 and, for instance, the discussion of the relation of his photographs to his paintings in Marina Vaizey, *The Artist as Photographer* (New York, 1982). On p. 76 of that study there is a juxtaposition of one of Nash's photographs of the aircraft at the Cowley dump and *Totes Meer*. See p. 77 for commentary on Clark's reluctance to show Nash's photographs; Nash himself would not publish his photographs, although he did want them exhibited.

photographs and paintings together, but Clark reluctantly said that it wasn't possible:

> Some day an art critic of authority must break down the public distinction between art and photography, but God forbid that the Ministry of Information should be the first to try and do this, especially as the people who come to see the War Artists Exhibition are usually very simple and have come primarily for non-aesthetic motives. Can't you imagine the indignant letters we would get, and the floods of requests from photographers of the baser sort that their work should be shown too?[46]

Water-colours by Nash of wrecked aircraft were shown in the National Gallery and were very well received. John Piper reviewed them favourably in the *Spectator* and wrote to Nash privately in September 1940: 'I have said they are the best pictures the war has produced. I ought to have said they are the only ones.'[47]

The magnificent *Totes Meer* (now in the Tate Gallery) was submitted in 1941; it is perhaps the finest English picture to come out of either the First or the Second World War, a painting of lyrical desolation. Nash had been working on similar themes for some time, such as his *Winter Sea* of 1925–37. *Totes Meer* resembles his powerful pictures of the First World War, but is the work of a maturer artist and has far greater strength and depth. Nash takes man-made forms and connects them with nature and waste. Yet there is the subtext of triumph: the British had brought down the planes. In 1948 Eric Newton pointed out the development in Nash's work:

> No other artist could have tackled the most difficult aspect of the second world war – its aerial aspect – as Nash did. In fact, no other artist could do more than produce photographic representations of it. Nash's understanding of the personality of planes and the meaning of flight enabled him to interpret the war in the air of 1941 as memorably as he had interpreted the war in the mud in 1916. And again he was able to sum up his experience in two major works. *Totes Meer* and *The Battle of Britain* are better pictures than the *Menin Road*, not only because they are more imaginatively conceived but because they are more coherently designed. They have a sustained unity of which he was incapable in his twenties. *Totes Meer* is not just an elaborate allegory by a man struck with

the bright idea of turning wrecked aeroplanes into breaking waves, hinting at skeletons and setting the moon in the sky as a trademark of the romantic painter. It is a factual account of the behaviour of twisted and torn metal, and it could only be arrived at after a searching examination of the famous 'Cowley Dump'.[48]

Newton had changed his mind about Nash's appointment. In 1940 he had apparently thought it was a waste, or at the least an inappropriate use of talent, commenting that it was 'rather like asking T.S. Eliot to write a report on the Louis–Farr fight or Stravinsky to compose a march for the Grenadier Guards'.[49]

Nash wrote to Clark about the picture in March 1941:

Totes Meer Dead Sea (very much *not* The Dead Sea of course). Based on actual scene. One of the larger dumps devoted to wrecked German planes alone. You will remember the set of photographs I showed you. The thing looked to me suddenly, like a great inundating sea. You might feel – under certain influences – a moonlight night for instance – this is a vast tide moving across the fields, the breakers rearing up & crashing on the plain. And then, no; nothing moves, it is not water or even ice, it is something static and dead. It is metal piled up, wreckage. It is hundreds & hundreds of flying creatures which invaded these shores (how many Nazi planes have been shot down or otherwise wrecked in this country since they first invaded?) Well, here they are, or some of them. By moonlight, the waning moon, one could swear they began to move & twist & turn as they did in the air. A sort of rigor mortis? No, they are quite dead & still. The only moving creature is the white owl flying low over the bodies of the other predatory creatures, raking the shadows for rats & voles. She isn't there, of course, as a symbol quite so much as the form & colour essential just *there* to link up with the cloud fringe over head. There are also six so-called studies accompanying the paintings, of different sizes. They were made *alongside*. They are comments & notes about the colour to re-inforce the dozen photos I took for detail.

On a more prosaic level Nash wished to receive £300 for the picture, and in a letter some days later to Dickey he suggested that a reproduction be made to depress the Nazis and to influence neutrals.[50]

In November 1943, in a letter to the art dealer Dudley Tooth, Nash elaborated on the significance of the painting:

When I came to study airplanes I found in them the same evidence of personality as I saw in trees and stones, except that the animal resemblance was more pronounced. The personality, in fact, was seldom a mechanised one, and aerial creatures though they were, this confirmation suggested most often the inhabitants of the earth or the sea – when it did not conjure up the monsters of pre-history.... So, for some time, I persisted in my preoccupation of the monsters in the fields although I made other studies of planes in flight, but very few quite isolated from the land below. It was this research that led me to the larger concern of broken German planes in the mass which suggested to my mind the large painting Totes Meer. Although Totes Meer had a direct bearing on the Battle of Britain, I wanted to express in *aerial terms* the triumph of that victory.... Landscape at night has always fascinated me.... By the end of 1940 I had to a great degree exhausted my interest in the personality of air planes.[51]

Dickey informed Nash that 'Your picture 'The Dead Sea' was received with acclamation at yesterday's meeting of the Artists' Advisory Committee', and Clark wrote to Nash that it was 'the best war picture so far I think'.[52] The value of the picture was instantly recognized, both as a work of art and as potential propaganda. As Nash himself wrote about the picture in August: '*Dead Sea* is not entirely a fantasy. It was inspired by an actual phenomenon.... It symbolizes the defeat of Germany's aerial invasion of England in 1940 when between August & October 2,375 Nazi planes were destroyed.' This statement provided the basis for the official statement put on postcards of the picture issued by the supervisor of publications, who had called the German planes the 'invading aerial Armada', but made the phrase more prosaic on the card itself: 'Germany's aerial invasion.'[53]

Nash's other great painting of the war is the *Battle of Britain* of 1941, now in the Imperial War Museum. Of the *Battle of Britain* Nash wrote:

The painting is an attempt to give the sense of an aerial battle in operation over a wide area, and thus summarize England's great aerial

victory over Germany. The scene includes certain elements constant during the Battle of Britain – the river winding from the two areas across parched country, down to the sea; beyond, the shores of the continent, above, the mounting cumulus concentrating at sunset after a hot brilliant day; across the spaces of sky, trails of airplanes, smoke tracks of dead or damaged machines falling, floating clouds, parachutes, balloons. Against the approaching twilight new formations of the Luftwaffe, threatening.[54]

The Advisory Committee had commissioned the painting in July 1941 for £200.[55] When it arrived in October Clark was delighted: 'I think it one of the most thrilling works of art yet produced by the war. I think in this and Totes Meer you have discovered a new form of allegorical painting. It is impossible to paint great events without allegory, but unfortunately we no longer accept symbols like those which satisfied the classical painters, and you have discovered a way of making the symbols out of the events themselves.'[56] Nash replied with a warm letter of thanks.[57]

<p style="text-align:center">❖ 8 ❖</p>

Clark wanted to have all sorts of approaches and all sorts of artists included in the War Artists' Scheme, but his special concern was with those who might be regarded as too advanced, too experimental, and hence might not be thought appropriate. In his autobiography he explains: 'I was not so naive as to suppose that we should secure many masterpieces, or even a record of the war that could not be better achieved by photography. My aim, which of course I did not disclose, was simply to keep artists at work on any pretext, and, as far as possible to prevent them from being killed.'[58] In the second month of the war he wrote in the *Listener*:

> The first duty of an artist in wartime is the same as his duty in peace: to produce good works of art.... As a fireman he will be of very little use to his country, but if he is a good artist he may bring it international renown, and even as a mediocre artist he will help to create that body of

images through which a country exists for the rest of the world. . . . [The artists of the First World War] did leave a record of the war which the camera could not have given. There are certain things in life so serious that only a poet can tell the truth about them.[59]

The artists to whom he was closest, Moore and Sutherland, were among the most gifted modernists of their generation. They would emerge as the most important artists of the Second World War. If it had not been for Clark's particular interest they might not have been urged, as artists more abstract than realist, to participate in the scheme.

To be sure, important work was done in the war theatres outside England by such war artists as Anthony Gross, Eric Ravilious, Edward Bawden, Leonard Rosoman and Edward Ardizzone. Yet it is striking that the most memorable art of the war should have been done on the Home Front by Moore and Sutherland in London, by Stanley Spencer in the shipyards on the Clyde, by John Piper in his architectural pictures, and by Paul Nash in his extraordinary paintings of aircraft in the air war over Britain in the summer of 1940. Perhaps the most extensive patronage scheme for British artists that has ever existed, the War Artists' Scheme resulted in nearly six thousand works of art, most of them eventually distributed to museums, with the Tate Gallery and the Imperial War Museum having the first pick.[60] It also led to a higher estimation being placed by the general public, as well as by those who were more seriously responsive, upon British art not only of the present but of the past.

Clark, looking back, saw the War Artists' Advisory Committee through a rosy glow. In fact, disputes occurred, particularly between the service representatives and the other members, not least over the work of Paul Nash:

It was important to form a committee that would be more or less acceptable to conservatives and yet be in sympathy with the left. . . . We had over one hundred meetings, and never a harsh word spoken. I have said that I did not suppose that the war artists scheme would produce many outstanding works of art. In fact it did. Paul Nash, who was seconded to the Royal Air Force, painted two or three beautiful and moving pictures, *The Dead Sea of German Aeroplanes*, and the splendid,

tonic *Battle of Britain*, which more than any photograph records our feelings at that time. John Piper was the ideal recorder of bomb damage, and Graham Sutherland transferred his feelings for the menacing forms of roots and trees to twisted girders and burned-out bales of paper. Above all the tube shelters gave Henry Moore a subject that humanised his classical feeling for the recumbent figure, and led to a series of drawings which will, I am certain, always be considered the greatest works of art inspired by the war. Of course we commissioned a great number of portraits, and I hoped to discover some painter who would give new life to this declining form of art. But, alas, the only portraits that rose above mediocrity were Epstein's bronze busts.[61]

Or, as he wrote to William Rothenstein a little more than two years after the outbreak of the war: 'I am glad you feel that the War Artists' work is improving. We have cast our net very wide and inevitably caught a few fish which do not suit the cultivated palate, but we have tried very hard to avoid mere picture-making and stuck to sincere records of experience, whether imaginative or factual.'[62]

Despite Clark's urgings, Moore had not been particularly interested in becoming an official war artist as there was nothing in the war thus far that ignited in him even a spark of inspiration. However, when the Blitz began in September 1940 he almost immediately changed his mind: 'Then there were things happening in London.'[63] And the artist responded.

|❖| 9 |❖|

The use of the London Underground stations as shelters was a development for which the people of London themselves were responsible. The government wished to keep the tubes free for possible troop movements and essential services, and was explicitly opposed to the idea of using them otherwise, however logical that might seem, fearing what was called a 'deep shelter complex'. It was also fearful that the people gathered together in the Underground would be vulnerable to Communist anti-war propaganda – this was still the period of the German–Soviet pact – and that

'crowded shelters, besides being a perfect breeding place of various physical infections, would encourage every form of mass hysteria from defeatism to panic.'[64]

In fact, none of these dire predictions came to pass. The government considered limiting entrance to the Underground to *bona fide* travellers, using the police or troops if necessary, but this was never done and might well have met with considerable resistance. Indeed, in some cases people might be both travellers and shelterers, as they sometimes travelled along the line to a station they found congenial as a shelter for the night. As *Picture Post* remarked: 'Officialdom proposed that Londoners shouldn't use them [the stations as shelters]. Londoners decided otherwise.... London decided how the tube stations were to be used. Officials are co-operating.'[65] On 12 September, five days after the Blitz had started, the poor, who were becoming increasingly demoralized, seized the initiative and descended into the tubes.[66]

The Labour Party in particular pressed for improvement of the shelters. In October 1940 it called upon the government 'to take steps (a) to ensure the greatest possible degree of safety and comfort for people forced to shelter outside their own homes by increasing shelter accommodation and providing proper sleeping and sanitary arrangements in shelters.... (f) to establish adequate nursing and medical services in connection with large shelters and also for homeless and evacuated families'.[67] A committee was established to investigate these issues.

The London Underground shelters might not be particularly desirable – hygienically or psychologically – but people had gone down into them during the First World War and were determined to do so again. There was no legal way in which the government could prevent the buying of penny-halfpenny platform tickets that would allow anyone to go down into the tubes and seek shelter from the nightly raids. Eventually the government was forced to follow the lead of the populace and attempt to raise the standard of comfort and sanitation in the Underground shelters, providing lavatories and building tier bunks for children. Food and medical services rapidly improved. When Moore first saw the shelters, however, they were still at their most primitive.

In a way, the situation was emblematic of the war: the tube platforms were packed with shelterers while ordinary life went on and the trains continued to run, although on schedules affected by the raids. People

started to queue up early in the morning to get on to the platforms and establish their territory. Up until half past seven in the evening they had to keep eight feet from the edge; from eight o'clock until half past ten, four feet; and then when the trains stopped running they had the entire platforms, even slinging hammocks over the rails. Even so, of course, sleep was difficult, men averaging four and a half hours and women three and a half.

Not so surprisingly, many of the most dramatic and moving of Moore's drawings depict people sleeping. One observer noted: 'There are thousands of shelterers in this station [Holborn]; the whole of the spare escalator is occupied and the passage for bona fide travellers from street level to the platforms is just adequate and no more. The platforms themselves are crowded with people; the space left for people boarding and alighting from trains is certainly not enough during the rush hours.'[68]

An elaborate social life developed in the tubes, as private life was lived in public, and communities formed as so many people returned regularly to the same spots. For some who had lost their homes in the Blitz, the shelters became semi-permanent residences, particularly those stations not in operation. Small entertainment troupes toured the shelters; at the Swiss Cottage station a newspaper was published. The government in fact began to build deep shelters, but none was ready at the time the raids ended. At the end of the war there were still 12,000 people living in the tubes.[69]

These great nightly scenes contrasted extraordinarily with the comparative normality during the day – funds were even collected, in very small sums, by the shelterers to tip the tube porters for their extra clean-up work. 'About five, while it was still dark, and the raid was still going on, people began to leave. These were mostly men, postmen and labourers who presumably had to get to work. By about a quarter past five whole families were leaving, most of them apparently to go home and get a few hours' sleep in bed before starting the day's work. . . . At twenty to six the All Clear went. . . . By six o'clock there were only about half a dozen groups left on the platforms. By seven they were completely empty and the mess of papers and fruit had all been cleared away by the porters.'[70]

The government had, in a sense, wished to privatize shelters by giving families free Anderson shelters to install in their gardens. But this was restricted to those who had gardens in which to place them. The poor in their tenements in the East End obviously had no use for them, nor were

they likely to purchase a Morrison Shelter – a shelter in the shape of a dining-room table that one placed indoors – even though the price was subsidized. (In any case, this was not introduced until March 1941.) Many Londoners simply stayed at home during air raids; only four per cent of the London population went into the tubes. London was bombed for fifty-seven nights from 7 September 1940 to 1 January 1941, and during that period 13,339 people were killed and 17,937 injured.[71] During the entire war approximately 60,000 people were killed in the bombing of England, 86,000 seriously injured, 149,000 slightly injured and two and a half million left homeless.[72] Perhaps fifty per cent fewer might have died if they had taken shelter. In any case, the casualties were less than the early expectation that in the first two weeks of bombing 211,000 civilians would be killed and 422,000 wounded.[73] For the first two months 100,000 Londoners went down into the tubes each night; later the figures declined to an average of 70,000 to 80,000 people a night.[74] On the night of 27 September 177,000 people took shelter in the tubes, a record figure.[75]

The bombing of London was in fact one reason why Britain won the war. In August 1940 Germany had waged the Battle of Britain, essentially fought between the *Luftwaffe* and the fighter planes of the RAF; the German attacks were directed at air bases and strategic targets, in an attempt to secure air supremacy and reduce Britain's ability to wage war. If Germany had continued along these lines it would probably have been more successful. (Yet the bombing of such targets and of civilians, terrible as it was, was far less destructive of life, property and morale than had been expected.) In September 1940 Hitler was so enraged by the British bombing of Berlin that he launched the Blitz on London. The term 'Blitz' reflected Hitler's wish, but it was not, as the name suggests, one short overwhelming blow; rather, it was a continual bombing for months. As Hitler threatened: 'When the British Air Force drops two or three or four thousand kilograms of bombs, then we will in one night drop 150, 250, 300, or 400 thousand kilograms. When they declare that they will increase their attacks on our cities, then we will raze their cities to the ground. We will stop the handiwork of these night air pirates, so help us God!'[76] The start of the Blitz coincided with the moment when Britain expected invasion; on 7 September 1940 church bells rang to indicate its likelihood. By 15 September Hitler had decided to postpone the invasion of England indefinitely.[77]

I❖I10I❖I

Moore discovered these Londoners sheltering in the tubes during the Blitz early in September 1940, on a now legendary evening in the history of British art. In his account of the moment, he wrote:

> We owned a little Standard coupé and as a rule we used it when going into town. But one evening we arranged to meet some friends at a restaurant and for some reason or other went into town on the 24 bus instead of going by car. We returned home by Underground [because the buses had stopped running], taking the Northern Line train to Belsize Park station. It was a long time since I'd been down the tube. I'd noticed the long queues were forming outside Underground stations at about seven o'clock every evening but hadn't thought much about it, and now for the first time I saw people lying on the platforms at the stations we passed: Leicester Square, Tottenham Court Road, Goodge Street, Euston, Camden Town, Chalk Farm. It happened to be the first night on which a big anti-aircraft barrage was put up all round London. I think it was done to help the morale of Londoners more than anything else: it made a terrific noise and gave the impression that we were hitting back at the raiders in a big way. When we got out at Belsize Park we were not allowed to leave the station because of the fierceness of the barrage. We stayed there for an hour and I was fascinated by the sight of the people camping out deep under the ground. I had never seen so many rows of reclining figures and even the holes out of which the trains were coming seemed to me to be like the holes in my sculpture. And there were intimate little touches. Children fast asleep, with trains roaring past only a couple of yards away. People who were obviously strangers to one another forming tight little intimate groups. They were cut off from what was happening up above, but they were aware of it. There was tension in the air. They were a bit like the chorus in a Greek drama telling us about the violence we don't actually witness.[78]

For some the crowded scene on the Underground station platforms seemed like Dante's Inferno, not so much because of its horror or misery as

for its fantastic look. As one can imagine, humaneness and crankiness mingled in the shelters, as elsewhere in London; ironically some suspected that those taking advantage of the situation were likely to be German Jews![79] There were, as usual, class aspects; not unlike the 'quality' coming to look at the mad at Bedlam in the eighteenth century, sightseers from the West End would enter the tubes to gape at the shelterers.[80] As one of the shelterers remembered: 'Really it was degrading because they gave the impression they were looking down on us. In fact, we were a bit resentful about it.'[81] Seventy-nine regular stations on the tube lines were claimed by the shelterers, as well as disused stops such as South Kentish Town and Aldwych, and one that Moore depicted, the incomplete Liverpool Street extension, which could hold up to 10,000 shelterers. As trains were not yet running there, shelterers could stay for weeks.

In 1940 Moore had made a few sketches of aircraft on the ground in Sussex, but before the Blitz he had done practically nothing connected with the war. Now he had a purpose: not simply to record what he had seen that night and would see again night after night, but to return their humanity to the shelterers. His interest was in drawings as finished works in themselves and not, as heretofore, preliminary studies for sculpture. He included not only the people in the shelters, although they were his main interest, but also some of the life above ground in his drawings of bombed buildings. Forty years later he recollected the experience:

The first year of the shelter drawings was for me a very exciting and unique period ... The tremendous excitement of seeing, the morning after the raid, the blitzed buildings that had been whole the day before. If the drawings of this period reflect my feelings, it is because I was completely occupied in *only drawing* at this period. To me at that time it seemed that nothing had ever happened in the world like that before. Unlike anything that had ever happened in other wars. When I first saw a dead person I thought how remarkably beautiful. There is something so still, so dignified. Not the dead of war, but those laid out in a room.... All those hundreds of people huddled together in the Underground were rather like what one imagined were the people huddled in the bottom of a slave ship. I felt here was a group of people – having things done to them, and being absolutely helpless.[82]

'It was a huge city in the bowels of the earth. . . . I saw hundreds of Henry Moore Reclining figures stretched along the platforms. I was fascinated, visually. I went back again and again.'[83]

Robert Melville has compared Moore's descent into the tubes to Turner's rush to the burning Houses of Parliament in 1834. Moore's visit 'led directly to a series of drawings which record the strangest aspect of the most critical months in our history and which constitute one of the greatest pictorial achievements of British art.'[84]

Moore started his shelter drawings the very morning after his fateful ride in the tube, and on succeeding nights in September 1940 he continued to go down into the Underground stations. He would not disturb the privacy of the shelterers, but made quick notations on scraps of paper. He worked on the drawings later in his studio in Hampstead. As Wilkinson writes:

> After all, the shelterers were leading private or family lives, though in a communal environment. To have sketched them directly would have been an intrusion on their privacy. If, however, a particular scene or group of figures held Moore's attention, he would walk past a number of times trying to fix the idea firmly in his mind. Occasionally he went into a corner or exit passage to make hurried notes on the back of an envelope or on a scrap of paper, with brief descriptions or small sketches. These served as vivid reminders when he came to recreate the scenes.[85]

Moore himself remarked: 'You couldn't sit in the shelters and draw people undressing their children – it was too private.'[86]

It was a time of extraordinary artistic activity for Moore, the result of the conjunction of the pressures of war and inspiration. He would do as many as three drawings a day, along with the sketches. All told, he filled two sketch-books and part of a third, and finished about sixty-five large drawings.[87] Two locations in particular intrigued him: the uncompleted Liverpool Street extension; and Tilbury, not actually a tube shelter but rather a large warehouse basement where 3,000 people regularly took shelter, although it could cope, if necessary, with as many as 14,000.[88] Contemporary witnesses described the Tilbury basement with differing emphases:

First impression was of dim, cavernous immensity. The roof is made of metal girders, held up by rows of arches, old and solid ... giving a somewhat church-like atmosphere.

The floor was awash with urine ... only two lavatories for 5000 women, none for men ... overcome by the smell.

People are sleeping on piles of rubbish. ... The passages loaded with filth. Lights dim, or non-existent.[89]

Gradually, however, rules and regulations were established, and conditions improved. But even before that, Moore would not allow the sordid minutiae to subvert his vision of life in the shelters.

As we have noted, Clark had been pressing Moore virtually since the establishment of the War Artists' Scheme to become an official war artist. But Moore was unpersuaded: he did not believe that he could produce anything even remotely appropriate, and he expected he would be called up to do something useful – perhaps in camouflage, if not in machine tooling. Now, however, he had found a compelling subject in the Underground shelters, a theme that moved him profoundly. The moment was right to give in to the persuasive Clark's blandishments. Clark, seeing the first sketches, felt his campaign was vindicated, and Moore felt that he no longer had any excuse to refuse.[90]

The development in Moore's art did not come as a complete surprise to Clark, for the latter had noticed that, even before the experience of Belsize Park, Moore had been doing drawings that were not preliminary sketches for sculptures, even though their titles might suggest otherwise. For instance, Clark thought that, despite its title, this was true of a Moore drawing he owned, *Two Women: Drawing for Sculpture, Combining Wood and Metal* (1939): 'Of course it is not a drawing for sculpture in any medium, but a creature of his imagination which has taken so strong a hold on him that he made it into a painting.'[91] Clark had already felt that Moore was moving somewhat away from abstraction, and as he wrote: 'We [Clark and his wife] watched with infinite admiration how the abstract-looking style of the 1930's was modified, without any loss of completeness, by his observation of sleepers in the tube shelters. The process can be followed in one of the two small sketch books upon which all his own shelter drawings are based.'[92]

37

Clark had not suggested the shelters as a subject to Moore, but in retrospect the drawings were a natural coming together of Moore's qualities: 'In 1939 he was known purely as an 'abstract' artist, but I had fortunately seen one or two groups of draped figures that he had done in 1938 which suggested that the problem of representing huddled, sleeping forms would appeal to him technically; while the human qualities of courage and stoicism would appeal to his warmth of heart.'[93] Robert Melville has remarked:

> Moore was so fully prepared by his temperament and his surreal preoccupation with the human figure to discover the element of the marvellous and the mythical in the nightly descent of women and old men to the underworld, that it's difficult to think of his first sight of the ranks of sleeping figures in the tubes as fortuitous. The scene was unprecedented in actuality, but there is the clearest evidence of presentiment in a number of Moore's prewar drawings, and some of the objects which he carved in the years immediately preceding the shelter drawings contain curious symbols of the life in the tunnels.[94]

It was now of course a matter of getting officialdom to co-operate, but there was little difficulty with the War Artists' Advisory Committee. In mid-December the first group of drawings was sent to the committee. Dickey noted in a letter to the Home Office: 'Henry Moore's shelter drawings are now here. I did not produce them for the committee yesterday since I thought Clark ought to be there when this was done. They certainly seem very good to me. . . . Clark thinks we might well give Moore a commission, and you will wish to consider this suggestion from the Home Security point of view.'[95] Shortly thereafter, the committee made the arrangements for Moore to become an official war artist. The relationship between the committee and Moore is a fairly gentle example of what happens when artists and the Civil Service meet, as Moore was following his own compulsions and would not, ultimately, take the guidance of the committee. On 2 January 1941 Dickey, the committee secretary, wrote arranging for the purchase of four shelter drawings for thirty-two guineas and commissioned Moore to carry out a series of drawings on civil defence: 'The number and size of the drawings to be a matter for mutual arrangement, and the subjects to be chosen at your

discretion in consultation with Burke of the Ministry of Home Security. . . . With best wishes to you and yours for a happy New Year and the destruction of the Axis.'[96] Moore accepted the terms on 5 January and echoed Dickey's wish for the destruction of the Axis.

Some days later the conditions were spelled out; Moore had now become a sort of civil servant rather than continuing the more bohemian and freer life of an artist. He was to be entitled to third-class travelling expenses and, if he were away from home, £1 a day for maintenance. 'It will be necessary to submit all your preliminary sketches and studies, as well as the finished work, for censorship. This will be done by us and it is, of course, desirable that we should have your drawings as soon as conveniently possible after they have been completed. I must caution you not to show any of these works, even to your friends, before they have been submitted by us to the censor.'[97] The censorship issue was slightly ludicrous, as anyone in London, including spies, could go down into the Underground stations, but Moore was subjected to the same regulations as other war artists. Rather surprisingly, two months later he was still not quite sure of his official status. He wrote to Clark in late March about the registration of 41- and 42-year-old men scheduled to take place on 5 April, asking 'whether I can say I'm doing work for the War Artists' Committee'. He also expressed his gratitude to Clark for arranging the sale of one completed drawing and one future drawing to Colin Anderson, Clark's great friend and a wealthy art patron: 'It's very nice to have these reserve requests for drawings & to think at the moment there's more demand than supply. It's never been like that with me before.'[98]

In April the committee purchased six drawings – *Tilbury Shelter, Women in a Shelter, Shelter Scene: Bunks and Shelterers, Shelterers in the Tube, Brown Sleepers in a Shelter* and *Tube Shelter Perspective* – for fifty guineas, and two further drawings for twenty guineas. In May it purchased another two for twenty guineas.[99] The committee had three possible arrangements with artists: that they be full-time employees on six-month contracts (this was the arrangement with Paul Nash and Graham Sutherland); that the committee have an option on all their works, as with Moore; or that it purchase an occasional work. The government ultimately bought seventeen of the shelter drawings; the rest were Moore's to dispose of as he wished.[100]

When the shelters became more orderly, and Moore had expended his

extraordinary enthusiasm upon the drawings, he began to lose interest and momentum. The committee continued to treat him as a commissioned artist and assign him subjects for drawings. Moore was unlikely to respond favourably to such suggestions, despite an appearance of compliance. The committee wrote to him in August:

> At yesterday's meeting of the Artists' Advisory Committee it was recommended that you be commissioned to make drawings of certain Medical Aid Posts, including that of Stepney, the fee to be 25 guineas and the amount of work to be settled by mutual agreement as before. We cannot make this recommendation effective until we know that the Treasury are prepared to make us a grant for the third year of the war.... The subjects were suggested to Sir Kenneth Clark by Lady Louis Mountbatten and Mrs. Reginald McKenna. The First Aid Post under the Adelphi Arches, the Medical Aid Post under the Wharves at Bermondsey, and the Medical Aid Post at Stepney, which is under the bridge and lit by candles, were thought particularly likely to interest you. When you are ready to get going will you please communicate with Miss Lees, Secretary to Lady Louis Mountbatten, 55 Eaton Place S.W.1.[101]

To finish this little episode in the social history of painting, Dickey wrote to Miss Lees informing her that Anthony Devas was doing a portrait of Nurse Cochrane of Charing Cross Hospital, and that Evelyn Dunbar and Moore were to do further subjects suggested by Her Ladyship. On 19 August Moore wrote that he would be happy to undertake the commission. Nothing came of it.[102]

Meanwhile, Moore was to experience directly in his own life the consequences of the bombings. He and his wife had been staying for the weekend with a friend, the Labour MP Leonard Matters, in the village of Much Hadham in Hertfordshire. Matters and his wife urged the Moores to stay longer in the comparative safety of the countryside, although it was only thirty miles from London, and at night they could see the fiery glow of the air raids lighting up the sky. But Moore wished to return to London to work on the drawings:

> We left them on the Monday morning in the little Standard Coupé ... for which I had a small petrol ration, being a war artist. When we got to

Hampstead, the road leading to our studio was cordoned off by the police because of an unexploded bomb. A policeman said 'You can't go this way. Where do you live?' I said '7 Mall Studios,' and he said 'Oh, they're flat to the ground' with almost a kind of enjoyment in the devastation.[103]

We found that the warden had mistaken Parkhill Studios for Mall Studios, but although our place was not down it had suffered badly from the blast. The doors were blown out, all the windows and top lights smashed. Fortunately, only one of the sculptures was damaged – a reclining figure in brown Hornton. It's a rather soft stone and the figure was badly scratched by pieces of jagged glass. We managed to cover up the sculpture, but it was impossible to sleep there and we asked Leonard Matters if we could stay at his Much Hadham place until we found somewhere else to live.[104]

In Much Hadham the Moores discovered that they could rent half of a house called Hoglands. 'It was in a pretty tumbledown state, but anywhere was good enough in those days. On the first night we slept there, the nose of an anti-aircraft shell came through the roof.'[105] A month or so later they were offered the whole house, where they would live for the rest of their lives. Moore made a deposit of a third of the purchase price, using the £300 that the surrealist artist Gordon Onslow-Ford had paid him at the end of 1939 for a reclining figure carved in elm. (Onslow-Ford wrote about this work, now in the Detroit Institute of Arts and regarded as one of Moore's greatest accomplishments: 'Moore told me that he got tremendous satisfaction out of making holes in his work. The most exciting moment was when he saw the first speck of daylight coming in from the other side.'[106]

Much Hadham was Moore's base while he was making the shelter drawings; two days a week he drove the thirty miles into London, spending the night in the shelters making observations and only emerging from the Underground at dawn. He would then sketch for two days:

The rest of the time I spent working on drawings to show the War Artists' Committee. I would show them eight or ten at a time and they

would choose four or five leaving me to do what I liked with the rest. . . . I used to go often to Cricklewood and I was fascinated by a huge shelter at Tilbury. . . . But Liverpool Street Underground Extension was the place that interested me most. The new tunnel had been completed except for the rails and at night its entire length was occupied by a double row of sleeping figures.[107]

Alan Wilkinson finds the Liverpool Street drawing 'the most terrifying of all the shelter studies. . . . The spiralling tunnel suggests the eye of a tornado, a place of silence and yet of terrifying tension. It is as if we were within a sculpture, deep in a Moore cavern, inhabited by a race invented by him. The subterranean setting is timeless and anonymous; it is as if we had come unexpectedly upon the tomb of a mass burial. The bodies, swathed like Egyptian mummies, seem to belong more to the dead than the living.'[108]

It was a time of extraordinary artistic concentration for Moore: 'The air-raids began – and the war, from being an awful worry, became a real experience. Quite against what I expected I found myself strangely excited by the bombed buildings, but more still by the unbelievable scenes and life of the underground shelters.'[109] The first three or four months were the most intense, but he was at work on the shelter drawings for about a year, that is, more or less the entire period of the Blitz. It was his way of fully participating in the war; he created eternal images of what the war was like for the Londoner while the city was burning. He took the themes of his earlier sculpture – particularly reclining women – and raised their humanity to a new level. He had discovered a huge city in the bowels of the earth, a sort of counter-city to the one above, and he revelled in its chaos and confusion, the sense of the people both being oppressed and coping with their situation with a certain nobility. All his years of concentrating on life drawing for the uses of his sculpture prepared him to render these figures he found in the shelters in the London Underground during the Blitz.

Today we are half a century beyond the war, the Blitz, the Underground shelters – everything that inspired and occasioned the drawings. Having survived the historic past, they have won a secure place among the great works of the century. Scholars, critics, aestheticians and analysts of the collective unconscious feel free to range among them. They are variously

associated with Egyptian tombs, Etruscan funeral sculpture, the Nazi death camps and Jungian archetypes, but the one relationship that was essential to their existence – their relationship to Britain at war in 1940 and 1941 – tends nowadays to be underemphasized or even ignored.

|❖|111|❖|

The sketches were done in a comparatively new technique for Moore, combining pencil, chalk, wax crayon, pen and ink, and water-colour. He had inadvertently discovered the wax and water-colour effect before the war while doing a drawing for his three-year-old niece, Ann, with a few bits of crayon that she provided: 'I sketched with pen and ink, wax crayons and watercolour, using the wax-resist technique which I had discovered by accident before the war. . . . Wishing to add some more colour, I found a box of watercolour paints and was delighted to see the watercolour run off the parts of the drawing that had a surface of wax. It was like magic and I found it very useful when doing my sketch books.'[110] 'I managed to get some of the white crayon that's used for marking glass, and applied it to areas that I wanted to remain white. When the coating of wax is too thin, the watercolour soaks through, and it will be seen that in a few of the sketches small patches of watercolour have invaded areas of another colour.'[111] The colour was important, but secondary, and was mostly there for emotional effect.[112] Moore would also try the positions taken by the shelterers. 'It was as if he himself had to experience something of the tension and exhaustion expressed in the poses he had seen.'[113]

A fascinating contrast of artistic techniques was published in the magazine *Lilliput* in December 1942: a selection of Moore's shelter drawings, and several photographs by one of the great photographers of the period, Bill Brandt, who had been commissioned in 1940 by the Home Office to photograph shelters, particularly the Elephant and Castle and the Liverpool Street stations. *Lilliput* had been founded in 1937 by a German refugee, Stefan Lorant. Tom Hopkinson became the editor when Lorant left for America in 1939 because of complications about permission to remain in England. Juxtapositions were in the Magazine's tradition, but

usually they were comic – 'a pouter pigeon opposite a cadet on parade with his chest thrown out; Hitler giving the Nazi salute to a small dog with its paw raised'.[114] Despite *Lilliput's* devotion to humour, Hopkinson recognized the importance of the shelter drawings.

> The feature which gave me the greatest pleasure during the whole five years [as editor] were the shelter drawings of Henry Moore ... We used to meet regularly for lunch, sometimes every week, at a restaurant called Gourmets in Lisle Street, just north of Leicester Square. I looked forward to these lunches keenly for I had never met anyone so calm, so certain of himself and of what he was doing, and so generous towards the work of everybody else. One day he produced a book of drawings which he was making around the tubes and underground shelters. I looked through them fascinated and asked if we might reproduce some of them in *Lilliput*. He was happy to let us use them, and Bill Brandt took a series of shelter photographs to appear in the same number.[115]

Lilliput had used photographs extensively, about forty an issue, and Brandt was certainly one of the masters of the medium. Yet the magazine was perhaps too respectful of art as compared to photography: 'Obviously no comparison in artistic value is intended; a photograph, however, imaginative, is the record of a scene; a work of art sets out to convey the formal and emotional idea behind the scene.' *Lilliput* was selling Brandt short; photographs are certainly, particularly in Brandt's case, works of art and have a recognizable style; his photographs are extremely powerful. Both the photographs and the drawings tell us about the shelters; one need not agree with the art critic Paul Overy: 'Moore's shelter drawings are peopled not by people, but by Henry Moore reclining figures. One learns more about what it was like to shelter in the underground from Bill Brandt's photographs.'[116] Brandt said about his photographs: 'Deep below the ground, the long alley of intermingled bodies, with the hot, smelly air and continual murmur of snores, come nearest to my prewar idea of what an air-raid shelter would be like.' Moore's views were cited in the caption to his drawing of the same shelter: 'It seemed to him to stretch for miles, and its inhabitants to have been sleeping and suffering for hundreds of years. The picture is formalised to give an impression of an infinite number of people, stretching back in the distance.'

The *Lilliput* article also contrasted Brandt's photograph of people sleeping in the crypt of Christ Church, Spitalfields, with Moore's drawing of two women called the *Roman Matrons*. 'The two women, Moore says, were sitting quietly, and stoically accepting their situation; waiting for the night to come to an end. They might have been carved out of stone. . . . He wanted to make his figures timeless, suggesting that, though their situation might be strange, there was nothing new about suffering.' *Lilliput* also provides an extract from notations that Moore took to help him remember what he saw: 'Sleeping figures, arms in angles with heads. Heads in perspective from below, relaxed, innocent and abandoned. Old men, old women. A child sleeping, hands curled near face. . . . A composition of hands and arms arranged in its frame. Simplified forms like boulders on a shore.' (Years later, in the 1960s, Brandt would do just such a series of photographs.)

Next, the piece contrasted Brandt's photograph of a shelter near Victoria Station with a Moore drawing of a woman seated in the Underground: 'Her attitude has none of the courage of the 'Roman Matron'. She is helpless and pathetic in the tide of events that have brought her here. Moore records her individual emotion, while the people in the background are intended as a reminder that it is a suffering common to all.'[117]

The sketch-books, magnificent in themselves, are now easier to see (at least in reproduction) than the drawings, which are distributed in museums all over the world. In 1945 *Poetry London* published, in a comparatively inexpensive format, an unpaginated amalgam of eighty-two pages from the two sketch-books.* The format of the published shelter sketch-book attempts to reproduce the original book: Moore's name written on the second page, with the date October 1940, and then the title page superimposed on the cover with the notice, 'if found please return to Henry Moore, Hoglands, Penny Green, Much Hadham (Herts)'. The sketches have an immediacy of power and observation, although they do not have the greater timelessness of the finished drawings.

The pictures of the bombed streets of London are, as Kenneth Clark points out, more or less transition drawings of Henry Moore figures.[118]

Poetry London itself was a phenomenon of the war; its editor, Tambimuttu, was a fixture of the literary and pub scene. Moore had already done some drawings for the journal in 1942.

One sees harbingers of the future, such as two figures suggesting the seated king and queen that Moore sculpted after the war. He still thought of himself primarily as a sculptor, and he noted on one drawing: 'Do drawings worked out from some within note book, but carried out more especially for sculpture.' There are quite a few sketches of two women in a shelter, a theme used in some of the most powerful drawings. An extensive notation appears beneath a reddish group of three figures: 'Platform scene of sleeping people 3 or 4 people under one blanket – uncomfortable positions, distorted twistings – All kinds & colours of blankets, sheets & old coats. Two figures in sleeping embrace. Masses of sleeping figures fading to perspective point of tunnel. Groups of people sleeping, disorganized angles of arms & legs, covered here & there with blankets.' He did quite a few pages of various sleeping positions, and these emphasized the ways in which the sleepers came increasingly to resemble Moore-like figures. He frequently used the crayon technique; many of the sketches are in red, green and blue. There is a colourful sketch of two children sleeping in bunks, as well as extraordinary close-ups of sleeping heads. On a page with two sleeping figures sharing a green blanket he noted: 'Remember figures last Wednesday night (Piccadilly Tube). Two sleeping figures (seen from above) sharing cream-coloured thin blanket. (drapery closely stuck to form) Hands & arms – Try positions oneself.'

The sketch-books themselves have survived; one is in the British Museum collection of prints and drawings, the other was in the possession of Irina Moore until her death in 1989. In the British Museum collection there are sixty-six magnificent sketches. They are not exclusively of shelters; there are some sea subjects and abstract figures. The light preliminary sketches and colours convey a certain gentleness, a compassion for those in the shelters. The final drawings are more formal and more terrifying; they suggest more of the horror of being in the tubes, even if the situation is met with a combination of resignation and defiance. The sketch-book in Irina Moore's possession was published in 1967 with eighty collotype reproductions of far higher quality than those in the *Poetry London* edition. The actual sketch-book appears to consist of ninety-five pages, but not all were reproduced.[119] It includes lists of subjects for the drawings, not necessarily executed. From the Tilbury shelter, Moore noted, 'perambulators with bundles. Sick woman in bath-chair. Bearded Jews blanketed sleeping in deck chairs.... Muck & rubbish & chaotic

untidiness around'. The sketches of sleeping children are particularly loving; perhaps the most magnificent are the two sketches of children covered with blankets sleeping in bunks, also to be found in the *Poetry London* publication.

Clark emphasized the gentleness and strength of the sketches: 'He filled his notebooks with delicate observation and with groups worthy of a Greek pediment; he conveyed the stoicism of the shelterers by the fall of their cloaks, coats and blankets. He recorded the pathos of children, and the utter oblivion of snoring heads and finally he created a synthesis of the tunnel with its population of larvae that will remain one of the abiding images of the Second World War.'[120] In the latter part of the sketch-book are the sleepers; the most powerful of these look almost like corpses, and yet they are still alive, gathering strength to go on, fighters in the everyday war of the Blitz. The small-headed women on bunks parallel Moore's sculptures of reclining figures.

As yet, there is no *catalogue raisonné* of all Moore's work, the closest being the ongoing volumes of *Sculpture and Drawings 1921–1948* (London, 1969; first issued in 1944, completely revised in 1957). There we can see some of the shelter drawings themselves, particularly those acquired by the War Artists' Advisory Committee for the nation: *Tilbury Shelter, Tube Shelter Perspective* (presumably the Liverpool Street extension) and the magnificent *Pink and Green Sleepers* (now in the Tate Gallery). As was pointed out in the film *Out of Chaos*, made during the war about the war artists (most particularly Moore, Sutherland and Nash), the sleep in the picture is 'unnatural' but at the same time it is 'an oasis of tranquillity in the heart of a nightmare'. The drawings are at least twice the size of the sketch-book drawings and are in a finished state. *Shelter Scene: Two Seated Figures* (now in the Leeds Art Museum) is reproduced in Clark's book on Moore's drawings. Clark remarks about it: 'The two figures . . . are like late Roman patricians, awaiting the coming of the barbarians.'[121]

These drawings are masterpieces. They are more enduring than the sketches, and have been compared with Giotto's for their power. They have an extraordinary combination of horror and magnificence: 'His substitution of a toga-like garment for contemporary clothes heightens their anonymity. Elsewhere, the same classical robes emphasise the dignified bearing of the figures of his alternative view, representing the isolation from the mass of the single individual or a group of women. . . .

Two figures lie together, representing a personal relationship in an impersonal world.'[122]

Two major strands of Moore's art meet dramatically in the shelter drawings: the abstract qualities derived from his interest in primitive art that give the works great power, and the humanism he had found in the paintings and sculptures of Florence. There is a sense of eternity about the drawings, the more so as time passed, prompting the critic Keith Roberts to describe them in 1976 as 'a vision about the whole War. It could be an Etruscan funeral chamber; but it might also be about Buchenwald. . . . These drawings may just possibly turn out to be Henry Moore's supreme achievement.'[123]

Moore himself was aware that his work was significant, although not that his way of doing sculpture would change in good part because of the experience of the drawings: 'It humanised everything I had been doing. I knew at the time that what I was sketching represented an artistic turning point for me, though I didn't realise then that it was a professional turning point too.'[124] The drawings were particularly effective because of their detachment and compassion, a sense of personal involvement along with a full measure of objectivity. Moore was attempting to capture a paradox: both the distance of the individuals in the shelters from the raids and their heightened awareness of what was happening to them.[125] Herbert Read was magisterial but correct in his summary:

He saw the pathetic crowds of homeless people in their underground shelters, huddled in casual but monumental groups, abandoned to their misery, and he felt impelled to record what he had seen. The result was a series of 'shelter drawings' which constitute the most authentic expression of the special tragedy of this war – its direct impact on the ordinary mass of humanity, the women, children, and old men of our cities.[126]

Moore's interest in the shelters decreased as they became increasingly organized: 'Up to perhaps the first two months of 1941 there was the drama and the strangeness, and then for the people themselves and for me it was all becoming routine.'[127] He finished the shelter commission in September 1941, with the sale to the committee of two drawings, which were formally acknowledged thus: 'the upright sleepers and the four grey sleepers,

accepted in fulfilment of the commission, the Artists' Advisory Committee recommend for purchase your drawing of two sleepers with green and pink for a fee of ten guineas [presumably in addition].'[128]

Early in 1941 Herbert Read had suggested to Moore that he might want to sketch coal miners, and Moore agreed to this as his second commission from the War Artists' Advisory Committee. He spent two weeks down the mines in his native Yorkshire, sketching directly with the consent of the miners. 'I didn't find it as fruitful a subject as the shelters. The shelter drawings came about after first being moved by the experience of them, whereas the coal-mine drawings were more like a commission. Everything to do with the shelters moved me much more deeply than the coal mines and the shelter drawings came much easier and more naturally.'[129] The First Aid Post commission proposed by Lady Mountbatten, which Moore had reluctantly accepted, was hanging over his head. The committee proposed a new idea, that he should do drawings on 'Objects Dropped from the Air', but nothing came of it.[130] He then informed Kenneth Clark that he was not interested in any further commissions and again began to work on ideas for sculpture, heavily influenced by this period of total commitment to drawing.

| ❖ |12| ❖ |

Moore had undoubtedly been one of the most prominent British artists of the 1930s, but he had not yet become well known beyond artistic circles. With the shelter drawings his fame began to grow at home and abroad. He came to stand for the qualities for which Britain was said to be fighting the war. (Of course, some still found his work too modern and abstract for their tastes. But Moore's achievement of international standing dates from the shelter drawings.) In 1941 a show of British art – 'Britain at War' – at the Museum of Modern Art in New York included four of his shelter drawings. In effect, this was his launching in America (one of his works had been shown at the Modern in 1936).[131] In 1943 he had his first one-man show of forty water-colours and drawings in New York at the Buchholz Gallery, as well as in Los Angeles.

In 1942 Kenneth Clark arranged to display a large number of the drawings in the National Gallery. The English, starved for art – the National Gallery, had for safety reasons, removed its collections of paintings and stored them in a slate quarry in Wales – flocked to the Moore exhibition, and its impact was considerable. Ordinary Londoners had no difficulty in recognizing experiences that many of them had known intimately. Moore's art was no longer accessible only to the few; and, as critics were quick to point out, he had achieved his effects with no sacrifice or compromise of his individual genius. There were also exhibitions of work by other British war artists on the empty walls of the National Gallery, seen by those who came to hear the daily lunch-time concerts and by other visitors. As Stephen Spender presciently remarked in his introduction to a catalogue of their work: 'In this war, by 'War Pictures' we mean, pre-eminently, paintings of the Blitz. In the last war we would have meant pictures of the Western Front. . . . The background to this war, corresponding to the Western Front in the last war, is the bombed city.'[132]

In the National Gallery there were also several rooms of a permanent exhibition of official war artists, and Moore himself regarded his pictures there as his first connection with the general public.[133] His drawings were hardly realistic, yet the thousands who saw them identified with them and felt that they rendered a familiar experience, for the great majority of these viewers had inevitably seen the shelterers in the Underground.

The popularity of the shelter drawings also had the practical effect of financially liberating their creator. He no longer had to teach and could devote himself exclusively to his art. At the same time it became easier for collectors to acquire Moores, as drawings were far less expensive than sculptures.

The war had focused greater attention on the arts. Exhibitions of older British artists, such as 'British Art since Whistler' in the National Gallery, took place in the spring of 1940.[134] There was an increased sense of the British heritage in art, a point made by exhibitions of Augustus John, Walter Sickert, Ben Nicholson and Jack B. Yeats. The masterpieces of the National Gallery itself were not ignored: one picture a month was brought back from Wales, and hence benefited from a concentrated viewing. (There were also a few pictures left in London from the permanent collection that Clark felt were not worthy of preservation: 'Alas, the few pictures which are hanging there now, the poor stragglers for whom

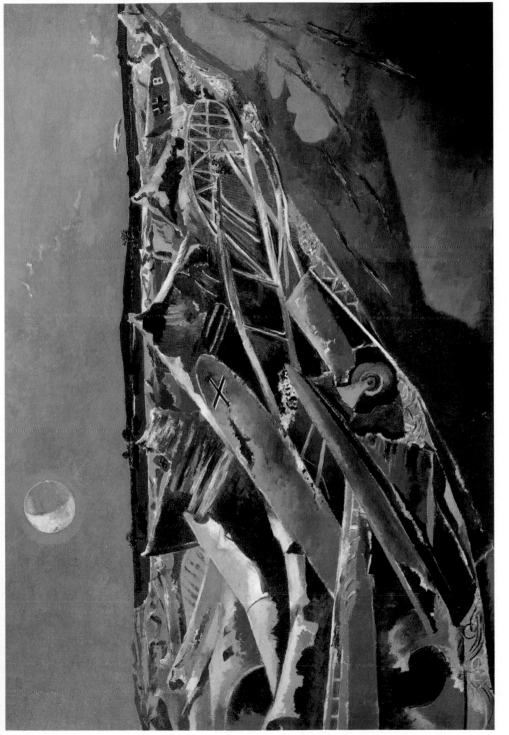

Totes Meer (Dead Sea), Paul Nash 1940-41

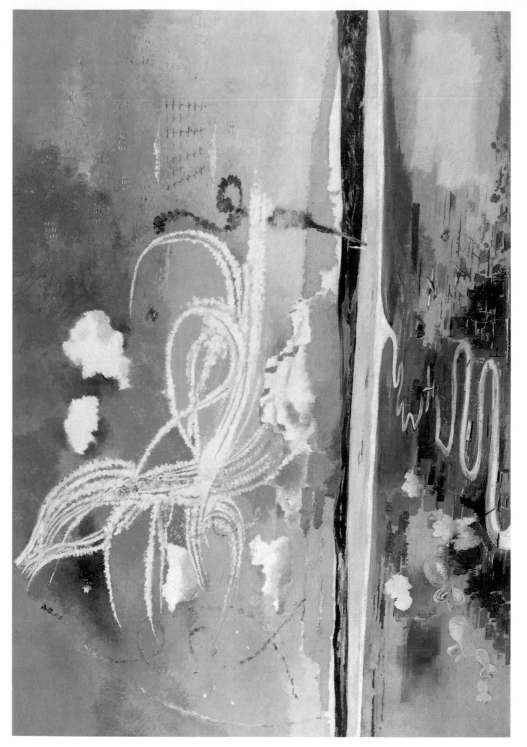

Battle of Britain, August - October 1940, Paul Nash

Two figures sharing the same blanket, Henry Moore 1941

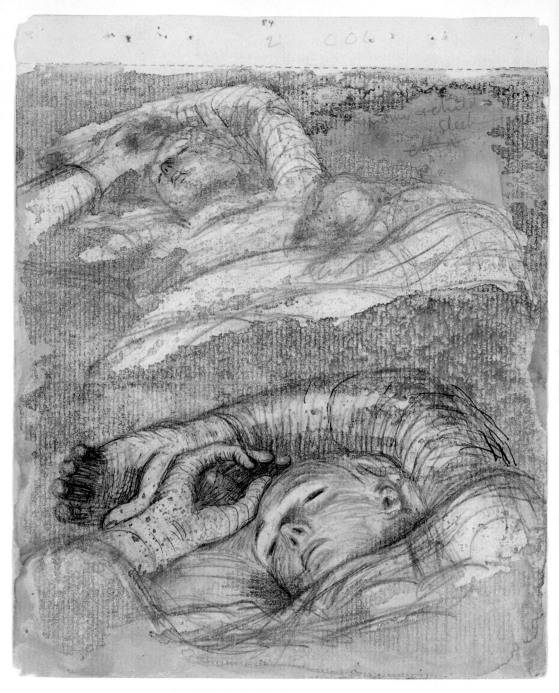

Study for shelter sleepers, Henry Moore 1941

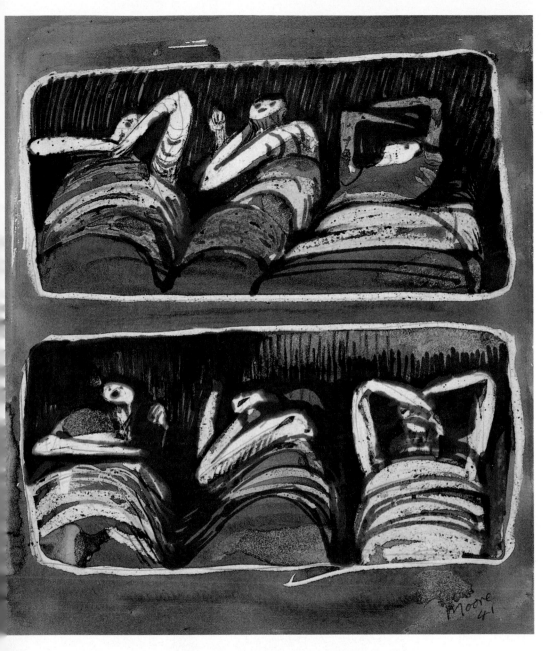

Sleeping positions, Henry Moore 1941

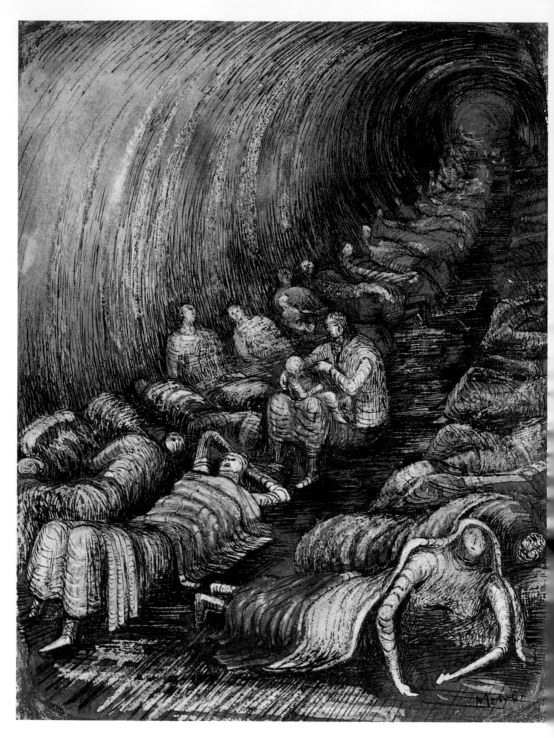

Tube shelter scene, Henry Moore 1941

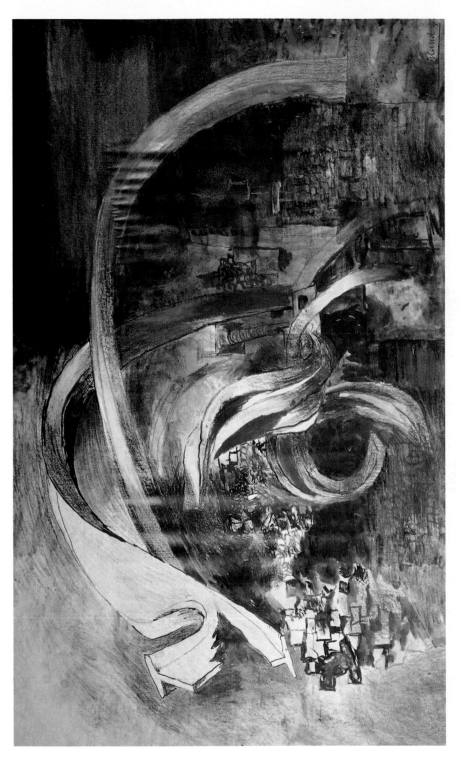

Devastation 1941: City Twisted Girders(2), Graham Sutherland

Devastation 1941: An East End Street, Graham Sutherland

possible destruction seemed more glorious and more ecconomical than existence in retirement, are not worth a visit, the amateur must try to preserve his curiosity until after the war.'[135]

There might even have been some counter-reaction to Moore: an artist who was becoming so popular might lose some of his integrity. 'It was as if the prophet of a secret society had suddenly joined the Salvation Army.'[136] Read wrote about Moore's growing popularity: 'When these drawings were first exhibited, it was said – by some sadly, by others exultingly – that Henry Moore had abandoned his modernism, his surrealism, and had returned to the ordinary naturalistic style as practised by our academicians. No statement could be so superficial, so obtuse and insensitive. Henry Moore has surrendered nothing of his achievement of his individual style, his "modernism".'[137] The shelter drawings elevated the experience – traumatic as it was – of a comparatively small percentage of the population of London to a national event. The shelterers became generalized and stood for the Wartime suffering of the ordinary person.

During the First World War the powerful paintings and poetry from the Front were its most prominent artistic achievements. In the Second World War the artists who were at the Front made considerable and memorable contributions. But the Home Front was almost as involved as the fighting fronts, and the artists who worked primarily in England created the greater artistic works. This was true not only of Moore and Paul Nash but also of Graham Sutherland.

| ❖ |13| ❖ |

In the bombed city Moore was the artist who memorialized the Underground; Graham Sutherland painted its ruined streets and devastated buildings. He was already an artist of some reputation when the war broke out – he was then 35 – but it was his work as an official war artist that acted as his bridge to becoming far better known. By then Sutherland had been an artist for eighteen years, the first eight as an engraver, producing darkly handsome scenes, very much in the style of Samuel Palmer and the etcher F. L. Griggs. Later, his work became increasingly abstract, much

influenced by nature and by his frequent visits to Wales, his observation of objects by the seaside – rocks, driftwood, birds and wild plants – lending them a kind of totemic significance. His pre-war paintings tended to be of romantic landscapes.

Like Moore, Sutherland was teaching at the Chelsea School of Art and he too put himself down for a training course in precision tool-making – as we have seen, neither of them had any response to their applications. He continued to teach in a diminished capacity until June 1940. Soon after, at the prompting of Kenneth Clark, he became a war artist. Clark was already a close friend: they had been introduced in 1934 by Jack Beddington who ran Shell Oil's enlightened artist support programme, which included work by Sutherland. Clark was particularly captivated by a poster, *The Great Globe, Swanage*, that Sutherland had created for Shell. (Coincidentally, Paul Nash used a photograph of the same object to illustrate an article, 'Swanage, or Seaside Surrealism', in 1937.)[138] Clark was an early purchaser of Sutherland's work, arranged for his first one-man show in 1938 and wrote the introduction to the catalogue.

From the very beginning of the war the need for Sutherland to continue to pursue his art was much on Clark's mind. On 5 September 1939 he wrote to Sutherland's wife, Kathleen:

I believe most strongly that Graham should go on painting. It is the highest form of national service which he can perform. I will see that he is put on a register of artists, so that he will get any government work that is going, & also on the camouflage list, but that mayn't take effect for some time. Don't worry about money. I will do what I can to make up for Chelsea, & inclose an interim dividend. When our house at Upton is finished you could come & stay there. I believe that voluntary communism should precede the real thing. ... It is everyone's duty to be as happy as possible, & the artist's duty to go on painting. Of course, G. won't be conscripted, 1) because they won't take people his age for a long time 2) because when they do he isn't sufficiently robust & 3) because we shall have him exempted. The idea of going on the land is rubbish. Why does he think he is serving his country better by digging potatoes than by painting the few pictures now being produced in England which have any chance of survival?

A little more than a week later Clark wrote to Sutherland: 'I am hoping that you are gradually achieving enough peace of mind to go on painting. Meanwhile I have had your name put down for camouflage work & illustration, & you may be called on for either or both, but probably the former. I am on the committee dealing with both, & the selection seems to me to be very fair. May I advise you *not* to go & live with your mother. Family life is really fatal to any creative work.'[139] The Sutherlands were living in Kent, as were the Moores. The county was becoming more and more militarized, being the area where an invasion was most likely to occur, and the Sutherlands did accept the Clarks' invitation to come and live with them in their house in Gloucestershire. There he worked on illustrations for *1 Henry VI*, a turning towards the national mythology in time of war, for the Limited Editions Club of New York; in 1943 he would provide quite splendid abstract illustrations for David Gascoyne's *Poems 1937–1942*, published by *Poetry London*.

Clark helped to arrange for Sutherland to become an official war artist in the autumn of 1940. From then until 1945 he was employed by the government through the War Artists' Advisory Committee. His first assignment was in Wales, around the bombed area in Swansea. Even before that he had done some comparatively unsuccessful war work: drawings for camouflaged aircraft and of gun-testing sites near Melton Mowbray. But his imagination was stirred by the experience of Swansea:

Swansea was the first sight I had of the possibilities of destruction as a subject.... I hadn't yet begun to feel any sense of what these remains really *looked* like. Later ... some were to become like great animals who had been hurt.... During these terrible months I found I didn't inquire as to the future at all.... My feeling at the beginning of the war from the point of view of my work was one of being thrown down in a totally unfamiliar field. There was I who, up to then, had been concerned with the more hidden aspects of nature. I had been attempting to paraphrase what I saw and to make paintings which were parallel to rather than a copy of nature. But now, suddenly, I was a paid official – a sort of reporter and, naturally, not only did I feel that I had to give value for money, but to contrive somehow to reflect in an immediate way the subjects set me. It was not until the advent of the air-raids that I could see any ways open to combine the aims of my work before the outbreak of

war with the task then in front of me. It was difficult too to see how any-
thing I could do as a war artist could help the course of the war and – of
course – it didn't. One cannot escape the fact that some of us were
protected.[140]

It was in June 1940 that he had his first contact with the War Artists'
Advisory Committee, and his first assignments. However, it was not until
November 1940 that he became a salaried war artist, at £325 plus expenses
for six months, and this continued until 1945. In the second half of 1940 he
sold pictures to the committee, but he had not completely committed
himself to being a war artist. He wrote to Dickey in August: 'Unfortun-
ately I have undertaken to be trained as a munition gauge maker, with a
practical certainty of a job at the end of three weeks training or so. . . . I
must see if I can get a release from this work, or try & get the date of
starting postponed.'[141]

Sutherland was now painting for the committee on a fee basis, having
been promised fifty guineas.[142] The committee tried to be as generous to its
artists as possible. Dickey wrote in explanation to Sutherland: 'You ask me
how much work will be required for the fee and how long it will take you.
Our plan has been to leave it more or less to the artists to produce what they
think is fair for the fee in cases of this kind and to get the work done at the
pace which suits them best. I need hardly say that we have had to take
strong measures from time to time in order to prevent artists from being
too generous!'[143] The committee helped with such minor but vexing
matters as acquiring petrol coupons. More seriously, it attempted to find
congenial subjects, but there is some evidence that Sutherland, like Moore,
found that aspect of the situation slightly constraining. In July 1943 Clark
wrote to him: 'Have you thought anymore about your next commission?
Would that it were possible to get you exemption without one, but that I
fear is impossible, or at least doubtful.'[144]

Sutherland was attached to the Ministry of Home Security and the
Ministry of Supply. In this connection he was at St Paul's during the
bombing of London. The minutes of the War Artists' Advisory
Committee note: 'Agreed that *Mr Graham Sutherland* be asked to spend
some nights in London at St. Paul's to give him an opportunity to see any
fires which might be started, as well as study other subjects on quiet
nights.'[145] Sutherland himself wrote about this experience:

Once, I went on the roof of St. Paul's. The gathering place of authorities and others – architects and business men – who had volunteered to be there to put out incendiaries was the gallery round the base of the dome. This passage between walls was probably the strongest place in the cathedral. All, when not on duty, slept and lolled on deck-chairs. I remember thinking that it was like being in an ocean-liner.'[146]

In 1941 Sutherland painted his most effective war pictures: his bombscapes and close-ups of devastation in the City of London and in the East End. The empty silent streets lined with wrecked and gutted houses had an eerie timelessness, they were like the remains of an ancient city long abandoned. Sutherland made them his subject:

During the bombardment of London, on a typical day, I would arrive there from Kent where we had resumed living, with very spare paraphernalia – a sketch-book, black ink, two or three coloured chalks, a pencil – and with an apparently watertight pass which would take me anywhere within the forbidden area. It wasn't watertight at all. I was arrested several times, especially in the East End! And once there I would look around. I will never forget those extraordinary first encounters: the silence, the absolute dead silence, except every now and again a thin tinkle of falling glass – a noise which reminded me of the music of Debussy. The first place I went to was the big area just north of St. Paul's – I suppose about five acres.... Everywhere there was a terrific stench – perhaps of burnt dirt; and also the silence. There was nobody about; just a few police. Very occasionally there would be the crash of a building collapsing of its own volition.... I remember a factory for making women's coats. All the floors had gone but the staircase remained, as very often happened. And there were machines, their entrails, hanging through the floors, but looking extraordinarily beautiful at the same time.... [V]ery soon the raids began in the East End – in the Dock areas – and immediately the atmosphere became much more tragic.[147]

The City, as virtually exclusively a place of business, was deserted at night, but in the East End human beings were packed in. Yet Sutherland's drawings continued to be limited to buildings, and the long receding perspectives of the empty streets, not unlike those Moore achieved in his

drawings of the Tilbury and Liverpool Street extension shelters. Like Moore, Sutherland would first do sketches and then work up his drawings. And, like Paul Nash, he also used photographs. The bombed buildings took on characteristic Sutherland forms, that spikiness and angularity of his work. It was a stipulation of the committee that the work be based on eyewitness material, but it was not necessary to do the finished picture on the site. The external world had come to conform to Sutherland's vision.

In his City bombscapes Sutherland used his eye for nature to deal with the destroyed products of man, the shattered qualities of the objects, their twists and turns – similar to things that he had observed so closely on the beaches and in the woods in Wales – and their organic quality, as if the wrecked machines he painted had once been alive. He was able to give the same emotional intensity to his bombscapes as he gave to his pictures of nature, to convey an extraordinarily wide-ranging sense of devastation. He stated in a round-table conversation with Moore, Clark and V. S. Pritchett, published in the *Listener* in November 1941: 'The forms of ruin produced by a high explosive force have a character of their own, but the effect which they have on one's emotions will vary according to one's mood.' An exchange between Pritchett and Clark in the same conversation sums up much of the relationship between art and the war. Pritchett argued that Clark seemed to be assuming that 'art *is* concerned with ordinary human emotions about life'. Clark replied that art is 'a concentration of human emotions and experience communicated in a controlled and intelligible manner through an appropriate medium. . . . This inner life . . . must be constantly refreshed by visual experience. . . . We are members one of another.'[148] As Sutherland wrote to Eric Newton: 'As you know, I am a tremendous believer in the part that the subject has to play in making a picture. For me it is the force of the emotion derived from the vision of the subject which determines & moulds the pictorial form. The sorts of emotion that one feels will vary. For instance the forms of ruin produced by a high explosive force have a character of their own.'[149]

Sutherland made innumerable sketches but comparatively few finished paintings. The pictures were of bombed buildings, fallen roofs and huge burned paper rolls. Many were distributed to museums in England but Sutherland kept more than three hundred of his sketches.[150] Most of these are now in a private collection in Italy.

Eventually, through the War Artists' Scheme, six thousand works of art

were acquired. Of these 114 were Sutherlands; twenty-three were kept at the Imperial War Museum, eighty-seven are in museums in Britain, and three are in museums in Australia.[151] On 9 April 1941 the committee acquired nine Sutherlands, among them *Fallen Lift Shaft*, *Fired Offices with Ventilator Shaft* (now in the City of Manchester Art Galleries), *Ruined Buildings* and various other scenes of devastation.[152]

Douglas Cooper has pointed out the rich double purpose of Sutherland's wartime paintings:

> His are among the few war pictures which have real artistic value as well as being genuine records of our time. What makes them remarkable is that they are, simultaneously, imaginative evocations of generally shared experiences and also more or less factual records. The familiar everyday sight, the hideous incident, has been transformed into a symbol of a greater and more searing struggle. . . . His great contribution, it seems to me, has been his discovery of pictorial images which should assist us to bridge the gap imaginatively between the separate realms of the human, the organic and the mechanical.[153]

| ❖ |14| ❖ |

The war resulted in Sutherland's work becoming much better known; it was frequently on exhibit at the National Gallery. Postcards, pamphlets produced under war economy standards – such as a series of eight slight volumes on war art issued by Oxford University Press – and prints were sold at the gallery. It was practically the only museum open in London during the war, and contained works by Sutherland, Moore and other war artists. This concentration of cultural activities in one place, including the extremely popular lunch-time concerts performed by Myra Hess and others, put a new and special emphasis upon culture, a valuation of its greater importance while war was being fought and also an ever-growing interest in British cultural achievements, a cultural nationalism in time of war.

An exhibition of the work of Moore, Sutherland and John Piper in

Leeds from 25 July to 28 September 1941 may well have marked the English acceptance of a subdued native modernism at the national level, an acceptance not just restricted to London. Leeds itself had a tradition of being receptive at least to modern art from abroad. The exhibition there was further testimony to the conviction that it was essential to continue creating art in wartime, to preserve the civilization put at risk by the war. Since a ministry had taken over the Leeds Art Gallery's main building in the city centre, the museum had moved its gallery to a country house, Temple Newsam, near Moore's birthplace in Castleford. The show was concocted by Clark and the director of the Leeds gallery, Philip Hendy. (They were then on good terms, but Clark was later very disapproving when Hendy succeeded him as director of the National Gallery.) As early as December 1938 they had corresponded in a rather tentative, exploratory way about the possibility of an exhibition of the work of Moore, Sutherland and Piper, but it needed the impetus of the war to bring the exhibition about. There was a belated return to the idea in February 1941 and the planning began in earnest. In April Hendy urged Clark to open the show: 'It would be so nice if you [could] manage it, and I feel that my career in Leeds had attained its apogee. . . . We are so undisturbed up here and work goes on so much as usual that it seems quite unreal.'[154] Jane Clark responded on her husband's behalf: 'It will be the first time we can all see their work fully represented and Kenneth thinks it is splendid of you to have arranged it all. . . . J. M. Keynes has just bought a lot of Henry Moores.'[155]

Clark himself lent quite a few pieces to the show – thirteen Moores, eight Sutherlands and one Piper – but made a stipulation: 'Only please do not exhibit them all under my name, as it would look silly. I leave it to you tastefully to cook the catalogue, putting in [some] as lent by me and the rest lent anonymously. There are not quite as many as I would have liked because some of the best are in America and others in Australia. . . . I shall be able to speak with more conviction than is usual in opening the Exhibition.'[156] Late in June, Moore was not sure that he would attend: 'I don't know that I want to be present at the actual opening for I always find those occasions a bit uncomfortable.'[157] When the time drew close, however, he changed his mind. A rather tipsy expedition by train (Jane Clark had brought along twelve half-bottles of Orvieto Secco) up to Leeds for the opening ensued, consisting of the Clarks, the artists and the Colin

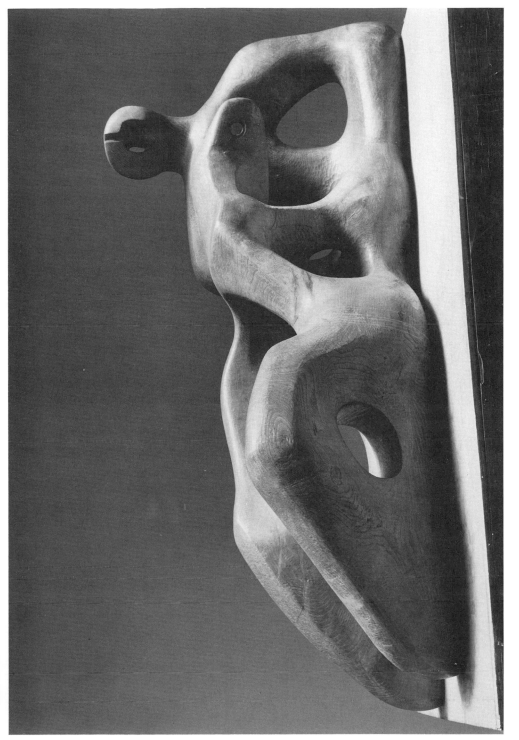

Reclining Figure 1939, elmwood, Henry Moore

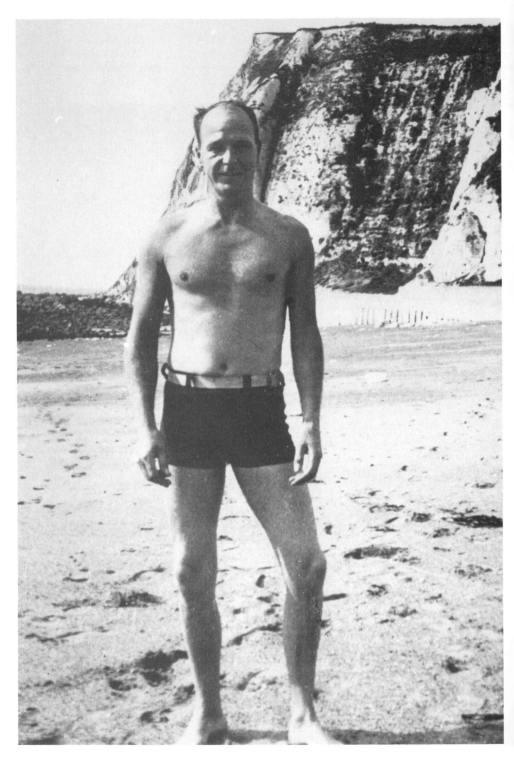

Henry Moore bathing off Shakespeare Cliffs, Dover

September 3rd, 1939, Henry Moore

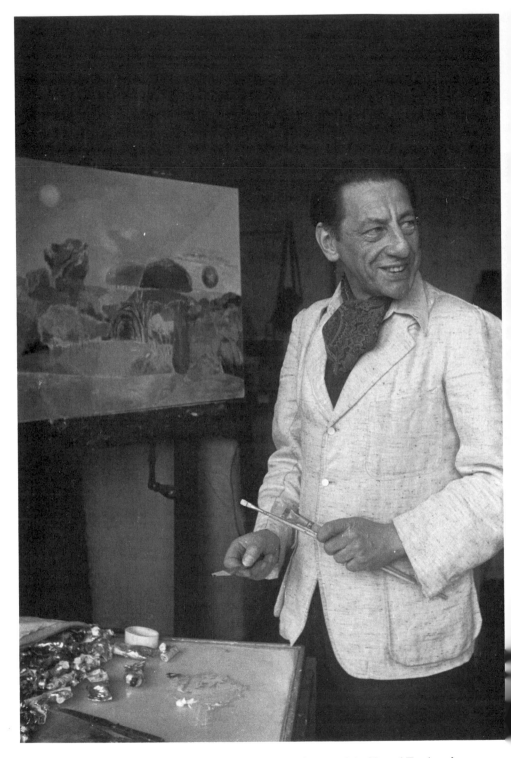

Paul Nash working on sketch design for 'Landscape of the Vernal Equinox'

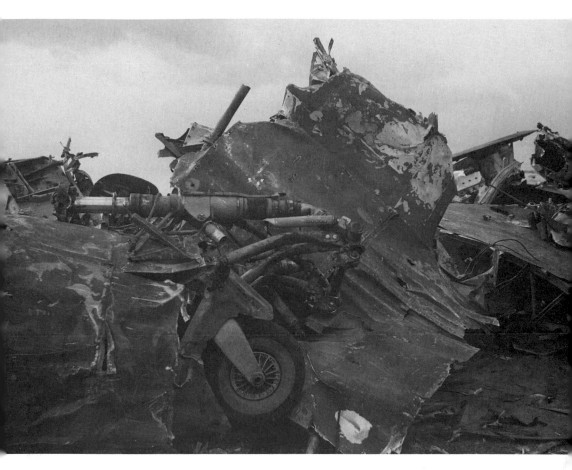

Wrecked German aircraft at Cowley Dump Oxfordshire, 1940

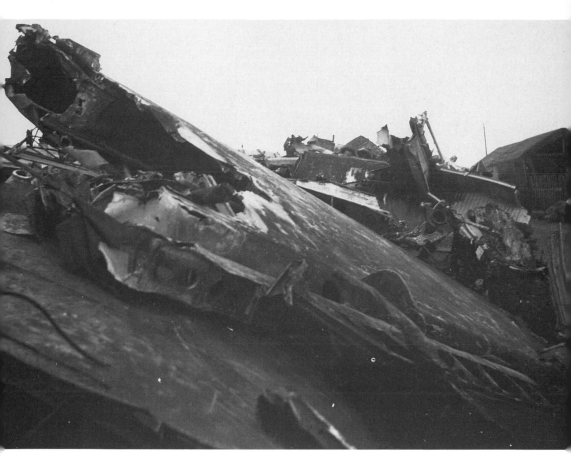

Wrecked German aircraft at Cowley Dump Oxfordshire, 1940

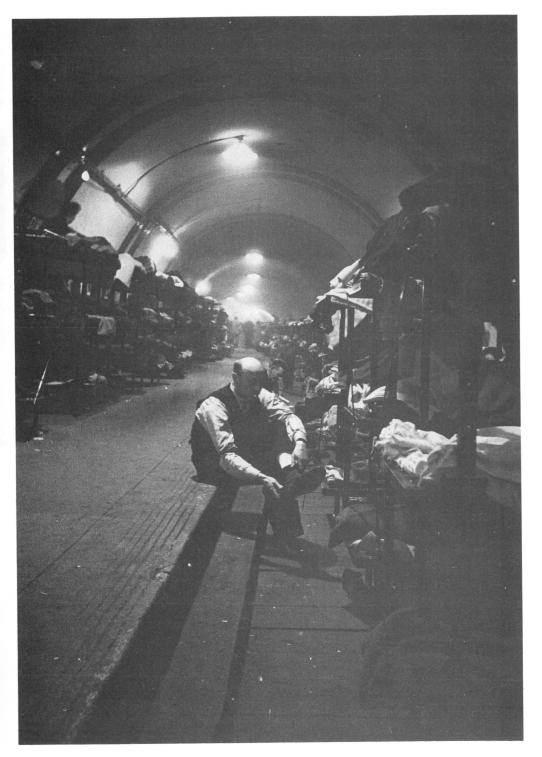

Tube shelter (and overleaf)

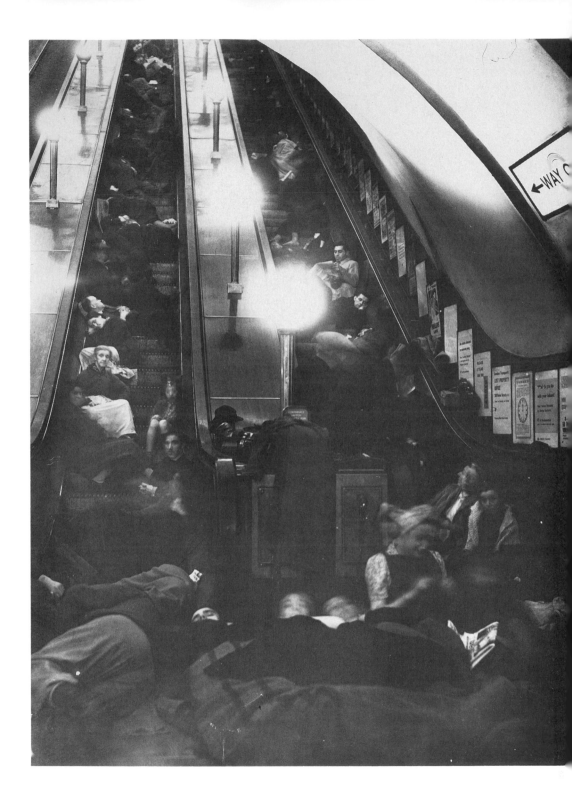

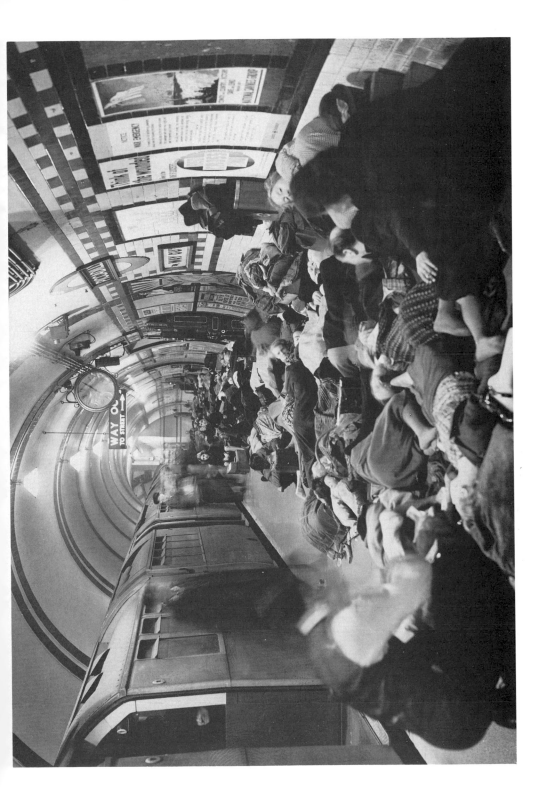

Henry Moore at Hoglands, Hertfordshire, 1940

Moore with Graham Sutherland (left), John Piper and Kenneth Clark at Temple Newsam Leeds in 1941, at the time of their joint exhibition

Portrait of Graham Sutherland 1943

Graham Sutherland, Henry Moore and Myfanwy Piper picnicking on the train to Leeds

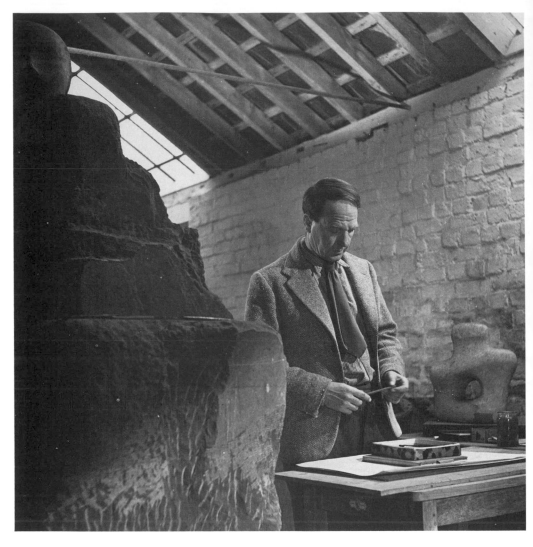

Henry Moore in his studio at Much Hadham during filming of
'Out of Chaos', 1943

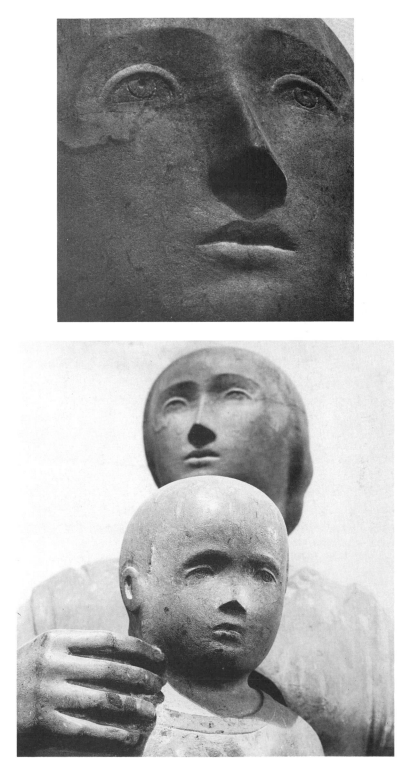

The Northampton Madonna and Child, Henry Moore

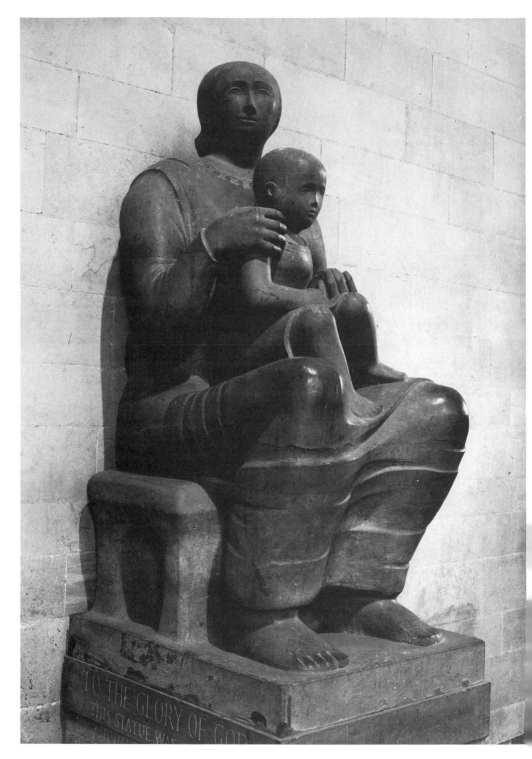

The Northampton Madonna and Child, Henry Moore

Andersons, great friends of the Clarks and considerable patrons of the arts. Morna Anderson took memorable photographs of the jolly group.

The exhibition at Temple Newsam was a great success, and Clark wrote appreciatively to Hendy: 'I don't know which to admire most, your courage in conceiving the Exhibition, your tact in persuading your Committee to allow it, or your taste in arranging it. . . . I very much liked your foreword, and in particular what you have written about Henry Moore, the best thing yet done, I think, on this difficult subject.'[158] In the catalogue Hendy emphasized that Moore was a native, in a sense returning home in this exhibition in Leeds: 'Although Henry Moore is a Yorkshireman who has been famous for at least a decade, this is the first occasion on which so much of the work of any of these three artists has been exhibited in England outside London.'[159] Twenty-eight of Moore's sculptures were displayed, the most recent being *The Helmet*, done in 1940, and fifty-eight of his drawings, including fifteen shelter drawings, most privately owned by Clark, the Andersons, Robert Sainsbury and Keynes. (There were forty-three Pipers and thirty-four Sutherlands in the exhibition.) Quite a few of the sculptures and drawings were for sale, contrary to what Hendy had expected would be allowed by the conventions of a museum exhibition.[160]

Moore himself was extremely pleased with the exhibition and promptly wrote to Hendy to tell him so: 'I appreciate very much indeed all the effort & enthusiasm you've given to it – & the spirit needed to discount whatever amount of opposition & criticism there might be from some quarters (and that could have been I imagine, considerable).'[161] Sutherland also wrote gratefully to Hendy: 'As for your foreword to the catalogue, I believe it to be admirable, & speaking for myself I don't think I have ever had my aims put forward with such real understanding & for that I'm really grateful.'[162] Hendy had written: 'As an artist, he [Sutherland] wants to reproduce not so much what he has seen as what he felt when he saw it. He communicates his own excitement to us in the most intense form that he can conceive, sometimes by an elemental impression of the actual scene, sometimes by only a few bits of it, sometimes in a shape entirely of his own creation.'[163]

Travelling exhibitions of works by Moore, Sutherland and Piper were organized by Lillian Browse for the British Institute of Adult Education and for the Council for the Encouragement of Music and the Arts. In all,

52,034 visitors saw the travelling versions; 1,529 catalogues and twelve works were sold.[164] Small towns that had probably never seen modern art before were exposed to these sculptures, paintings and drawings that were hardly realistic, although not exceedingly abstract. The Leeds show and its offshoots were successful and can be given credit for helping to change the attitudes of the public, particularly the public outside London, towards the English practitioners of modern art.

<div align="center">❖ 15 ❖</div>

Moore was certainly becoming much better known, even a celebrated artist. Perhaps the turning point in his public reputation was the creation of what many consider his greatest single work of sculpture, the *Madonna and Child* of 1943–4, done for St Matthew's Church, Northampton. Like the shelter drawings, it represents a splendid combination of hieratic power and transcendental humanism. As such, it was the product of the influence of wartime and a statement of the values for which the war was professedly being fought. The *Madonna and Child* was Moore's first new major sculpture since the outbreak of war, and, as it turned out, the last that he would actually carve himself for many years. (Most of his post-war sculpture would be small moulded clay or plaster maquettes, which were then enlarged and cast in bronze. The model of the *Madonna and Child* was eventually cast in bronze, in an edition of seven, the first piece of Moore's to be treated that way.) In many respects, it was a pivotal piece.

From the point of view of the creation of the *Madonna and Child*, the most significant visitor to the 1942 National Gallery exhibition including some of Moore's shelter drawings was an Anglican clergyman, the Reverend Walter Hussey, at that time vicar of St Matthew's in Northampton and subsequently Dean of Chichester. Hussey, a collector of modern art, had long felt that the Church of England should once again resume its historic but long-neglected role as a patron of artists. He was closely involved with modern British art; he formed a quite extraordinary collection, including works of Frank Auerbach, Edward Bawden, Richard Eurich, David Jones, Kitaj, John Minton, Paul Nash, John Piper (who produced, among other

<div align="center">60</div>

works for Hussey, a painting of St Matthew's Church), Eric Ravilious, Ceri Richards, Matthew Smith, Graham Sutherland and some earlier artists, as well as a shelter drawing and other works by Moore. Believing that the Church should support contemporary art, he commissioned works both for St Matthew's and for Chichester Cathedral. In 1975 Kenneth Clark would call him 'the last great patron of art in the Church of England'.[165] Hussey was likely to know of developments in the arts in any case, but his awareness of them may have been sharpened by the evacuation of the London County Council arts schools, including the Chelsea School of Art where Moore had taught, to Northampton. He was also warmly interested in music, and he had followed closely the careers of Benjamin Britten and Peter Pears. Writing to Pears on the latter's seventy-fifth birthday, he said:

> I look back with gratitude for the many kindnesses and much inspiration you have brought to me since 1943. Very early on there was the time when I stood spellbound in the wings and heard you sing in *La Bohème*; there was the unforgettable experience of the first night of *Peter Grimes*; and that night in the Wigmore Hall when you sang the *Donne Sonnets*. I remember the occasion in S. Matthew's, Northampton, when I was so moved by your singing of 'Waft her, angels' from Handel's *Jephtha* that I very nearly forgot to turn over the page for Ben![166]

Hussey, who would also commission Graham Sutherland to paint a powerful Crucifixion for St Matthew's, unveiled in 1947, had taken both the Sutherlands and the Moores to the fifth performance of *Peter Grimes* after its opening on 7 June 1945.[167] In 1943 he had commissioned Britten's cantata *Rejoice in the Lamb*, set to the intriguing and rather odd words by the mad nineteenth-century poet Christopher Smart. He also arranged for a fanfare for brass instruments by Michael Tippett for the fiftieth anniversary of the Husseys, father and son, as vicars of St Matthew's. The jubilee was set for 21 September, St Matthew's Day, which was also the fiftieth anniversary of the opening of the church. Hussey felt no hesitation about asking conscientious objectors such as Britten and Tippett to compose pieces for his church. He had also arranged for other musical performances there, taking advantage of the displacement of musicians from London during the war to arrange for concerts – such as several by the BBC orchestra conducted by Adrian Boult – in the church to 'maintain

morale'. No concession was made to popular taste – the programme consisted of works by Wagner, Delius and Schumann.[168] These activities fitted into Hussey's conception of what the Church should do for the arts, but it also served to keep the arts alive during the war.

Hussey was strongly moved by the shelter drawings he saw in the National Gallery; it occurred to him, seeing those figures of women cowled in draperies, often holding a child, that Moore might be persuaded to carve a Madonna and Child for St Matthew's. As he wrote, 'The drawings seemed to possess a spiritual quality and a deep humanity as well as being monumental and suggestive of timelessness.'[169] He wrote to Moore proposing the commission, and in due course Moore accepted. The piece would be a gift presented by Hussey's father, the Reverend Canon J. Rowden Hussey, the first vicar of St Matthew's, as a thank-offering by him for the jubilee of the opening of the church. The statue was not ready in time for the event, yet the day was celebrated in style with the Britten and Tippett compositions, the latter played by bandsmen from the Northamptonshire Regiment.

Walter Hussey has told the story of the statue. He had some preliminary correspondence with Harold Williamson, the Principal of the Chelsea School of Art, who seems to have misunderstood the degree to which the shelter drawings were consistent with Moore's previous work:

> In the case of these shelter drawings which have proved so popular, I should have thought he must have consciously compromised for they follow a line so widely divergent from the extremely abstract sculpture done before the war. But then, I think there is a divergence in any case between his sculpture and his drawings, and I am sure the sculpture lies nearer to his heart. Perhaps the influence of the Norman (?) sculpture at the church at Barfreston where he lived in Kent will come back to him, and he will visualise that ancient tradition blooming again, as it were, in S. Matthew's![170]

Moore was working carefully and slowly. In March he wrote to Hussey that he had not yet started the drawings for the commission. However, he began to make sketches in April, and by June was at work on clay models. He kept Clark informed of his progress, and wrote to Hussey that Clark 'very kindly said he'll be pleased to come out here when I've got the little

clay models done to help decide which is the best and whether he and I both think I've produced an idea right enough for this'.[171] Both Clark and Sir Jasper Ridley, Director of the Tate Gallery, visited Moore to help him select from the five models. Hussey did not anticipate difficulty from the Parochial Church Council, the diocesan authorities or the Chancellor, but he was reassured by Clark:

> I consider [Moore] the greatest living sculptor and it is of the utmost importance that the Church should employ artists of first-rate talent instead of the mediocrities usually employed. As you will have seen from the models which he showed you yesterday, he has thought out the problem of the Madonna and Child most seriously, and his sketches promise that this will be one of his finest works.[172]

Hussey wrote to Clark that his letter helped with the Church Council – it 'supplied just the authoritative opinion that was needed'.[173] Hussey would also solicit opinions about the models from the art critic Eric Newton and Bishop Bell of Chichester. There was general agreement on the most naturalistic model.

Yet Moore felt some uneasiness about the nature of the project. He believed that, although the Church had been a great patron of the arts in the past, 'the general level of Church Art has fallen so low (as anyone can see from the affected and sentimental prettinesses sold for Church decoration in Church Art Shops)'. So he continued to make sketches and clay models:

> only then should I be able to say whether I could produce something which would be satisfactory as sculpture and also satisfy my idea of the Madonna and Child theme too. There have been two particular motives or subjects which I've constantly used in my sculpture in the last 20 years – they are the 'Reclining Figure' idea and the 'Mother and Child' idea – (And perhaps of the two the 'Mother and Child' has been the more fundamental obsession.) And I began thinking of the 'Madonna and Child' for St Matthew's by considering in what ways a 'Madonna and Child' differs from a carving of just a 'Mother and Child' – that is by considering how in my opinion religious art differs from secular art. It's not easy to describe in words what this difference is, except by saying in general terms that the 'Madonna and Child' should have an austerity and a nobility and some touch of grandeur (even hieratic aloofness,) which is

missing in the 'everyday' 'Mother and Child' idea. From the sketches and little models I've done, the one we've chosen has I think a quiet dignity and gentleness. And I have tried to give a sense of complete easiness and repose, as though the Madonna could stay in the position for ever (as being in stone she will have to do).[174]

Again we see the combination of the two themes that had previously been in conflict in Moore's work, and that had been resolved in the shelter drawings.

For the sculpture Moore acquired a two-ton block of Hornton stone from a village near Northampton. It arrived at Hoglands in September, the month of the jubilee, and the carving began. He anticipated that the earliest he could be finished was November, but he wrote reassuringly to Hussey: 'I'm enjoying being back at carving again after so long only drawing.'[175] There followed six weeks of hard work, carving ten to twelve hours a day. Finally completed and ready to be shown, the statue was transported to Northampton in February 1944.

In Volume I of Moore's *Sculpture and Drawings* there are photographs of the small-scale models for the seated *Madonna and Child*, as well as a magnificent picture of the work in progress, with the two figures emerging from the stone. There are also two detailed pictures. But of course the best way to see the statue is to go to the church in Northampton. The head of the Madonna is at an angle, so she looks at the viewer coming down the aisle; the Child, whom she holds in her lap, gazes directly forward. Somewhat more than life size, but not too much so, still in touch with ordinary people, it is a work of 'noble undated beauty' – the phrase is Nikolaus Pevsner's – and it radiates calm and serenity, a vision of peace created in a time of war.

The dedication of the statue took place on 19 February 1944, with Clark to unveil and Dr Blagden, the Bishop of Peterborough, to dedicate it and preach.* Hussey had worked on preparing the public. At the suggestion of

*Mandell Creighton, the eminent historian and churchman, had, as Bishop of Peterborough, laid the corner-stone of St Matthew's in 1891. J. Rowden Hussey had become minister in 1893. Benjamin Britten's jubilee piece, *Rejoice in the Lamb*, had already been performed there on 21 September 1943. Hussey remained vicar of the church until 1955 (having succeeded his father in 1937), when he became Dean of Chichester. At Chichester he continued his patronage of the arts, including the commissioning of Leonard Bernstein to compose the *Chichester Psalms* in 1965.

his father, on the Sunday before the unveiling he discussed the statue in his sermon (Moore had said that he was unable to talk about his own work in a public way, although he could do so in personal conversation). There was time to prepare, as the date was being continually postponed. The original hope had been the 21 September jubilee, and then possibly November. Hussey told the congregation:

> The Holy Child is the centre of the work, and yet the subject speaks of the Incarnation – the fact that the Christ was born of a human mother – and so the Blessed Virgin is conceived as any small child would in essence think of his mother, not as small and frail, but as the one large, secure, solid background to life. There is pictured humanity at its highest dignity; there is symbolized all that is best in motherhood as it appears to a small child. The Holy Child sits safely in His mother's lap, with her protecting hands on Him; but He looks out quite unafraid, and her hands do not grip or restrain Him, for she presents Him, offers Him to the world, as He will offer Himself. . . . The Blessed Virgin looks away into the distance, towards those who first approach the statue from afar; the Christ Child looks intently at those who stand straight in front of the statue only a few feet away.

In his sermon Hussey argued that it takes time to understand a difficult work, and cited the opinions of Herbert Read and Kenneth Clark on the greatness of Moore as a sculptor, and of Julian Huxley, the Bishop of Chichester, T. S. Eliot and Eric Newton on the appropriateness of Moore creating this particular statue.[176]

The unveiling ceremony itself did not take place on time: a bomb had fallen on the railway line, and the train from London with the Moores, the Clarks and the Sutherlands was three hours late in reaching Northampton.*

*Benjamin Britten was prevented by a bad arm from returning to Northampton to conduct another performance of *Rejoice in the Lamb* (see Britten to Hussey, 28 February 1944, in Donald Mitchell and Philip Reed (eds.), *Letters from a Life: The Selected Letters and Diaries of Benjamin Britten 1913–1976* (Berkeley, Calif., 1991), vol. 2, p. 1188). Clark wrote to him that he had missed a difficult trip: 'You were well out of that day at Northampton because owing to a bomb on the line our train was three hours late each way, and we spent most of the day cold, hungry and frustrated in a non-corridor train, which we finally left at Willesden in the middle of the night' (Clark to Britten, 2 March 1944, copy, Clark Papers).

Immediately on their arrival at the church the service started, and Moore asked Clark to unveil the statue. In the course of his talk, Clark said: 'It is a very long time, perhaps almost a hundred years, since the Church has employed a sculptor who worked in a living style.' Like Hussey he was anxious to disarm criticism, arguing that like religion itself, art was not immediately understandable. He ran the risk of sounding somewhat defensive, as well as possibly patronizing:

> It is true of course that many of our Lord's sayings were of marvellous simplicity, but when we look at the fundamentals of our belief we find that they are in the form of mysteries – the Trinity, the Incarnation, the Redemption, to name only a few. . . . Religious poetry is of all poetry the most difficult, because it is concerned with the greatest Christian themes. . . . The figure which I have the honour to unveil in a moment may worry some simple people, it may raise indignation in the minds of self-centred people, and it may lead arrogant people to protest. But I am sure there will be many people in this building, who do not pretend to any great familiarity with the arts in general or with the modern idioms of art, who will feel every day more and more the fundamental beauty of this figure; and they will feel, I do believe, notwithstanding its apparent severity, a great harmony of feeling, even a great tenderness of feeling; and they will feel that harmony of forms which lies at the root of sculpture, as it does of architecture and music and all the other arts.[177]

There were hostile reactions in the local press, in many letters to the Northampton *Chronicle and Echo*: 'To my normal mind it is revolting.' 'Hoping this unfortunate piece of sculpture will be removed by public demand.' But in the national press there were articles praising the piece; not surprisingly, it was attacked by Alfred Munnings, the reactionary President of the Royal Academy.[178] As Clark predicted, however, the statue established itself not only among the critics but also among the population of Northampton.

Moore himself seemed satisfied by the event. On 14 April he wrote to Juliette Huxley, Julian's wife, about the trip:

> We had the most awful tiresome journey both ways there & back. The actual dedication & unveiling went all right. . . . The statue has caused a

lot of fuss in the Northampton local press, but through it, to quote the vicar 'people still flock to see it & there must have literally been thousands already. The vast majority are deeply impressed, & they are all made to think; so that is as satisfactory as one could wish.' That's what the vicar tells me, & although at first I was very sorry the local press was running a kind of stunt on it; it seems to have done no harm.[179]

The *Madonna and Child*, carved in brown-veined green Hornton stone, is quite magnificent in its setting, calm and consolatory, placed against a plain stone wall in the church, on the right side of the altar in the north transept – two serene figures, the head of the Child almost the same size as the head of the Madonna; her hands gently hold him. The statue was unmistakably derived from the shelter drawings of mothers and children, and from the use of drapery in them. The shelter drawings had moved Moore in a somewhat more realistic direction, and he himself acknowledged, 'I'd never have done the Northampton Madonna without the war.'[180] While the statue echoes the shelter drawings, it goes beyond them, a movement towards serenity and resolution after the terror and pain of the bombings.

The shelter work and the *Madonna and Child* marked Moore's emergence as one of the most famous artists in England, and as one of the world's foremost sculptors. In 1943 forty of Moore's drawings and water-colours were exhibited in New York; in 1946 he had a show of drawings at the Phillips Gallery in Washington, and, most important, an exhibition of fifty-eight sculptures and forty-eight drawings at the Museum of Modern Art in New York. From then on, every year he had numerous exhibitions around the world. Looking at Moore's international fame, John Russell would marvel:

This he has achieved with one major carving in a provincial church and a group of drawings. It is one of the most curious reversals of English art-history, or taste-history, that this should have come about so swiftly and as a result of work different from anything he had done before. In part it was due, certainly, to our tendency at that time to look around for something that would make sense of the war and confer a lasting dignity upon what was in its cumulative effect a period of unmitigated exhaustion. . . . And he did it again, though perhaps less obviously, [with the *Madonna and Child*]. This is the least 'modern' of all his works, and

like the 'family groups' on which he began at about the same time . . . it brought thousands of people an extraordinary feeling of serenity and repletion . . . an architecture of consolation.[181]

As Robert Melville has argued, Moore returned to sculpture deeply affected by the experience of the shelter drawings. 'The figures [of the shelter drawings] are not imitative of sculpture, and if occasionally they have the look of a somewhat harder substance than flesh it is because the shelterers themselves tended to assume an effigial stillness, a static patience. The large simplicity of forms brought Moore's deep-rooted regard for some of the Renaissance masters to the surface and some of the drawings of sleepers seemed a new contribution to the theme of the sleeping disciples.'[182] Or as John Russell remarked: 'Moore was able to raise those tedious hours below ground to the scale of epic.'[183] He now combined the power of the primitive with the intelligence and compassion of humanism. He was a 'visionary of the real'.[184] 'The tube shelters gave Henry Moore a subject that humanised his classical feeling for the recumbent figure, and led to a series of drawings which will, I am certain, always be considered the greatest works of art inspired by the war.'[185]

The shelter drawings and the *Madonna and Child* had been Moore's reaction to the war. It was a war in which everyone in Britain was involved, and it was appropriate that these drawings not only made Moore so much more accessible, much better known than before, but also that they emphasized the commonality of experience for the ordinary people who took shelter in the Underground. The sketches and drawings universalized the shelterers, lifted them above themselves and gave them a feeling of antique tragedy, of an all-too-human combination of bravery and fear. And in the process, Moore had created masterpieces.

PART 2
❖ ❖ ❖

Humphrey Jennings

|❖| 1 |❖|

H ENRY MOORE was already established as an artist by 1939; he had been singled out by discerning critics as one of the great sculptors of the century. The drawings he was to make during the Blitz – of London civilians taking shelter in the Underground – are accounted among his most significant achievements, but even without them he would have a secure, outstanding place in the history of twentieth-century art. The situation of Humphrey Jennings provides a very striking contrast. Promising in his twenties, in his early thirties still promising, in 1939 he had not yet found a role, an identity, a vocation to which he was totally committed, and he remains a clear-cut instance of an artist brought into being and fulfilment by the war. Out of the experience of the Blitz came his masterpiece, the film *Fires Were Started*.

Humphrey Jennings, was born on 19 August 1907 in the East Anglian countryside, in the pleasant village of Walberswick on the Suffolk coast. His family belonged to the 'lower-upper-middle class' – to use a discrimination of George Orwell's, whose own family, also of that class, came to live in the 1920s in Southwold, directly across the estuary from Walberswick. In short, Jennings' background was very different from Moore's working-class background, a miner's cramped house in a grimy industrial town in Yorkshire, and much more usual (certainly in the world of pre-war England) as a starting place for young artists and intellectuals. (True, it was precisely from that working-class background that two of the great twentieth-century English artists were to emerge, Moore and D. H. Lawrence – both miners' sons – but they were extraordinary exceptions.)

Jennings' parentage was artistic: his father was an architect, a restorer of old buildings, his mother a talented painter. They were Guild Socialists and his mother ultimately a Gurdjieffian. Later in her life she ran a shop,

first in Walberswick and then in London, that sold French pottery and textiles. Humphrey's paternal grandfather, Tom, was a well-known trainer of racehorses at Newmarket, and it became a Jennings signature in his films that there was always a shot of a horse being led through the streets. Jennings himself has been compared by a friend, the poet Charles Madge, to an artistic horse in the style of Géricault or Stubbs, 'full of nervous energy and ready to gallop off at any moment'.[1]

The Suffolk countryside, with its glorious old churches (built with the proceeds of the wool trade) and their tall belfries rising up over the flat landscape, captured Jennings' imagination even as a very young child. In later life, in 1943 in the midst of the war, he would write a poem recalling 1910 in which one of the most famous of those churches, Blythburgh, very close to Walberswick, would figure memorably. Even more memorable, however, are the glimpses the poem offers of Jennings' sunlit, joyful, solemn childhood, and the pastoral evocation of a far-off lost Edwardian world.

> It was a time of artists and bicycles and blue and white spotty dresses.
> They had a little boy who was carried in the basket of his mother's
> bicycle and they
> Used to picnic on the common between Walberswick and Blythburgh.
> In the summer the gorse on the Common bright yellow and a spark from
> the train
> as it passed would set the dry bushes on fire.
> How hot those flames of gorse, how hot even the day itself!
> How cool the inside of Blythburgh Church – the shade of a great barn
> from whose
> rafter and king-posts the staring angels outspread wooden wings.
> The solemnity of a child.
> The intensity of the sea-bird.[2]

Jennings had the proper education for one of his class: public school and university. He attended the Perse School in Cambridge, where his main interests were Greek, French, Latin, acting and sport; then in 1926 he was awarded a scholarship by Pembroke College, Cambridge. The Perse School had been recommended by a family friend, A. R. Orage, the editor of *New Age*, who had recently retreated to Fontainebleau to become a disciple of Gurdjieff at his Institute for the Harmonious Development of Man. The school was unusual in its curriculum and its methods of

teaching, comparatively advanced for the period, although it did not fall into the category of such radically experimental schools as Bedales. It was also unusual in not being as geographically isolated as many of the English public schools; rather it was in one of the two greatest university towns in England. Consequently, there was likely to be a good deal going on to stimulate an imaginative and bright child like Jennings. Even as a schoolboy he was sufficiently his own person to take advantage of such opportunities, and indeed his independent nature may account for his being kicked out from both the school's Officers' Training Corps and its Boy Scout troop. However, he did very well in his studies, and was conspicuously successful in theatrical activities: he acted, he designed scenery and in February 1921, when he was only 13, he was the principal author of a play, *The Duke and the Charcoal Burner*, performed in the school hall by his class-mates and subsequently published.[3] Written in not bad rhyming verse and with prose passages, some of them improvised by the boys themselves, the play was based on a story from the *Arabian Nights* transposed to a medieval setting, and was about a charcoal burner who gets his wish to be a duke for a day.[4]

Promising and precocious, Jennings went up to Cambridge in 1926 to read English and was soon launched upon a brilliant academic career. It was an exciting time in Cambridge English studies, given the presence there of I. A. Richards, and Jennings and William Empson stood out as the most promising of his students. However, this was only one aspect of Humphrey Jennings, who seemed to stand out in whatever he did and who, in his undergraduate years, seemed to be doing everything. He was a notable among notables. Michael Redgrave, John Lehmann, William Empson, the painter Julian Trevelyan (with whom Jennings ran a Cambridge art gallery for a time), Jacob Bronowski, Kathleen Raine, Julian Bell, Richard Eberhart, Malcolm Lowry and John Davenport were all contemporaries and friends of his. They comprised a literary-poetical-cultural avant-garde at Cambridge in the late 1920s, and Jennings was at the forefront. With Empson, Raine and Bronowski he edited the little magazine *Experiment*, seven issues in all, published from 1928 to 1931.

Jennings did brilliantly academically, receiving a First in both parts of the English tripos, the second with distinction, and then a postgraduate fellowship. He was also unusual for a would-be academic in that in 1929 he married, at a comparatively young age for an academic of his class, Cicely

Cooper, the sister of a school contemporary, and of an Anglo-Irish family. (One of her younger brothers, junior to Jennings at the Perse, would be killed fighting for the Spanish Republic during the Spanish Civil War.) Jennings embarked upon a dissertation, never completed, on the poet Thomas Gray, who had been a Fellow at Pembroke; he continued to design sets and costumes for plays, including Euripides' *The Bacchae*. But his literary and artistic activities ran in tandem with his abiding interest in the significance of the ordinary, his glorification of the quotidian.

The Cambridge influence was crucial, and one could say that Jennings was very much a Forsterian. It is appropriate that Lindsay Anderson would choose the most famous Forster phrase, 'Only connect', for the title of an essay on Jennings, and if any generalization could be made about his films, it is that they all attempt to be the bridge connecting the prose and the passion. As Kathleen Raine put it: 'He was looking for the images which would be not private images at all but public images.'[5] That is, the pictures in his films would be private moments that would nevertheless have deeper and more public resonances.

Not uncommonly, the years Jennings spent in Cambridge, the scene of his academic successes both at school and at university, were a time of trying to find a specific commitment; the appeal of the academic life appeared to be fading. There were also financial problems (he never had much money). He spent some time working as a schoolteacher and also worked for the Festival Theatre in Cambridge; after that he spent some time painting in Paris. He had more or less left Cambridge by 1932, and he eventually came to loathe the academic world.[6] He was one of those rare, golden undergraduates who seem to turn up in every generation, dazzling his contemporaries with the variety of his gifts. It was taken for granted that he was destined for some marvellous future, but perhaps he was too talented at too many things, and it would be years before his life came into focus.

He regarded himself as a left-winger politically, but less extreme than others. In a letter of 15 March 1933 to Julian Trevelyan he seemed to distance himself from movements on the far left – 'The University is ahem going Marxist' – and from the newest developments in poetry: 'The Auden's and Day Lewis's and so on are a positive menace. Bill [Empson] is well out of it in Japan.'[7]

His interest in art and painting continued, but sometime in 1934 he began his real career – the life in films – working for John Grierson, the

famous documentary film-maker. Jennings joined Grierson's film unit at
the General Post Office (GPO), founded in 1933 to produce documentary
films supported by the government. Grierson had been making films for the
government since 1929 when the Empire Marketing Board was established.
That year his film *Drifters* started the documentary movement in Britain,
and was the first of what some regarded as a seemingly endless series of films
about commercial fishing. Grierson was undoubtedly the most prominent
British documentary film-maker in the 1930s. The government connection
was also extremely important for the future and the significance of
documentary films during the Second World War, even if Grierson himself
wasn't involved in those films, having left England for Canada.

Sir Stephen Tallents supervised Grierson's films from 1929 to 1935, first
as his employer at the Empire Marketing Board and then at the Post Office.
(Tallents left the Post Office in 1935 to work for the BBC. Grierson himself
broke with the GPO Film Unit in June 1937 and his departure signalled a
shift towards a less rigorous and sectarian view of what film documentaries
should be.) Grierson's aim was to produce what he called 'the drama of the
doorstep': he sought to present 'ordinary' life without any particular
concern for an evolving plot. His interests were less aesthetic than were
those of Jennings: 'poet', in Grierson's vocabulary, was not a term of
praise. In 1932 Tallents had written a pamphlet, *The Projection of Britain*,
that emphasized such activities as making films that would put forward
Britain's interests, but in a comparatively subtle way. When the Ministry of
Information was set up in 1939 Tallents was the projected Director
General, the second in command. He did not achieve that post, but his
career was a linking factor in ensuring that films, particularly documentary
films, were likely to be supported by the government in peace and war. The
Crown Film Unit, established in 1940 at the Ministry of Information, was
the successor to the film unit at the GPO. In 1952 the Conservative
government of the day closed it down.

In 1934, when he began to work for Grierson, Jennings discovered what
he believed might be his *métier*. He worked on four films that year, one with
Grierson. With other prominent figures in the documentary movement –
Alberto Cavalcanti (who succeeded Grierson as head of the GPO Film
Unit), Basil Wright and Stuart Legg – he worked on three shorter films,
Post-Haste, *The Story of the Wheel* and *Locomotives*. He also contributed shots
to *Coalface*, and acted in *The Glorious Sixth of June* and *Pett and Pott*.[8] He was

just beginning, he was not completely at home, and he was yet to find his own style – it would require the war to precipitate that. 'The Griersonian tradition – into which Jennings only fitted uneasily – was always more preachy and sociological than it was either political or poetic.'[9] His practical knowledge was always limited, he was the director with the overall conception; he never learned how to use a camera.[10] From his own point of view the work was not especially challenging.

However, his early experience at the centre of the documentary movement in Britain was important in shaping the directorial expertise he would later bring to bear when making the sort of films that he wanted to make. It was from Grierson that Jennings acquired those ideas about film documentary that would be so important in the making of *Fires Were Started*. He was less interested than Grierson in direct propaganda, in exploiting the pulpit aspect of a documentary film, its potentially heavy-handed editorial function. This is made apparent in a recorded discussion that took place between Jennings and J. B. Holmes after the war. Jennings pointed out that documentaries, unlike commercial movies, were concerned with the ordinary rather than the extraordinary. Furthermore,

> it should be quite clear from the beginning that the making of documentaries must not be confused with the making of shorts in general, and again it must not be confused with the making of newsreels. ... [Documentaries involve] taking a real person, not an actor, placing him in a situation very like that in which he might find himself in real life, and allowing the rest of everyday life to go on around him. ... In that way the individual is situated in society – he is part of that life that we are talking about.[11]

Paul Rotha, another eminent documentary film-maker, made a similar point, although his approach is closer to the didacticism of Grierson than to the more indirect methods of Jennings:

> Let cinema attempt the dramatisation of the living scene and the living theme, springing from the living present instead of from the synthetic fabrication of the studio. Let cinema attempt film interpretations of modern problems and events, of things as they really are today, and by so doing perform a definite function. Let cinema recognise the existence

of real men and women, real things and real issues. . . . The documentary method may well be described as the birth of creative cinema.[12]

Donald Mitchell, in the study from which the quotation from Rotha is taken, goes on to write of the influence of the documentary film movement on the young Benjamin Britten who had some connection with it as a composer in the 1930s. One might argue that Rotha's emphasis on reality was hardly original or unique; it was a view characteristic of much art during the 1930s, and into the war as well. The GPO's most famous documentary was *Night Mail*, made in 1936, notable both for the long poem by W. H. Auden recited by Stuart Legg and John Grierson in the latter part of the film, and for the background music composed by Britten. Mitchell points out that Britten, who had reproduced in his score the sound effects of the night train,

> had of course always had this marvellous, well-nigh photographic ear – if the paradox may be forgiven – and he continued to use it whenever he had need of it. We hear it, as fresh as ever, in Act I of his last opera, *Death in Venice*, when the sound of the engines of the ship ferrying Aschenbach back to Venice explodes into life. No one who has been on deck at that moment can mistake the mechanical shudder, rattle and clatter for anything else. This is, I suggest, a manifestation, an example of the 'pictorial' that precisely fulfills, I think, what John Grierson means when, in describing the objectives of the documentary film and its characteristic techniques, he talked about 'the creative treatment of actuality'; and it might well serve as a very neat summing-up of one aspect of Britten's treatment of sound.[13]

Of course a note of caution has to be sounded not only about such figures as Grierson and Rotha, but also about Jennings and Britten. Particularly in the 1930s they were deeply concerned with the 'ordinary' person, like so many young artists on the Left. However, as would become more evident when war broke out, what the mass audience at whom their art was aimed really wanted, and what these middle-class artists thought they wanted, might be two very different matters. This issue is not our concern here, since we wish to consider the quality of the work that was produced, and its appropriateness to wartime, rather than its success or failure in reaching a

wider public. Much recent film criticism has reacted against the élitism of the documentary film-makers of the 1930s and 1940s. The film historian Clive Coultass provides a useful example of this reaction: 'The origins of the British documentary movement lie in the thirties with a group of usually left-wing but definitely middle-class intellectuals whose interpretation of the outlook of ordinary Britons, and particularly their representation of working-class people, should be regarded with caution.'[14] Ironically, Jennings, being more poetic and aesthetic than most of the other documentary film-makers, to some extent avoided the dangers involved in claiming to speak for the vast majority or preaching to it. However, the sort of patronizing élitism that Coultass and others have in mind is wincingly in evidence in Jennings' 1944–5 film *Diary for Timothy*.

Jennings was different from the other documentary film-makers among whom he found himself. In a way he was less committed than they were to the one pursuit; he had wider interests, was perhaps more of a dilettante. Still, his early experience at the heart of the documentary movement in Britain was very important in shaping his skills and interests. There were, however, two other almost contrary yet reinforcing movements with which he became involved in the 1930s: surrealism and Mass-Observation. Each, in its idiosyncratic and distinctive fashion, deepened his interest in ordinary life, or rather in singling out aspects of it for close investigation in a poetic way. All this would make itself felt in his later film career, to which he brought the sensibility of a modernist.

There has always been something 'difficult' about modernism in England, as if in crossing the Channel it became more anaemic, more susceptible to being ignored by the public, inciting only a certain disdain or disgust. The visual Arts had a tradition of being a sphere in which the English might indulge with some success, but it was not a major strength. In England the greatest achievements tended to be in the written word. There had been a spurt of interest in modernism at the time Jennings was leaving Cambridge for the wider world of London. In 1934 two of the artists with whom we have been concerned here, Henry Moore and Paul Nash, had joined forces with a number of others to form the group Unit One. A show of their work was mounted at the Mayor Gallery in London, and, with Herbert Read as its spokesman, the group represented a step in the rise of modernism in English art – a slow progress, it must be said – and a link to the slightly later surrealist development in England.

The ties of English modernism with its Continental counterpart were reinforced by the increasing number of refugee artists fleeing to England from Germany. A tour of the Unit One show in the provinces did represent an effort to bring the English public to a greater understanding of advanced, experimental painting and sculpture, but it was not until the war years that English modernism was finally accepted – for divers reasons, in part because of isolation from the Continent, in part perhaps as a show of patriotism – by a wider audience both in London and elsewhere.

In June 1936 the famous, some would say infamous, International Surrealist Exhibition, which Humphrey Jennings helped organize, opened for four weeks at the New Burlington Galleries in London. It included several pieces by Jennings, an oil, two collages and three image-objects. These works did not make a strong impression, and although Jennings continued to paint throughout his life, his paintings are less distinctive than his films.*

Surrealistic ideas and examples were being brought over from Paris by the painter Roland Penrose and the poet David Gascoyne; others involved with the exhibition were Jennings' old Cambridge friend Hugh Sykes Davies, McKnight Kauffer, Henry Moore, Herbert Read, Paul Nash, André Breton, Paul Eluard, Man Ray, Salvador Dali and E. L. T. Mesens. The show itself was international in its representation: four hundred objects by fifty-eight artists from fourteen countries; among the foreign artists were de Chirico, Max Ernst, Giacometti, Paul Klee, Magritte (Jennings bought his picture *Au Seuil de la Liberté*), Miró, Picasso and Tanguy. Dali, as usual, captured the most publicity, particularly when he almost died while giving a lecture on paranoia from within a diving suit. (The helmet was so heavy that he couldn't be heard when he spoke. There wasn't enough air for him to breathe, he couldn't lift the helmet off, and he was rescued only at the last minute from asphyxiation.) The exhibition attracted crowds of the curious, some of them art lovers, and certainly served to make surrealism, as practised by British and Continental artists, much better known in England. It did little, however, to modify the

*Forty-seven oil paintings, 20 drawings and water-colours, and 14 collages, chosen by his surrealist colleague Sir Roland Penrose, were part of the exhibition 'Humphrey Jennings: Film-maker, Painter, Poet' at the Riverside Studios, London, in 1982. (Figures from Charles Madge, 'A Personal Vision', *Times Literary Supplement*, 15 January 1982, p. 54).

generally prevalent sceptical attitude towards modernism. Surrealism was a kind of political statement, attesting to the rottenness of society in the aftermath of the First World War, but in a more poetic and anarchic way than the social realism of the left-wing political movement in art represented in England by the Artists International Association. In 1936, and again in 1938, there were debates between the two groups that proved little beyond the differences between them. Surrealism was attacked by Anthony Blunt in the Marxist *Left Review* (edited by Montagu Slater) for being politically irresponsible. But the surrealists were in agreement with the Left on the key issue of the Spanish Civil War, publishing a pro-Loyalist declaration in *Contemporary Poetry and Prose*; Mesens organized a tour of Picasso's *Guernica* to raise money for the Republic. Despite the artistic differences with the Artists International, the surrealists had a room containing 118 works at its April 1937 exhibition.

Jennings was always drawn to the poetic, and it was the combination of his poetic sensibility with the realist subjects of his films that made them so extraordinary. Surrealism, although it seemed defiantly esoteric, even shocking, in 1936, made it a point to focus upon casual details – the look, say, of an eye in a Magritte, or of an ear in a Dali – giving these familiar details a disturbing strangeness. Something very like this can happen in a film close-up, when the camera zooms in on a detail to make it unforgettable.[15]

The publication *London Bulletin*, edited by Mesens with assistance from Jennings and others, served as a way for the British surrealist group to spread its ideas. (Mesens also ran the London Gallery, where surrealist shows were held.) Jennings made quite a few contributions to the *Bulletin*, including a prose poem in 1938 (translated into French by Mesens) and a few paragraphs on the paintings of Magritte. It is easy to see how Jennings' film eye was shaped by surrealist art – the juxtapositions of the ordinary, the tradition of a higher or different form of reality to be found in dreams and the unconscious. Jennings wrote:

In Magritte's paintings beauty and terror meet. But their poetry is not necessarily derived from the known regions of romance – a plate of ham will become as frightening as a lion – a brick wall as mysterious as night. His painting is thus essentially *modern* in the sense required by Baudelaire. Simultaneously Magritte never allows himself to be seduced by the immediate pleasures of imitations. Precisely his passionate

interest in the concrete world has made him remember that a painting itself is only an *image*.[16]

In the March 1939 issue of the *Bulletin* there was a poem about Humphrey Jennings by Paul Eluard, and Jennings continued to exhibit with the surrealists in London, Paris and Amsterdam. The London Gallery itself had a one-man show of paintings by Jennings. His paintings are interesting but not distinguished; one of the most reproduced is of a racehorse; the image hearkens back to his grandfather and forward to his affection for having horses in his films. English surrealism tended to be more romantic and more interested in the actual visual world than did its European counterparts, and this can easily be recognized in Jennings' films. As in the paintings of Paul Nash and Graham Sutherland, so too in the films of Humphrey Jennings the mystery and romanticism of the particular object under scrutiny would have its peculiar importance.

A concern for ordinary people is apparent in all Jennings' work. At times there might be uncertainty as to what attitude he, as a member of the middle class, should take towards their ordinary problems; this concern is perhaps most unsatisfactorily resolved in the famous *Diary for Timothy*. (In the film he and other Cambridge figures – Michael Redgrave as narrator and E. M. Forster as writer of the script – depict in a rather patronizing way the world of the future for the ordinary Briton after the Second World War.) This interest in the ordinary person is also reflected in Jennings' immense collection of documents, *Pandemonium* – he started to collect the material for it in the 1930s and it was finally published (in a much shortened form) in 1985, long after his death. *Pandemonium* is a vast anthology of the Industrial Revolution, ranging from 1660 to 1866, depicting how British society went from the more primitive rural world to an industrial, machine-driven society. Jennings' Cambridge contemporary Jacob Bronowski makes clear how the collection fitted in with Jennings' ultimate interest in film, and how he conceived documentaries: 'He was collecting extracts from writers of every kind – poets, scientists, compilers of catalogues, social innocents – and putting them together rather like a film sequence, so that each extract illuminated its neighbours.'[17]

In an article in the *London Bulletin* Jennings noted that in July 1938 'the London Gallery will present an exhibition of 19th Century Drawing and Engravings of Machines', and he went on to state that 'Machines are

animals created by man' – an idea with which Paul Nash would certainly have agreed – referring to Blake's Tiger as 'an animal regarded as a machine at the time of the industrial revolution'.[18] In the article he made an explicit comparison of a 1769 letter by Watt on the Kinneil Engine and Marcel Duchamp's note on *La Mariée mise à nu*. Jennings was obviously fascinated by the relationship between the development of machines and the rise of realistic art, and then the inversion of this relationship in the 'higher reality' of cubism, Dadaism and surrealism: 'The pre-eminent example of the automatic machines – the steam railway – developed at precisely the same time as the realism of Géricault, Daumier, and Courbet.'[19] His painter's eye and his surrealist tendency to use found objects in unexpected juxtaposition were extremely important in shaping his approach as a film-maker.

The next issue of the *London Bulletin* included a sampler of *Pandemonium* 'to suggest rapidly some of the varying situations of MAN in this country in having to *adapt himself* rapidly to a world altered by the INDUSTRIAL REVOLUTION, and in particular to THE IMPACT OF MACHINES on everyday life'. In this small collection of texts Jennings quoted from, among others, Blake, Fanny Kemble, Engels and Samuel Smiles.[20] During the war he was to work fitfully on this mammoth manuscript, which he never completed. Perhaps he never really meant to complete it – there would always be something more to be added.

Along with his interest in high art – surrealism – there was also his almost compulsive concern with the ordinary person. The two strains are connected – indeed, they might at times be regarded as mirror images of each other. The politics of the period meant that those who were left-wing, particularly if they were young and middle class, were anxious to find out more about the vast mass of 'the people', those who were suffering so acutely, it seemed, from the political system and the Depression. Out of this need came the creation of Mass-Observation in 1937. Along with Tom Harrisson and Charles Madge, Humphrey Jennings was one of the originators of this attempt to find out more, through the use of observers, about ordinary life in England. Madge, a Cambridge poet and contemporary of Jennings, was now a reporter on the *Daily Mirror*; he was anxious to discover what ordinary people felt about the abdication of Edward VIII. Harrisson, whose background was in anthropology, was fascinated by the idea of applying its techniques to his own country, both through observers

and through keepers of diaries recording their daily lives. Madge believed in the linkage of scientific observation and a left-wing point of view. Late in 1936, in response to a letter in the *New Statesman* asking for a study of reactions to the abdication, Madge wrote back that such a plan was already in operation, formed that autumn by himself with Jennings, the surrealist David Gascoyne and the film-maker Stuart Legg.[21]

Harrisson, whose only poem happened to be published alongside Madge's letter in the *New Statesman*, was at the time in Bolton ('Worktown'), where he was 'observing', putting to use the anthropological skills he had learned in the New Hebrides. Bolton would become a subject for Mass-Observation in prose, in paintings by William Cold-stream and Graham Bell, and in photographs by Humphrey Spender. (Coldstream and Bell belonged to the realist Euston Road School of painting, which was opposed to the surrealists.) Jennings' 1939 film *Spare Time*, about working-class leisure in the North of England, was the one film made by him to be directly influenced by his work with Mass-Observation, although his official involvement with the group had ended two years before, as early as September 1937. The intention behind *Spare Time* (made by the GPO to be shown at the 1939 World's Fair in New York) was to present working-class Britons at play, which it does through a succession of objectively presented glimpses of 'ordinary' life, and with a kind of random juxtaposition: football, pigeon-racing, wrestling, a band practice, a Saturday night dance and a coal-miners' choir. Throughout the film Jennings is the invisible impersonal observer, but the sensibility of the film grew out of what his friend Julian Trevelyan described as 'his Surrealist vision of Industrial England; the cotton workers of Bolton were the descendants of Stephenson and Watt, the dwellers in Blake's dark satanic mills reborn in the world of greyhound racing and Marks & Spencer'.[22]

Madge, Jennings and Harrisson met and exchanged ideas for what became Mass-Observation, and published a letter signed jointly in the 30 January 1937 issue of the *New Statesman*. The letter was written by Harrisson and may not precisely reflect Jennings' views. Nevertheless, it has a combination of grandness and ordinariness suggestive of the strengths (and perhaps the weaknesses – a certain vagueness) of Jennings' approach, his impressive ability to illuminate ordinary events. The letter began: 'Man is the last subject of scientific investigations', and argued that

the plan of Mass-Observation followed in the tradition of Darwin, Marx, Freud and Breuer. The hope was to expand the number of observers from fifty to five thousand in order to look into such subjects as: 'Behaviour of people at war memorials'; 'Shouts and gestures of motorists'; 'The aspidistra cult'; 'Anthropology of football pools'; 'Bathroom behaviour'; 'Beards, armpits, eyebrows'; 'Anti-Semitism'; 'Distribution, diffusion and significance of the dirty joke'; 'Funerals and undertakers'; 'Female taboos about eating'; 'The private lives of midwives'.[23]

Under the editorship of Madge and Jennings the first Mass-Observation report, *May the Twelfth*, was published in September 1937; it was a compilation of ordinary activities on the Coronation Day of George V. The publication, mainly Jennings' work, was not as successful as later Mass-Observation studies such as *Britain* (1939) and *The Pub and the People* (1943). *May the Twelfth* marked the high point of Jennings' participation. The hope for five thousand observers was a long way from being fulfilled, although the report was optimistic: 'Early in 1937, fifty people in different parts of the country agreed to co-operate in making observations on how they and other people spend their daily lives. These fifty Observers were the vanguard of a developing movement, aiming to apply the methods of science to the complexity of modern culture.'[24] Eventually Madge and Jennings did organize a group of five hundred, dedicated to recording their doings on the twelfth day of each month.[25]

In an interview in 1975 Tom Harrisson talked about Jennings' participation, and the significance of the experience for his work:

If you take the Coronation Day survey published by Faber, and designed by Madge and Humphrey, they conceived of it as a kind of paean in words. Moreover, they believed they would get a mass concept of a new sort, because it was religiously 'out of the words of the people.' We are, of course, talking about a period when the upper classes and the intellectuals were groping to get out amongst the proletariat and establish communications across the class-gap which was very, very real in those days, and which the war in Spain had brought out in another way. . . . Those two were working together and great friends and there was a number of other people involved – other poets, and other filmmakers. . . . There were a lot of painters involved, too. All these people had a kind of visionary concept, not only about film but about

everything, an approach which was unscientific-literary, or poetic-literary. It wasn't a question of 'social-realism' at all – in fact, just the opposite: a kind of social super-realism. Not surrealism, super-realism. They had an idea about truth – rather akin to the old story about putting all the monkeys in the world at all the typewriters in the world, you eventually produce the Bible and all the books in the British Museum.[26]

Harrisson provides a picture of Jennings at this time as a man who had not yet found his vocation, who was likely to move on to something else. One does already see his belief, which would be so important in his films, in the value of interesting juxtapositions: 'He was a person who liked *wild* ideas. He believed, for instance, that coincidence is one of the keys to human behaviour. . . . He was a terribly excitable person, good-looking, attractive, teeming with ideas, talking the whole time, never listening to anybody. But a really wonderful chap.'[27] As Ian Dalrymple remarked about him, 'his self discipline (apart from his rages) was perfect'.[28] Harrisson visualized him still talking as he accidentally backed off a cliff to his death while choosing camera set-ups on the island of Poros in Greece in 1950.

These background experiences – Cambridge English, painting, surrealism, Mass-Observation – were all appropriate preparations for Jennings' work for the Crown Film Unit (the new name for the Post Office group when it came under the Ministry of Information in 1941). Until then, he continued writing, painting and broadcasting. In 1936 he made a film for Shell-Mex, and in 1937 he returned to the GPO, but his sequence of great films did not begin until 1942.

|❖| 2 |❖|

The intensity and importance of Jennings' activities underwent a transformation once war broke out in September 1939. Films became more 'serious' in their purpose, in the sense that they were meant to serve as propaganda. The nub for such activity was the Ministry of Information, about which we have heard from Kenneth Clark. Housed in the Senate House of the University of London, it formed the model for Orwell's

Ministry of Truth in *Nineteen Eighty-Four* and was splendidly parodied in Evelyn Waugh's *Put Out More Flags*:

You know I should have thought an air raid was just the thing for a surrealist; it ought to give you plenty of composition – limbs and things lying about in odd places, you know.... Sir Philip Hesketh-Smithers went to the folk-dancing department. Mr Pauling went to woodcuts and weaving; Mr Digby-Smith was given the Arctic Circle; Mr Bentley himself, after a dizzy period in which, for a day, he directed a film about postmen, for another day filed press-cuttings from Istanbul, and for the rest of the week supervised the staff catering, found himself at length back beside his busts in charge of the men of letters.[29]

The Ministry of Information, a huge operation designed to employ a thousand civil servants, controlled the spheres of information and propaganda. As A. J. P. Taylor cynically remarked, the only value of propaganda is that it keeps intellectuals out of mischief in wartime. The ministry was active, as we have seen, in supporting war artists, but it also supported film, including within that category not only documentaries but also commercial films and newsreels.

While affiliated to the Post Office the GPO Film Unit had already been part of a bureaucracy. Before being taken over by the Ministry of Information, it had completed twenty-eight films, had twenty-one films in production and had abandoned seventeen projects, all at a cost of £45,050. Its facilities were bad: its headquarters were still in Soho Square, it had a terrible projection room and primitive studios in Blackheath. (Jennings himself, as a director, below the rank of senior director, received an annual salary of £416.)[30] When the film unit was incorporated into the Ministry of Information by the spring of 1940 the bureaucratic situation became worse (although the physical conditions improved), and there difficulties in making progress on films. As Gerald Noxon wrote: 'It was a discouraging period for documentary film-makers in England, for we had all come under the control of the Minstry of Information whose ponderous bureaucracy and continuous internal struggles for power had virtually eliminated documentary production. And this at a time when we felt it was so badly needed to offset the dismal condition of national morale produced by the "phoney war".'[31] The documentary film-makers may have felt that

the commercial film-makers were being favoured. There was some question about whether the unit might be abandoned, and the ministry commissioned a report by Harold Boxall. In August he recommended that the unit be kept. The alternative was that films would be made exclusively through commercial firms, which he felt would be much more expensive. He also hoped that the unit would produce films that would be commercially distributed and make a profit. Yet Boxall felt that feature-length films should be avoided so as not to compete with commercial firms. Both the Crown Film Unit and commercial companies should be encouraged to make films that would assist the government 'in publishing information and reconstruction of actual incidents that are now becoming part of our daily lives'.[32]

In some respects the ministry was overprepared. It was initially expected that, once the war started, the bombing of London would be immediate and devastating – the bomber would always get through. Much more destruction had been anticipated earlier in the war, although when the Blitz did start in September 1940 it was bad enough. The officials probably exaggerated how easily morale would be affected, and how easily enemy agents would penetrate British society and help to cause demoralization. Moreover, those elements of the Left associated with the Communist Party were active defeatists because of the Nazi–Soviet Pact. The period of the phoney war gave the ministry time to sort itself out. Running the Films Division proved to be a massive operation for the ministry, which in the course of the war was involved in producing 1,887 films as well as approving 3,200 newsreels and 380 feature films.[33] By 1942 these films, and others approved by the ministry, were being shown to between twenty and thirty million film-goers weekly.[34] The ministry was not in charge of making commercial films but obviously its approval (and financing) was extremely important in terms of supplies, exemption from conscription for those making the films, and so forth. An arrangement was made that five minutes in each showing at commercial cinemas would be put at the disposal of the Crown Film Unit.[35]

One should not exaggerate the extent of British phlegm and stoicism, for in many ways the British are a violent and excitable people. Yet there is some truth in the cartoon that appeared in *Punch* on 14 August 1940, and was later used as the frontispiece to Michael Balfour's *Propaganda in War 1939–1945*. It depicts a rural pub with two silent farm workers

contemplating their pints of beer and a silent bartender standing there. The caption reads: 'Meanwhile, in Britain, the entire population, faced with the threat of invasion, has been flung into a state of complete panic.' Still, there was no telling how devastating the war would be or how the populace would react to bombing and the very real threat of invasion.

During the First World War the diffusion of propaganda had been rather *ad hoc* and slow in developing. This time there was an attempt to be better prepared. As early as 1935 a subcommittee of the Committee of Imperial Defence looked into the problem of news in wartime. A year later a plan for a ministry was set up.[36] In July 1939 Sir Samuel Hoare put the plan to Parliament, and personnel was assembled in August: 'Nine hundred and ninety-nine Civil Servants sprung to their office chairs.'[37] The Ministry of Information had a rocky early history, and a series of ministers, until it stabilized under Brendan Bracken. The Films Division was particularly troubled. Ironically, rather than controlling and disseminating news, the ministry, full of contentious people able to express themselves well, itself became unwelcome material for newspapers. Sir Joseph Ball, previously Director of Information for the Conservative Central Office, became the head of the Films Division. He wished to use commercial film and newsreel companies as well as advertising agencies. This infuriated those who were committed to the documentary movement. Our chief concern here is not the effectiveness as propaganda of such films as *Fires Were Started*, but it is perhaps true that film, to a greater extent than other media, is dedicated to communication in an immediate sense. On the other hand, lasting aesthetic values are not the same as immediate impact in the cinema. How does one balance the questions of aesthetic strength and effectiveness as propaganda? Thorpe and Pronay, in the introduction to their listing of films made during the war, tend to take a 'populist' stand; yet they do not resolve the question of artistic value. In their view the films made by the documentary movement were good art and bad propaganda. Yet Jennings' films were shown in more cinemas and were more popularly successful than Thorpe and Pronay imply. Is it not important for a government, even in wartime, to support artistic activities as well as purveying propaganda? How much difference does propaganda make in any case? As Thorpe and Pronay point out, those who were interested in documentary films were probably as much if not more influenced by what they read. Yet, as they also point out, those who were influenced by

documentary films were likely to possess considerable influence upon others and hence might be effective carriers of ideas about the war.[38]

At first, when Sir Joseph Ball was head of the department, the more commercial film interests were in the ascendant at the ministry: 'It should be remembered that in the situation envisaged for the operation of the Ministry of Information, film propaganda was to be the medium for reaching ordinary people, the industrial and urban working men, their wives and their children, who would have to stand up to the enemy's aerial warfare. The decision to ignore the documentary movement in planning the work of film propaganda must then be said to have been in accordance with the evidence available at the time and with the planned purpose.'[39] It was not that those involved were unaware of the documentary movement, but rather that they chose not to support it.

In the belief that London would be bombed as soon as war was declared, many cinemas were closed and a considerable audience for propaganda films was temporarily removed. But with the phoney war and the need for relaxation, cinemas were reopened. In fact, this was the issue on which Sir Joseph Ball lost his job, for it was he who had ordered the cinemas closed. It has been improbably alleged that Margot Asquith, whose son Anthony was a prominent film director, organized a secret meeting to cabal against Ball over this decision.[40] As someone who had previously been involved in publicity for the Tories, Ball was regarded with some suspicion by the documentary film-makers and others. Those who were at first excluded were powerful and imaginative individuals who were able to fight for their own interests. Ball was seen as a leader of the philistines. He was replaced at the end of 1939 as head of the Film Division by one of England's most cultivated men, the Director of the National Gallery, Sir Kenneth Clark. (There is a story, no doubt apocryphal, that someone made the mistake of thinking that Clark was connected with film-making when they heard of his involvement with pictures.) Clark, as we have seen, was a central figure in the preservation of the arts in Britain during the war: he supervised the removal of the treasures of the National Gallery to quarries in Wales; he was chairman of the War Artists' Advisory Committee which did so much for artists. His role in the Ministry of Information was less clear but was likely to favour those who were aesthetically more interesting rather than those on the 'populist' wing.

The class implications of this situation at the Ministry of Information are

clear. The intellectuals tended to be more left-wing, yet they also had a tendency to try to impose upon the 'people' what they thought they should see rather than what they might more genuinely enjoy. Given the nature of English society, it is hardly suprising that one should find this 'élitist leftism' emerging. If anything, there was a reinforcement of class conceptions, most notably caught in the famous gaffe of the poster designed for the multitude: '*Your* Courage, *Your* Cheerfulness, *Your* Resolution WILL BRING US VICTORY.' As Ian McLaine has remarked:

> An increase, or perhaps the resumption of class consciousness may be attributable more to the propagandists' insistence on the reality of 'equality of sacrifice' [the bombing of Buckingham Palace was a famous example] – which focused attention on the breaches of the doctrine – than to glaring instances of privilege. The implementation of a state philosophy of egalitarianism, while making people acutely sensitive to its failures, gave the temporary sensation if not the abiding substance of equality. Perhaps the most important single reason for the failure of class resentment to assume threatening proportions was its absorption into the public's post-war aspirations.[41]

The tone of the description of Clark's activities by Thorpe and Pronay, writing forty years later, reveals the degree to which aesthetic and class questions interrelate in England. They do recognize Clark's qualities: '[Clark] was a much better choice in personal terms: politically uncommitted, popular with the quality press, and with proven ability in the field of management in the arts as a result of his work as Director of the National Gallery. He was also – and this was his main asset – fashionable in intellectual circles, in fact he was regarded as one of the most brilliant younger stars of the artistic and literary establishment.'[42] The most dynamic period, however, at least in terms of documentary films, did not take place until Jack Beddington, whom Clark had brought in, replaced him in April 1940 as head of the Films Division. Clark was promoted to Controller of Home Publicity, then head of Planning, finally leaving the ministry in August 1941, pushed out by Bracken when the latter became Minister of Information.

Clark's attitude is suggested in his own accounts of his experience in the ministry. As he remarked, with perhaps excessive insouciance, more than

thirty years later: 'It was a perfectly useless body, and the war would have been in no way affected if it had been dissolved and only the censorship retained.'[43] The rapid change-over of not particularly effective ministers also hampered the ministry in its early years. First there was Lord Macmillan, an eminent Scottish jurist who had served in the ministry during the First World War, but who was hopeless in the control of news, which after all was the ministry's major task. Sir John Reith was minister from January to May 1940. He was the powerful founding director of the British Broadcasting Corporation, but a famously tactless and ruthless man. (Chamberlain had wished to replace Macmillan with Hore-Belisha, who had ceased to be Secretary for War in January 1940, but Halifax thought it would be a mistake to put a Jew in the position!) Reith believed in cowing his subordinates but, although as the founder he may have been able to do this at the BBC, the independently minded individuals at the Ministry of Information were hardly likely to be co-operative. Clark, who took to him because he 'was so crazily independent of all accepted opinions', nevertheless reported the following conversation:

Reith: 'You have an independent income.' I admitted that I had. 'That's bad,' he said. I answered that both William Morris and Ruskin had independent incomes, and without them literature, design and the socialist movement itself would have been much the poorer. 'It's all right for you,' he said, 'but it's not so good for me. I can't get you to obey me so easily.'[44]

As the appointment of Clark indicated, Reith, whose own proclivities at the BBC were certainly élitist, favoured the documentary over the commercial film-makers. He reorganized the Films Division in April 1940, appointing Jack Beddington as its head, a position he would retain until 1946. Beddington had Sydney Bernstein as his adviser, and that in itself signalled a combination of the documentary and the commercial traditions. The Films Division became far more active than it had been. Beddington's appointment was a further triumph for the documentary tradition. Educated at Wellington and Balliol College, Oxford, Beddington had been the director of publicity for Shell and as such had been responsible for a large film unit. (In 1936 Jennnings had made *The Birth of the Robot* for Shell.) Beddington brought in the eminent documentary

figure Sir Arthur Elton. Thorpe and Pronay emphasize the class aspect of it all, pointing out that Elton was a baronet and had been educated at Marlborough and Jesus College, Cambridge.

> By background, personality and manner he was singularly well qualified to harmonise the high-minded approach of most of the 'production' divisions of the reconstructed Ministry of Information with the documentary movement. . . . The principle behind the earlier policy was that the cinemas were the places where contact could be made with the maximum number of people who could not otherwise be reached. The new documentary-inspired policy placed maximum emphasis on developing a non-theatrical distribution system for their films which, it had to be realised, could not even in wartime be forced upon the cinemas.[45]

This was not necessarily ineffective, as Roger Manvell notes:

> During the period 1940 to mid-1945, I was responsible in wartime Britain for the organization of a hundred or more screenings a week of Ministry of Information films, first (1940–43) in the southwest region of Britain and later (1943–45) in the northwest region. This amounted in all to some 25,000 showings, and in a high proportion of these I would always include, one by one, a film by Jennings as soon as they became individually available. . . . The public screenings lasted normally from half an hour (two or three shorts), screened by our mobile projectionists in factories during meal breaks, to ninety minutes or more (five or six shorts) for afternoon or evening shows designed for general audiences (women's institutes or guilds, for example) with halls available (however small) in town or village. Special screenings were given (often on Sundays) in local theaters when not in use for normal exhibitions. Such screenings permitted longer films to be shown, such as *Fires Were Started*, which otherwise were shown in regular cinema programs.[46]

Helen Forman has remarked about non-theatrical distribution of films during the war: 'It was estimated that in the 12 months ended August 1942, an audience of 12 million was reached.'[47]

A parliamentary committee on expenditure recommended against this

new policy, but a compromise system was worked out that combined the best of both approaches. The left-wing tendencies of the documentary makers were not completely suppressed, but both commercial film-makers such as the Boulting Brothers and Asquith and documentary makers such as Rotha and Watt were able to make films. For instance, John Boulting made *Journey Together* for the RAF Film Unit, with a cast including Richard Attenborough and Edward G. Robinson.[48] The documentary tradition may have restricted the numbers who saw the films, or enjoyed them, but on the other hand the audiences were far larger than those who had seen such films before the war. The documentary film-makers had established a particular British style which, because of the war, became far better known.[49]

In August 1940 Ian Dalrymple, a commercial film director, took over as the producer for the Crown Film Unit. He replaced the distinguished Brazilian Alberto Cavalcanti, probably for xenophobic reasons. 'The Unit could get on with *making* the films, while I would fight for facilities, conditions and opportunities.'[50] As Thorpe and Pronay remark, and they are not, on the whole, sympathetic to the documentary side: 'Under his [Dalrymple's] patient, highly professional, yet sensitive guidance, the Crown Film Unit produced a matchless series of films, the best of which, in the tradition of Renaissance art, elevated good propaganda of the moment into lasting works of art.'[51]

When Winston Churchill came to power in May 1940 he appointed Duff Cooper Minister of Information. He was not a success, the chief memory of his ministry being investigators who were nicknamed 'Cooper's Snoopers'. Churchill remarked that he had harnessed a thoroughbred on to a dung cart. Duff Cooper felt that it was an impossible situation. 'The main effect was that there were too few ordinary civil servants in it, and too many brilliant amateurs.... I appealed for support to the Prime Minister. I seldom got it. He was not interested in the subject. He knew that propaganda was not going to win the war.'[52] Duff Cooper 'had the political experience that Reith so conspicuously lacked, but with his graceful intelligence had a low opinion of the "common man" and was almost less well qualified than Reith to placate the press'.[53]

Harold Nicolson became Duff Cooper's parliamentary secretary. The Ministry of Information thus had in prominent positions two of the most mandarin figures in English society at the time: Harold Nicolson and

Kenneth Clark. Clark was probably more effective than Nicolson. As the former remarked about the latter: 'There was a curious air of futility in Harold. He had absolutely no gift for politics at all and was equally useless at what one might call the preliminaries of politics, meetings, interviews etc.'[54] Nicolson himself sensed this in his own way. As he wrote in his diary about a dinner with Clark: 'He says that it is a mistake for people like ourselves to imagine that people not like ourselves will see things in the same proportions. He says that we ought always to keep our technique enclosed in a small circle and to adopt another technique for people outside. I hate that sort of thing. I refuse to be all things to all men.'[55] As Nicolson's biographer remarked about the ministry: 'seldom have so many literary intellectuals been assembled under one roof. For them to pull in harness at such a time was a lot to expect. And they did not pull in harness.'[56] In any case, both men left the Ministry of Information, Nicolson being asked to resign in July 1941 so that his post might go to a Labour MP. Nicolson was bitter, feeling rightly that his political career was over. As he wrote in his diary in grand fashion: 'Omnium consensu capax imperii nisi imperasset.'[57]

Brendan Bracken, who had Churchill's confidence, came into office in the summer of 1941. He had been Churchill's parliamentary private secretary, was a close personal friend and disciple and was the first Minister of Information to have an intimate knowledge of Fleet Street. He also had an excellent staff: Sir Cyril Radcliffe as his Director General and two able secretaries, Alan Hodge and Bernard Sendall. The history of the ministry has been excellently told in Ian McLaine's *Ministry of Morale* and need not be repeated here. However, it should be borne in mind that the traditional tensions of British society – the amateur versus the professional, the higher intellectual values as opposed to the immediately effective ones – that dogged the ministry in its operations also played a part in the history of the films made during the war. We are interested in *Fires Were Started* as it reflects the achievement of, and commitment to, humane values in wartime, but the tensions between the documentary and commercial traditions, as well as other tensions at the ministry, would have an effect upon that film, as we shall see.

In 1941 the GPO Film Unit – a group of about seventy – was moved to the ministry and renamed the Crown Film Unit. Jennings had continued to make films dealing with the war for the GPO such as *The First Days* and

Spring Offensive. The best-known of this early group, *London Can Take It*, co-directed with Harry Watt, was completed in 1940. A ten-minute film made largely with an American audience in mind, it was narrated by Quentin Reynolds. Sydney Bernstein, subsequently the great British television mogul, arranged for its screening in the United States. On 25 October 1940 Nicolson recorded in his diary that the film was a 'wild success' there and made £11,180.[58]

Once the documentary film-makers came to the ministry their facilities expanded, most notably with their use of Pinewood Studios, closed since 1939. (In September 1940 Jennings sent his wife and two daughters to America, and in 1941 he moved to Dalrymple's house near Pinewood.) There was valuable cross-fertilization between the commercial and documentary film-makers. Writing of this *rapprochement*, Basil Wright, an important figure in the documentary movement, observes:

> This is frequently described in terms of one way traffic, with the feature people learning realist techniques from the documentarists. But the boot was also on the other foot. When the Government took over the then largest studio in Britain – Pinewood – and there installed the Crown (ex-GPO) Film Unit, together with the film units of the Armed Forces, a lot of documentary-makers grabbed with joy at the elaborate film-making facilities available there.... In the end, however, the two elements achieved a good balance. Documentary had always *some* studio facilities ... and the feature men, by having to face wartime realities in order to convince not only Government officials but also the general public, who were in the course of experiencing those realities, learned not only extra values from location shooting but also how to achieve greater verisimilitude in the studios themselves.[59]

The three major films that Jennings made before *Fires Were Started* – *Heart of Britain*, *Words for Battle* and *Listen to Britain* – were all quite short. They were all important in building up his skills and providing experience for the group who would presently work on *Fires Were Started*. All three films were produced by Ian Dalrymple, and on all three Stewart McAllister was the editor – on *Listen to Britain* he was also co-director.

In *Heart of Britain* there are the juxtapositions and the use of music that would be a prominent part of Jennings' films. This film is deliberately set

outside London. There is a visit to blitzed areas in the Midlands and the North and, among other scenes, shots of a Yorkshire choral society singing the 'Hallelujah Chorus' from Handel's *Messiah*, and the Hallé Orchestra in Manchester playing Beethoven's Fifth Symphony. (It is striking that, in contrast to what had happened during the First World War, German music was not banned in Britain; in fact, at least in America, the first bars of the Fifth ('V' in Morse code) became a symbol of Allied victory. And indeed the Hallé Orchestra had been formed in Manchester under the influence of Germans who had settled in the city generations before.) Echoing Jennings' interest in the development of industrialization, the film showed Britain as a great industrial nation. It made a point of paying attention to the North, generally short-changed in cinematic depictions of Britain; it emphasized that the British people, though slow to anger, were determined to win; and there was a continuing emphasis on the importance of the preservation of culture, indeed in this case German culture, even if it had been domesticated by the British – Jennings wrote to his wife in January 1941; 'People are singing Handel and listening to Beethoven as never before.'[60] The narration in the film concludes, with the 'Hallelujah Chorus' in the background: 'These people are slow to anger, not easily roused. . . . The Nazis will learn . . . that no one with impunity troubles the Heart of Britain.'[61]

Using the 'Hallelujah Chorus' at the end of the film raised some problems, although not of nationality. The question was how uplifting a documentary should be – this indicates the differences between the more realistic Grierson tradition and the poetic approach of Jennings. In March 1941 he wrote to Cicely Jennings: 'I have been accused of "going religious" for putting the Hallelujah Chorus at the end. . . . This of course from Rotha and other of Grierson's little boys who are still talking as loudly as possible about "pure documentary" and "realism" and other such systems of self-advertisement.'[62]

Words for Battle consisted of readings by Laurence Olivier of great English-language texts by Camden, Milton, Blake, Browning, Kipling, Churchill and Lincoln. They were coupled with shots of evacuees, the land, convoys, young fighter pilots and bombed buildings, suggesting the eternal values of the country while depicting its suffering because of the war. Roy Armes, in *A Critical History of the British Cinema*, noted that *Words for Battle* 'fuses the literary heritage of Blake, Browning and Kipling with

the words of Abraham Lincoln and Churchill and moves on to the music of
Handel and shots of ordinary men and women, depicted implicitly as heirs
to this great tradition'.[63] The film began with Handel's Water Music.
Jennings wrote to his wife in America about filming that sequence:

> Queer life: we were recording Handel's Water Music (of all things) the
> other night at the Queen's Hall with the LPO – and the sound comes out
> from the loudspeaker with the sound-truck in the street. Near the end of
> the session there were 'chandelier' flares overhead – lighting up the sky –
> and music echoing down the street: the planes booming and the
> particular air-raid sound: people kicking broken glass on the
> pavement.[64]

As it happened, this was the last recording the London Philharmonic
Orchestra made – it lost its instruments shortly thereafter in an air raid.
Jennings himself was quite pleased with the film. He told his wife, '[It]
sounds very highbrow and queer but although it might well have been we
chucked ourselves into it pretty deep and the result turned everybody's
stomach's over and was a huge and quite unexpected success in theatres
here.' In the same letter he talks about the general wartime situation, and
his own: 'Thanks to the Russians, thanks to the RAF and the Navy, thanks
to Roosevelt and thanks especially to luck the situation here – I mean the
civilian situation after two years of war – is really remarkably good. . . .
Reading [Silone's] Fontamara and Moby Dick. Painting a picture of
Walberswick. Writing a poem about Lanark. Making a film as I said about
music (Mozart and Roll out the Barrel.)'[65]

In 1942 Jennings, in collaboration with Stewart McAllister, made *Listen
to Britain*, considered the first of the trinity of his major films, the other two
being *Fires Were Started* and *Diary for Timothy*. It was twenty minutes long;
Heart of Britain had only been nine minutes, and *Words for Battle* eight. In
Listen to Britain Jennings' technique, so influenced by surrealism and Mass-
Observation, was now even more finely honed. It had become unmistak-
ably his, and was a far cry from the usual newsreels of the day. There is no
narration, other than a spoken foreword by Leonard Brockington, who
urges the viewer to hear the music of Britain at war, the war song of a great
people. Thereafter, the film is a succession of images, each fitted to
appropriate music, from 'Roll Out the Barrel' to 'Rule Britannia'.

Interspersed are the sounds of nature – wheat rustling in the wind – the roar of aircraft. There are exhilarating moments, sometimes of an extraordinary poignancy, including a shot of a woman singing at a piano in an ambulance station. And there are memorable glimpses of women factory workers, their hair carefully protected, singing along to the popular music from the Tannoy, the muzak of the day. Merely to provide a list of the shots in the film fails to make clear its poetic power; it is both a film of strong artistic merit and, in the finest sense, a work of propaganda. It conveys the strength of character of the British as well as their activities in the war effort. 'On film ... Jennings' cleverness was transfigured into eloquence and lyricism. ... His learning, his sense of history, his poetry, his eye for transcendent analogies, his recurring images, even his taste in music now served a purpose.'[66]

As the film recorded, amusements still continued, both for the factory workers and for those who came to the lunch-time concerts at the National Gallery. Shown in the film is one of the most celebrated examples of the preservation of culture: Myra Hess playing Beethoven, and at this particular (staged) concert in the presence of Queen Elizabeth and Kenneth Clark, who had arranged the concerts. Clark later recalled the first of Hess's concerts: 'The moment when she played the opening bars of Beethoven's "Appassionata" will always remain for me one of the great experiences of my life: it was an assurance that all our sufferings are not in vain.'[67] After the 'Appassionata' Hess played her arrangement of Bach's 'Jesu, Joy of Man's Desiring'. Clark remarked: 'I confess that, in common with half the audience, I was in tears. This was what we had all been waiting for – an assertion of eternal values.'[68]

The concerts organized by Myra Hess with Kenneth Clark's support were one of the great cultural phenomena of the time. With the outbreak of war and the expectation that the bombing of London would start immediately, cinemas, theatres, concert and music halls were all shut. In early September Hess came up with the idea of noontime (actually starting at 1 p.m.) hour-long chamber music concerts at the National Gallery, with the admission price of one shilling. The concert series began on 10 October 1939; performances were given Monday to Friday at 1 p.m. until 10 April 1946; in all, the series included 698 concerts for piano, chamber groups and small orchestras. The attendance varied from 250 to 1,750 people daily, with a thousand people coming the first day, for a grand total of 824,152

people over the six-year period. Myra Hess herself performed 146 times. It is striking that the most popular works were those of Bach, Beethoven and Mozart, which formed a considerable part of her own repertoire, as well as pieces by Brahms, Schubert and Schumann. Quite soon the popular addition was made of a canteen that sold sandwiches, frequently prepared by Joyce Grenfell.[69]

Roy Armes has summed up the conclusion of *Listen to Britain*:

The finest and most celebrated sequence is the final one, in which Jennings moves with total assurance from an urban landscape and the sound of a B.B.C. workers' programme to the music-hall stars Flanagan and Allen entertaining in a workers' canteen, then on without pause to a Myra Hess concert before the Queen in the National Gallery. Next the music carries us out into Trafalgar Square and to the docks, before being drowned in the noise of a tank factory. These latter sounds give way in turn to a military band, and then an unseen choir sings 'Rule Britannia' over images of urban and rural landscapes. The transitions are breathtaking and the effect of such fusing together of the most varied material into a single rhythmically linked passage is to lift the film above mere observation and allow the images to take on a full symbolic meaning. Jennings's film becomes in fact a meditation on British values asserted against an enemy who is never named. [It is characteristic of Jennings that there is almost no reference in his films to the enemy. It is positive propaganda.] The director's personality is concealed behind the use of the most of the most public of imagery (the National Gallery denuded of paintings [while at the same time people are shown looking at an exhibition of war pictures there], the statue of Nelson, etc.) in a context in which war seems almost a natural disaster which fosters a single spirit of unity binding the whole people together. Thirty-five years later the film still seems marvellously exact, not necessarily of the situation as it actually was, but of the way in which Britons felt it to be — a crystallization of the myths which gave the country its incredible powers of resistance.[70]

It was particularly appropriate that the filming of Myra Hess playing the Mozart concerto should have taken place in June 1941, before Russia or

the United States had entered the war but when nevertheless the Blitz appeared to be over and Britain, even if alone, was unlikely to be defeated.[71]

Gavin Lambert remarked that the film's technique 'is based completely on the power of association. . . . The sounds and images, in themselves and their different contexts, bring back a particular time and climate with almost overwhelming aptness. . . . ordinary people . . . without a trace of patronage or caricature.'[72] The film captures the quintessence of what one thinks of as the British character: the understatement that masks an unyielding determination. Jennings projected the same message in an even more effective way in his next film, *Fires Were Started*.

<center>| ❖ | 3 | ❖ |</center>

There were shots of the effects of the Blitz, which had started with a vengeance in September 1940, in Jennings' early films for the Crown Film Unit, *London Can Take It* and *Listen to Britain*, but neither of these films had made the Blitz its central concern. It was only in 1942, in *Fires Were Started*, when the Blitz was over, that he celebrated the resistance and response of ordinary Englishmen and women to that extraordinary event.

In the spring of 1941 he wrote a series of poems on the theme of 'I see London' that captures the city in the Blitz:

> I see London at night
> I look up in the moon and see the visible moving vapour-trails invisible
> night flyers
> I see a luminous glow beyond Covent Garden
> I see in mind's eye the statue of Charles the First riding in double
> darkness of night and corrugated iron
> Over the corrugated iron I see wreathes of fresh flowers
> I see the black-helmeted night and the blue-helmeted morning
> I see the rise of the red-helmeted sun
> And at last, at the end of Gerrard Street I see the white-helmeted day,
> like a rescue man, searching out of the bottomless dust the secrets of
> another life

I see the great water of Thames like a loving muse, unchanged unruffled,
 flooding between bridges and washing up wharf steps – an endlessly
 flowing eternity that smoothes away the burning sorrows of beautiful
 churches – the pains of time – the wrecks of artistry along her divine
 banks – to whom the strongest towers are but a moment's mark, and
 the deepest-clearing [?] bomb an untold regret
 (April 1941)

I see a thousand strange sights in the streets of London
I see the clock on Bow Church burning in daylight
I see a one-legged man crossing the fire on crutches
I see three negroes and a woman with white face-powder reading music
 at half-past three in the morning
I see an ambulance girl with her arms full of roses
I see the burnt drums of the Philharmonic
I see the green leaves of Lincolnshire carried through London on the
 wrecked body of an aircraft
 (May 1941)

I see London in sun
I see the almond-blossom along Westway announcing the summer
On a bus at Rickmansworth I see the eyes of Spain and the eyes of East
 Anglia
I see the solemn cheeks of Wren's cherubim
On the walls of the city the solemn cheeks
 splinter cheeks
of Wren's
solemn cherubim
And the calcined stone itself
Like the music of Handel
 (no date)[73]

In October 1940 Jennings wrote to his wife about the response to the
nightly air raids:

Some of the damage in London is pretty heart-breaking but what an
effect it has on the people! What warmth – what courage! what
determination. People sternly encouraging each other by explaining that
when you hear a bomb whistle it means it has missed you! People in the

north singing in public shelters: 'One man went to mow — went to mow a meadow.' [An inspiration for the scene with the song in *Fires Were Started*?] . . . Everybody absolutely determined: secretly delighted with the *privilege* of holding up Hitler. Certain of beating him: a certainty which no amount of bombing can weaken, only strengthen. . . . Maybe by the time you get this one or two more 18th cent. churches will be smashed up in London: some civilians killed: some personal lives and treasures wrecked — but it means nothing; a curious kind of unselfishness is developing which can stand all that and more. We have found ourselves on the right side and on the right track at last![74]

He wrote from Ian Dalrymple's place in Chorley Wood, near Pinewood, in Hertfordshire:

At night over the tree-tops you can see the gunfire in London. . . . The night-fighters seem to be developing: astonishing thing — dog fights at night. From the ground you can see nothing of course — except somtimes when the moon is very bright and it's frosty and you can watch the white vapour-trails of the invisible machines twisting and curling — like gigantic wisps of cotton-wool stretched over the face of the moon and the night. . . . The war makes one think not of peace but of well-being: the riches of the earth and the warmth of the sun. . . . As I write it is becoming a delicious spring evening outside — the land shining after a day of drizzle; the birds winging so slowly across the valley — one's eye is accustomed to planes as the natural inhabitants of the sky — and the rooks cawing in the big trees behind the house.[75]

A month later he wrote:

life is much the same here for the moment. Sudden savage raids on London — most of which I seem to miss — much more going on North and West which I miss altogether so far. The spring cold and windy — very beautiful days and moonlight nights. We have a better regard for the moon now as it allows our night-fighters to go up. . . . Your remarks about Wellington and Waterloo and the last twenty years very good. Excellent analysis of same thing in George Orwell's *Lion and the Unicorn*.

Still quite a bunch of 'intellectuals' here who are afraid of becoming patriots.[76]

Jennings' films were in the documentary tradition, conspicuous for their lack of plot, being devoted to juxtapositions of images and sound, effective but by their very nature not suitable for feature-length presentation. As Dalrymple remarked:

[Jennings] had the artist's gift of setting up his camera at what might be called the *angle juste*; but his films until now had tended to be a series of static images of places and persons, their effect depending upon symbolic, enigmatic and sometimes epigrammatic juxtaposition of image and sound, worked out by himself and MacAllister [*sic*] in the cutting-room. It was Harry Watt who got me to allot him an action-subject, for the good of Humphrey's soul and the widening of his scope. With qualms I followed his advice: and when the chance came to devote a feature-length film to the Auxiliary Fire Service, I offered it to Jennings. The result was *Fires Were Started* which, despite arguments over the final editing to meet the distributor's views, emerged as a happy blend of realism with poetry. And it proved that Humphrey, who was a marvellously well-organised person, was as able to handle the active as he was the static.[77]

Watt had worked in the documentary movement, co-directed *London Can Take It* with Jennings, and made an extremely successful feature-length film, *Target for Tonight*, with McAllister as his editor. One other film, *The Bells Go Down*, a commercial feature made by Ealing Studios, had dealt with the fire service and was issued after *Fires Were Started*. Clive Coultass, despite his belief that the documentary film-makers have to be viewed with caution, is extremely enthusiastic about *Fires Were Started*: 'For the historian, it is the closest one will get to a realistic portrait of the training and operation of amateur firemen during the blitz and in terms of convincing a critical spectator of its authencity, it out-stripped almost all of the commercial feature films made up to that year (1943).'[78]

What were the aims of the ministry in its film programme? The obvious ones of propaganda, but in a typically understated British way: to point out what Britain was fighting for, how the nation fought, the need for

sacrifices, and also to provide a picture of British life and character, ideas and institutions.[79] Most of the films supported by the ministry were shorts, but there were also some features such as *Fires Were Started* and support for some commercial firms (partially to indicate that the government was not trying to set itself up as a rival).

Fires Were Started was made from February to April 1942 about events that had occurred more than a year before.[80] The Battle of Britain, between the RAF and the *Luftwaffe*, had been fought from July to September 1940. At that point, Germany, having failed to establish air superiority over Britain, turned to civilian and industrial bombing, and the Blitz began. From 7 September to 2 November there were raids every night except three, and frequent raids continued until 16 May 1941, with heavy bombing being resumed in March. All told, 30,000 people were killed.[81] The Germans made 1,386 raids on the Port of London, of an average duration of one hour forty-five minutes. The last serious raid was on the night of 10 May 1941 from 11 p.m. to 6 a.m., when the House of Commons was hit.[82]

The tide began to turn with the entry of Russia into the war in June 1941 and of the United States in December 1941, but the war was far from won. In contrast to the situation during the First World War, there was no firm division between the Front and the Home Front. With the death and destruction caused by the Blitz, there was much more unity of feeling in Britain, a quiet determination to fight. However, the mood of heroism should not be exaggerated – we know from Angus Calder's *The People's War: Britain 1939–1945* and other accounts that class divisions had not disappeared and that many wartime experiences were less edifying than subsequent memory might make them. There was the famous Ministry of Information poster, with its unfortunate class implications. There was English irony, such as the remark in a Wardens' Bulletin on 1 August 1940: 'It may be a privilege to see history in the making, but we have a feeling that it is being overdone at the present time.'[83] There was the ability to turn the June 1940 defeat at Dunkirk – the loss of men, equipment and France – into a moral victory because of the remarkable rescue of the British soldiers by every conceivable craft. There was a feeling that, now the British had 'their back against the wall' and were alone, the situation was better rather than worse.

The script for *Fires Were Started* was written by Jennings with the

novelist and short-story writer Maurice Richardson. Much of the dialogue was improvised while the film was being made in the winter of 1942, but the conception of the film was firmly in Jennings' mind as early as November 1941. It was to tell of a day in the life of a fire station in dockside London, from the morning as the fire-fighters report for duty until the following morning, after a night when they have fought a serious fire in a warehouse. The firemen's objective is not only to save the warehouse but to prevent the fire from spreading to a nearby freighter loaded with ammunition. The preparations of the firemen and the loading of the ship are counterpointed throughout the day; during the night German aircraft bomb the warehouse; fires are started, fought and contained; the end of the film juxtaposes the funeral of the fireman who has been killed fighting the flames on the warehouse roof with views of the freighter steaming down the Thames.

The film was designed to honour the National Fire Service, which did not actually exist under the name in 1940, the time of the film. This accounts for the firemen in the film wearing badges on their uniforms with the acronym AFS (Auxiliary Fire Service). The AFS and the London Fire Brigade, the more professional arm, later amalgamated to form the National Fire Service; the two groups were responsible for the fire defence of London.

The Auxiliary Fire Service, consisting of 23,000 men and women, had been founded as a civil defence measure in 1938. (Perhaps because the bombing of London did not start until September 1940, the force had shrunk by half by June 1940.) The fire-fighting was heroic – and that is celebrated in the film – but in fact, under the control of local authorities, it was also frequently inefficient. The solution, after the worst of the Blitz was over, was to nationalize the service, and the National Fire Service finally came into being on 18 August 1941. By the end of the war in Europe, 327 firemen and women had been killed in action and over 3,000 injured in the London region.[84]

There are notes and treatments of *Fires Were Started* in the archives of the British Film Institute: six drafts, dating from the end of October 1941 to the end of January 1942. The film was to start with the beginning of the 48-hour on-duty period for the unit of eight firemen, the most important being No. 5, Jacko, 'A type of Cockney saint', and No. 8, the 'new boy', with an emphasis on the emotional unity of the firemen, despite their

differences in origin. The shooting of the fire was to take place at St Katherine's Docks. The *Observer* film critic C. A. Lejeune, in the Sunday *New York Times* of 2 December 1941, quoted Dalrymple as saying: 'We shall do a story of the Fire Service, founded on a staggering incident that really happened in connection with a munitions ship in danger.'

In a treatment of the story written by Jennings in November 1941, he noted: 'It will end up with one man definitely giving his life to make sure that the curtain of water is kept up between the fire and the shell dump.'[85] By January 1942 the coda was worked out:

The final sequence of the film takes place a couple of days later. The big grey merchantman dropping her pilot and nosing out in open sea – into wind and weather – and contrast it with a scene in a small churchyard on the edge of a great city – a fireman's funeral. 'Jacko's' tin hat surrounded by other seven – chrysanthemums – the coffin carried by the other seven – the sub. with his head bandaged. Other members of Red Watch. Mrs Townsend Mrs Jackson. And the bugles blowing 'The Last Post'. The bows of the great grey vessel hurrying to join her convoy.[86]

There were new treatments practically every five days in January 1942, with finally a sixth treatment at the end of the month.

On January 11 Jennings wrote to his wife: 'Now beginning a biggish picture about the Fire Brigade – now called the National Fire Service – story pic. with characters etc. So far so good. Nice chance anyway. And of course smashing chaps – the firemen.'[87] Jennings decided that there should not be professional actors, and he chose firemen from various parts of London.

In the archives of the British Film Institute in London there is a shot analysis, and dialogue, of the first six reels of the film, up to the point when the subofficer is wounded; this analysis was compiled by Alan Ross, and is presumably taken from the film itself. There is also an analysis of the film by Philip Strick in the May 1961 edition of *Films and Filming*, and a description of the film in Hodgkinson and Sheratsky's study of Jennings, *Humphrey Jennings: More Than a Maker of Films*. A discussion of some scenes may make clear how the film combined a plot and a documentary. (It may have been an exaggeration to state that 'In fact he had one sheet of paper,

with just the outline, the beginning, the morning after, the actual fire, and afterwards, and he said "And that is all the script they're getting, mate."")[88]

William Sansom, who played the role of the new man, Barrett, and went on to become a very well-known author, has written a memoir of the shooting of the film. (In 1944 he published *Fireman Flower and Other Stories*, and his most famous story of the period was 'The Wall', which dealt with fighting a fire.)

The film was begun in a bleak month early in 1942 and carried through high summer: it was begun on location among the cobbles and bricks and rafters and ruins of London dockland, by then badly bombed and finished at Pinewood Studios, with green country all around. My actor-colleagues and I were chosen from different stations all about London – none of us professional players – and seconded from fire-fighting duties for the period. It was a dull lull period, with little bombing, so this was something to do. We were all glad to be away from station routine, all rebellious that we were not paid extra for these expert duties. Humphrey thus had to deal with an enthusiastic lot who had a convenient grudge whenever necessary – ideal constituents for the British temper.[89]

In the same sketch Sansom gives a portrait of Jennings:

He gave little of his own personal life away, he talked little of himself and only of work. He worked obsessed with the job in hand – and because he never spared himself he endeared himself to his employees, though he showed few of the usual endearing qualities, and certainly neither flattery nor histrionics. He was a man of medium height, tow-haired, with sharp blue eyes, inwards-pointing teeth and the shaped but blubbery lips of a Hollander, and his neck was so straight it pushed his head forward and often to one side. He shouted awesomely, and often smiled – but with the quick fade of one who has really no time for it.[90]

Fires Were Started opens in a documentary way with a text appearing against a bas-relief of firemen fighting a fire. 'When the Blitz first came to Britain its fires were fought by brigades of regular and auxiliary firemen, each independent of the rest, linked by reinforcement. In the stress of battle lessons were learned which led in August 1941 to the formation of a unified

National Fire Service. This is a picture of the earlier days – the bitter days of Winter and Spring 1940 and 1941 played by the firemen and women themselves.' (Regular firemen were paid £3 12s a week, with an extra 10s for rent, while members of the Auxiliary Fire Service received £3 5s with allowances for meals. The general work plan was forty-eight hours on duty and twenty-four hours off. There were 30,000 members of the Auxiliary Fire Service in London, who were summoned to duty on 1 September 1939, 'Mobilisation Friday', and there were 200,000 members nationally.)[91]

The film begins with the men of the watch arriving at the station, the last to arrive being the new man, Barrett. Children are playing in the street. As the men approach the station they pass a man standing in a doorway playing a wistful tune on a penny whistle. (As Sansom recollected, he was heard by chance 'where we were shooting, and instantly co-opted'.)[92] The camera cuts to a view of the freighter being loaded, then back to the station where the men are settling down, then to the arrival of Barrett, and a cut to the ship – the counterpoint continues throughout the film. In the opening scenes life goes on in an ordinary, uneventful way, even though the period of the war depicted in the film was the most harrowing for Londoners, who had to wait through the day for the bombers at night, when they were really on the front line and Britain was fighting for its life.

The crucial events of the film take place on the night of a full moon, when a raid would be particularly likely. 'It'll be a hard night tonight. Full moon.'[93] The firemen spend the day working on their truck and carrying out a fire drill. In the calm of the day Barrett and Johnny, who has been put in charge of the new boy, go down to Trinidad Street in the dock area. Prophetically, but in the most matter-of-fact way, Johnny says: 'You know it's a funny thing about these riverside fires. When it comes to it, there's never enough water.'[94] They watch the freighter being loaded; there is no allusion to the possiblity that they might be protecting it that night. A shot of the Thames opens outward: floating above the industrial smoke-stacks on the other side of the river are billowy barrage balloons – a peaceful scene of a nation at war. Barrett and Johnny return to the station, where the group is relaxing – some playing ping-pong, some at the pool table, some stretched out on their cots reading. Then there is a practice drill; the men assemble their equipment. It is now time for them to get ready to move. The camera cuts to the freighter, then back to the station, leading to one of the most effective sequences in the film. Barrett is at the upright piano,

playing Bach; then, at Johnny's urging, he plays something the men can sing along to, the folk-song 'One Man Went to Mow', with lots of flourishes. As each member of the group enters, finishes putting on his equipment, the song is repeated with the traditional refrains of 'five men, four men, three men, two men, one man and his dog went to a mow a meadow'.[95] The song moves to a mock-heroic climax as the chief enters on the final fortissimo.

In a BBC documentary about Jennings, Norah Lee, who was a researcher for him, remarked about this sequence: 'It did then build up from there because it brought out, tied up in [the story] *all* the characters of the men.'[96] Gavin Lambert commented on this scene: 'This is an unforgettable piece of human observation, showing Jennings' talent from every angle: it is at once humorous, ironic, touching, affectionate, a scene of perfect spontaneity in itself and of strong dramatic effect in its context.'[97]

Now the night, and the serious business, is about to begin. The weather is clear – no clouds, no fog. The siren sounds, and the 'Colonel', the most serious of the group, reads from Sir Walter Raleigh's poem 'O eloquent, just and mighty death'.[98] The first explosion is heard; the various fire-fighting crews start to leave the station. Finally the unit we have come to know is sent to Trinidad Street. The explosions grow louder, closer, more frequent. By the time the unit reaches Trinidad Street fire is raging through the upper floors of the warehouse there. The real danger is that the fire will spread from the warehouse to the freighter with its cargo of munitions. As the fire roars out of control the men make their way through the smoke, hoses are unwound, ladders are positioned, torrents of water cascade through the warehouse. Barrett is sent to look for water that can be pumped into the system. At just this moment Jennings introduces one of his signatures – an ostler and his horse clopping by – a surrealist moment, surely, but a suggestion too of the timeless, historical past of ordinary English life. The film cuts back from the ostler to Barrett, who has found an abandoned barge full of water at the edge of the river. He runs back to get a hose. The pace of the film quickens. The scene shifts from the warehouse to the fire station, where the operators, with admirable calm, are at their telephones, taking calls, tracking outbreaks of fire; their most splendid moment comes when an explosion causes the lights in the room to go out temporarily and plaster to fall. An operator emerges from under a table and pushes her hair back from her face. She has blood on her

forehead. She says over the telephone in a triumph of British understatement: 'I'm sorry for the interruption.'[99]

With each minute the situation at the warehouse becomes more desperate. The chief and Jacko, fighting the fire on the roof, are joined by Barrett, who has been sent up to warn them to come down. (The filming of these sequences was quite dangerous. Barrett was supposed to be doused with water to protect him while going through the flames. By mistake, paraffin was used instead. Sansom wasn't amused.)* There is a violent explosion and the chief is wounded. Men clamber up the ladders to bring him down, but Jacko stays on, continuing to fight the flames. There is another explosion, he falls and is killed.

Jacko does not say much in the film but his expressive face, his briefly glimpsed relationship with his wife, who keeps a small shop nearby, his courage, his determination and his death make him an eloquent, emblematic figure. Later, when the fire is finally under control, a tea van appears on the scene to bring the traditional cheering cup of tea to the exhausted firemen. There is an exchange between one of the group and a new arrival that is perhaps the most intensely emotional moment in the film:

'You 'eard?'
'No, what?'
'Jacko's copped it.'
'Copped it bad?'
'He's copped it, I tell you!'

The camera moves to a shot of Jacko's widow as she listens, painfully still, to an early morning news broadcast that provides the ultimate title for the film (it was first called, and present copies are titled, *I Was a Fireman*). 'It does not appear that casualties are likely to be heavy.... in one district the attack became concentrated and several large fires were started. These, however, were successfully prevented from spreading.'[100]

*'To avoid trouble an assistant was told to empty a bucket of water over me before I went up. Unfortunately, he chose the bucket of paraffin standing about for feeding the fire. With all the smoke-smell about nobody noticed. And so I ascended through the fire drenched with fire-lighting fluid. By some miracle of flash-points – or perhaps a last exudation of Humphrey's forceful will – that lively little living torch never went up' Sansom, '*Fires Were Started*' p. 5.

Humphrey Jennings directing Myra Hess for *Listen to Britain*

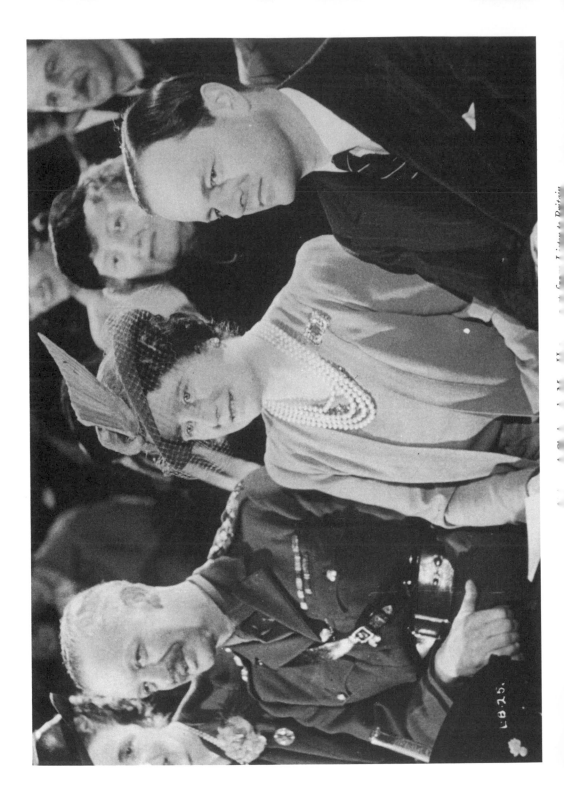

Humphrey Jennings directing *Fires were Started*

Barrett and Johnny at the docks

Barrett playing 'One Man went to Mow'

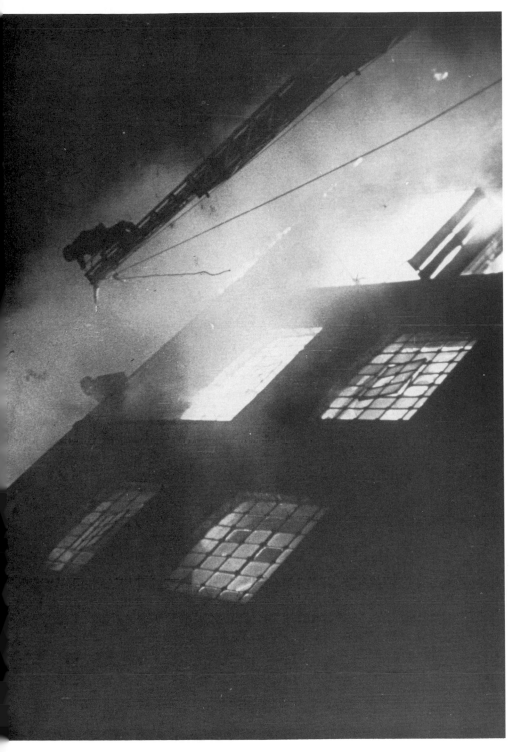

Burning warehouse

Jacko's dented helmet, surrounded by flowers on the rear of the Unit's fire truck

Back at the station the men are given more tea, and it is almost as if Barrett's receiving his mug of tea indicates his acceptance into the group, his taking the place of Jacko. Then, as a kind of epilogue, there is the counterpoint: Jacko's funeral and a panoramic shot of the ship leaving the port of London.*

Mere recapitulation cannot begin to capture the subdued grandeur of the film: its quiet heroism, the bravery of the firemen in action, the heavy destruction of the city and the sense of 'London's burning'. Or the extraordinary beauty of the images that follow one after another and that become part of our experience.

Fires Were Started was made as the tide was turning, at the 'end of the beginning', but it dealt with events in the recent past, still fresh in the minds of those who had lived through them. Its power to move us now, half a century later, testifies to the art and feeling with which it was made.

|❖| 4 |❖|

In a letter to his wife dated 12 April 1942 Jennings gave a detailed account of the making of the film:

> We have more or less taken over a small district, roped off streets, organised the locals and so on. It has been exceptionally hard and tiring work.... Of course the place and the people illuminating beyond everything. The river, the wharves and shipping, the bridge in Wapping Lane smelling permanently of cinnamon, the remains of Chinatown, the Prospect of Whitby and another wonderful pub called the Artichoke which is our field Headquarters. Reconstruction of a fire in the docks. A

*Sansom remembers this episode: 'The only revolt occurred over the funeral episode. Some of the men had already attended the real funerals of burned-up friends. They refused to carry this false coffin. Beneath this, I suspected deeper superstitions: they did not like acting in the old weed-grown churchyard, on holy ground, and among the symbols of death. They were, in fact, shocked. It took a long while and a lot of explanation before, sharp-eyed and sour for the first time, the men bore the coffin to and fro through the city weeds' (Sansom, '*Fires Were Started*', p. 7).

charming Fire-station at a school in the centre of Wellclose Square
which for all the world looks like Vermeer's view of Delft. Ridiculous
plaster rococo cherubs on the front of a blitzed house, an old man who
comes and plays the flute superbly well on Fridays, Mr Miller who owns
a chain of antique shops and specialises in Crown Derby, Jock who runs
the sailors Mission, Wapping Church mentioned in Pepys which we are
using for a fireman's funeral. And the people themselves, firemen and
others. . . . For the last two months we have been working at this down
there for twelve hours a day six days a week: we are now roughly half
way through and pretty exhausted: the results peculiar and very unlike
anything I have had to do with before: popular, exciting, funny –
mixture of slapstick and macabre blitz reconstruction. . . . It has now
become 14 hours a day – living in Stepney the whole time – really have
never worked so hard at anything or I think thrown myself into
anything so completely. Whatever the results it is definitely an advance
in film making for me – really beginning to understand people and
making friends with them and not just looking at them and lecturing or
pitying them. Another general effect of the war. Also should make me
personally more bearable. . . . The queer mixture of art-theatre stuff and
militarist training at the Perse is doing its stuff now – at least as far as I am
concerned. . . . Painting etc. I am afraid I haven't touched for months
now – but maybe when this pic. is finished I shall get back to a little.
Reading nothing. Life concerned with a burning roof – smoke fire water
– men's faces and thoughts: a tangle of hose, orders shouted in the dark –
falling walls, brilliant moonlight – dust, mud, tiredness until nobody is
quite sure where the film ends and the conditions of making it begin: a
real fire could not be more tiring and certainly less trouble. But what one
learns at midnight with tired firemen. . . . Things are having a
tremendous effect on me at the moment. Only for the good believe me –
making me much simpler and more human.[101]

On 29 May he wrote:

We are at last getting to the end of shooting the Fire picture which has
certainly taught me a thing or two. A great deal more confident –
happier dealing with people – capable – apparently – of directing funny
scenes as well as pathetic ones – capable of working inside a studio as

well as outside. . . . My (I say my but) firemen have certainly proved one thing to me, but proved it in practice – that all these distinctions of understanding and level and other such are total rubbish and worse – invented by people to mislead. And not merely the distinction made by the famous upper-classes but also those made [by] the grubby documentary boys who try to give a hand to what they call emerging humanity, the common man and so on. . . . Lately I have seen nobody. If I'm not at work on location I am at [word censored] which is miles from anywhere and very militarised anyway: a film factory.[102]

It was as if everything from his past life was coming together in the film.

I am finding more than ever that the chief problem at all times is to fit in all the worlds that exist together. The world of the day to day war – the world of the past (Suffolk, Cambridge) – the great landscapes of the USSR and USA – the rich nostalgia of France and Italy – the constant struggle of poetry and economics. . . . London – to look at – has settled down to a big village-like existence. Most of the damage demolished and cleared up. Endless allotments – beds of potatoes, onions, lettuces – in parks, in the new open spaces from bombing, tomatoes climbing up ruins – trees and shrubs overgrowing evacuated and empty houses and gardens – in some places shells of eighteenth century cottages with black blank windows and Rousseau-like forests enveloping them, straying out over the road – no railings – climbing in windows. Elsewhere the utmost tidiness and care in lines of planting on AA gunsites, aerodromes, firestations. The parks and squares open to all – all railings gone, shelters overgrown. . . . There is nothing so exhilarating as seeing even a few ideas one has long had really coming into being on the screen.[103]

From the point of view of the amateur actors as well, it was an exhilarating if exhausting experience. William Sansom remembered: 'Most of us had been through the Blitz with hardly a scratch – but in this job we all got burned, and so did Humphrey and his assistants. . . . The film was true to life in every respect. Not a false note – if you make the usual allowances for the absence of foul language which was in everybody's mouth all of the time.'[104] In the manuscript version of these remarks he

went on: 'It may be thought that, working with the men on the spot, such truth would be an inevitable result. I don't believe it. Romanticism, tricks for tricks' sake, false patriotism, militant smartness, intrusive humour and many other nuggets of Director's Delight could have crept in. But this director kept it clean, and infused the meat of realism with his own passion and intellect to make of it all a poetic work of art.'[105]

In the making of the film there was the irony of creating fires, reproducing the Blitz, and this caused some difficulties. The various authorities attempted to pass the buck in terms of giving permission, and the local residents were quite upset at first about the setting of fires.[106] Fred Griffiths played the Cockney humorist, Johnny, who is placed in charge of Barrett. This was his first film role, but he went on to have a considerable career, playing in two hundred films, among them *The Cruel Sea* and *I'm All Right, Jack*.[107] He recalled:

> Humphrey used to set that buildin' alight so much that he had the fire brigade down here about five or six times. You know, the real firemen, we had the appliances and we were all firemen, but we never had the gear to put it out. And it caused a bi' of animosity down 'ere, 'cause the lights in the sky and all 'at.... About the second night we had a deputation come down, wi' a letter, about that we were fifth columnists and we were lightin' up the sky for the Germans to come in and bomb us.[108]

Eventually, however, the local people became quite involved in the film, came by to see it being shot and even played bit parts. They became friendly in the local 'boozer', the Artichoke, which served as the film crew's headquarters.

Information concerning the more practical aspects of the filming is to be found in the papers that survive in the Public Record Office, such as the £5 fee paid to William Sansom for the rumba, 'Arrana', that he composed and played in the film.[109] There was also the question of damage done to Gooches Warehouse, The Highway, Stepney, but the fee for that was reduced from £100 to £69 10s.[110] Not surprisingly, although the film crew were fond of Jennings some of them found their director rather dictatorial. As Norah Lee remarked: 'While you were concerned with something that he was doing, he absorbed you completely into his work. And when he'd finished with this, you know, he just cast you aside completely.'[111] Sansom

records a different impression: 'Democracy the rule, Christian names all round, discussion and beer together after work – he gave us the sense of making the film *with* instead of *for* him.'[112]

Inevitably there were difficulties and misunderstandings during filming. *Fires Were Started* was the longest film that Jennings ever made, and disagreements arose between him and McAllister; this was only to be expected in the course of editing the film. One of the technicians recalled:

It was incredible the way they understood each other. . . . But they would have these disagreements over, perhaps, two frames, and I remember so well, that you go into the cutting-room, and these terrific scenes. 'You, don't you cut, grrr,' going on, you know. And Humphrey would say, insist on the two frames going back, and Mac very dour but he'd put them back, you see. . . . Mac would come back in the middle of the night and take 'em out again.[113]

There were problems with the Auxiliary Fire Service, and in April it was arranged that Commander Firebrace(!) of the service would see the film and indicate whether there was anything that he objected to. Apparently he did not demand any changes.[114] There were, however, more vexing problems with those who were supposed to arrange for the film's commercial distribution. Jennings probably felt optimistic about the distribution side, for, as he had written to his wife, *Listen to Britain* was well received in commercial cinemas both in Britain and in the United States. But this was obviously a much more ambitious undertaking.

In October 1942 eighty prints of the film were ordered and commercial managements were contacted. Difficulties began to arise in November when Lieutenant-Colonel Bromhead wrote to Beddington about his meeting with potential commercial distributors who felt that the earlier part of the film was unsatisfactory and that it would be best to move as quickly as possible to the fire sequence. He felt that it must be made clearer that it was the Volunteer Auxiliary Fire Service being depicted and not the regular London Fire Brigade: 'This in order to excuse the shortcomings of the obviously inexperienced firemen and not to let the world think that England (to quote these critics) has nothing better today to depend upon than those amateur firemen whose apparently casual methods are over-emphasised in the first half. Exception was also taken to the evident

unpreparedness of the crews while the raid was in progress and calls were coming in.'[115] As had been the case in the conflict between Air Commodore Peake and Paul Nash, the more bureaucratic minds did not appreciate the casual British heroic style that was being projected.

Beddington and Dalrymple were caught in the middle of the situation. Beddington reported to Dalrymple that the commercial distributors were very dissatisfied with the film, that Arthur Jarratt of the British circuit refused to book it in its present form, and that C. M. Woolf of General Film Distributors was reluctant to do so. Beddington, evidently summarizing their objections, wrote that 'a great deal of the beginning of the film should be cut and a narrator introduced who could both point the dialogue and give added emphasis to the value of the munition ship motif. I think he (or she) should also date the incident very clearly as having taken place two years before the new efficiency [sic] organisation of the present National Fire Service. I am afraid you and Humphrey will be very disappointed about this and I want you therefore to know that though I see no alternative I am really completely in sympathy with you.'[116]

In October there had been thoughts of having a sneak preview, and in fact there was a screening of the film in Wales; the response was enthusiastic although 'the projection, particularly the sound, was very poor and the audience was entirely Welsh and mostly "tough" (miners, etc.). The reception was most enthusiastic. The film seemed to be a revelation for most as to what had been going on in other parts of the country, despite the experience they must have had or heard of closely in Swansea and Cardiff.'[117] In early December another preview was held in Preston. The report was fairly neutral but quite misunderstood the story about Barrett and was certainly patronizing to the film; it seemed to support the doubts of the potential distributors – one of whom, Jarratt, was in fact sent a copy of the report.

> The audience reaction did not appear to be unfavourable; but, on the other hand, there were no enthusiastic comments. In conversation with members of the local press, police and fire fighting representatives, I gathered the consensus of opinion to be that the film was deplorably slow for the first half-hour (this time was taken up in depicting the boredom of the fireman's daily life, and was intended to show up by the contrast the blitz periods – unhappily audiences do not wish to be bored

these days); the blitz sequences were, on the other hand, particularly good, and even the fire authorities approved this. An outstanding error on the part of those responsible for the film was the careful building up of a character named Barrett for about half the film and then, for no apparent reason, dropping him. I would suggest that the film would make a good second feature up here, provided a good strong first feature was played with it.[118]

The prominent *Observer* film critic C. A. Lejeune was also shown the film. In her letter to Beddington, which is undated but must be from about this time, she supported the film strongly:

> In my opinion this is a film on which a stand must and ought to be made. It should be shown quickly, it should be shown widely, and it should be shown in its present form. Apart from a few small criticisms, which I have made to Crown, I think it is one of the finest documentaries we have ever made. I am quite sure it will bring prestige to the unit and to British films generally. I can guarantee that what I may call 'my' public will like it, and I have enough faith in the good heart of the wider public to believe that they will like it too. I have never known a film as honest and human as this one fail to get its message through.[119]

There was also a letter of 4 December from the film critic of the *Evening News*, A. Jympson Harman, whose response was strongly favourable: 'Here you have a film that for three-dimensional convictions, integrity and dramatic intensity, has rarely been equalled.'[120]

During this period Jennings had been away in Wales shooting *The Silent Village*, a film depicting the Lidice incident – in which the Germans had murdered the residents of a mining village in retaliation for the assassination of Heydrich, the Nazi 'Protector' of Czechoslovakia – as if it had taken place in a Welsh village. He had established excellent relations with the miners there, and he was in a radical state of mind, pleased with what he had done and therefore even less likely to be reconciled to the changes to *Fires Were Started* being demanded by commercial film interests. The Crown Film Unit had supported the project from the beginning, but the havers of the bureaucracy did complicate the situation. S. C. Leslie of the Ministry of Home Security wrote to Beddington on 15 December: 'One of our people met Humphrey Jennings the other day and

heard from him that Lejeune has seen it, thinks it the best documentary yet produced and proposes to say so as soon as it is shown. We don't really know whether the trouble is due to the trade's opinion of the film itself or to some wider issue between them and your Ministry, or a bit of both.' Beddington replied that seven to eight hundred feet were to be cut from the film. 'I am not influenced by Mr. Jennings or by Miss LeJeune, though it would, of course, be very valuable to us to get a good review from her when the film comes out.'[121]

Jennings gave his version of events in a long letter to his wife at the end of January:

> The trouble began about three weeks before Christmas over the Fire Service film – which although adored by almost everybody did not go down well with the commercial distributors – at least that was the story. They said it was too long and slow and so on. Quite likely from their point of view they were correct. In that case there was a little recutting to do and that would be that. But no. All sorts of people – official and otherwise who apparently had not had the courage to speak out before suddenly discovered that that was what they had thought all along – that the picture was *much* too long and *much* too slow and that really instead of its being the finest picture we had produced (which was the general opinion till then) it was a hopeless muddle which could only be 'saved' by being cut right down and so on. Well, of course one expects that from spineless well-known modern novelists and poets who have somehow got into the propaganda business – who have no technical knowledge and no sense of solidarity or moral courage. But worse – the opinion of people at Pinewood began to change – Ian [Dalrymple] of all people suddenly demanded what amounted to a massacre of the film – all this arising out of the criticisms of one or two people in Wardour street [the commercial film centre] – who had other irons in the fire anyway and who fight every inch against us trespassing on what they pretend is their field. In the meantime Lejeune of the Observer had seen it and said it was easily the finest documentary ever made and that to touch it would be like cutting up Beethoven!

Both Jennings and McAllister were unwell at this time, and Jennings felt that he would simply have to leave the Crown Film Unit. He was also

particularly worried about how the fight would effect his work on the current project in Wales, 'a real handshake with the working-class'. He returned to Wales 'for some final shots and I went down feeling very sick at heart and as we came into our beloved valleys and villages there it really was nauseating to compare the two Nations (as Disraeli called them) and to feel that precisely what had happened to the Fire Film was only too likely to happen to the Lidice one'.

He consulted Dai Evans, the agent for the South Wales Miners' Federation, with whom he had been working closely on the Lidice film. Evans wasn't there when Jennings returned to Wales, but left a letter for him that he had written on Christmas Day. Jennings quotes Evans in his letter to his wife, and Evans's letter itself has survived. Evans had been in London and had heard about the difficulty with the ministry and the commercial distributors, and that McAllister also blamed the trade unions. 'He has had a particular experience of trade unions at Pinewood, in what is after all, a very sheltered corner of this old world, far and remote from the maelstrom that gave rise to that great organisation, the Trade Union Movement, and formed what can be described as a completely wrong conception of the whole movement.' Evans went on to ask what more one could expect from vested interests. Yet he strongly urged Jennings not to leave Pinewood, adding that miners have known for a long time what has happened to the products of their labour.

Jennings found the letter very convincing, and it influenced him not to leave the Crown Film Unit and to do the best he could. 'So we took up again the battle of the Fire picture – got a certain amount more sense out of people and ultimately have got a sort of minimum re-cut which is at least not the massacre it was before.' In the meantime he had moved out of Dalrymple's house and into a room above the famous *Étoile* restaurant in Soho, where years before the Vorticists had congregated. (In 1944 he moved to 8 Regent's Park Terrace, the home of Alan Hutt, the Communist historian of printing who had introduced him to Welsh miners. Hutt's daughter, Jenny, worked with Jennings on *Diary for Timothy*. Jennings lived there for the next six years, his family returning from the United States in November 1944.) And he even found time when back in Wales to do readings for *Pandemonium* and continue the search for a publisher for it.[122]

Fires Were Started, cut from seventy-four to sixty-three minutes, finally opened in London in March 1943 at the Tivoli and New Gallery cinemas, distributed by General Film Distributors. A handsome brochure was produced with stills and captions that re-created the essence of the plot.[123] Although it was feared that the film would not be booked on circuit, in fact it was, and screenings around the country began on 12 April.[124] On March 24 a special screening was held at the Ministry of Information for those who had worked on the film, and the audience included such figures as Mrs Sadie Rappaport of the Artichoke and Mr Ching of Ching's Restaurant. In April the eight-man crew of the Heavy Unit put in personal appearances at the Holloway and the Hammersmith Gaumonts. The ad budget was increased from £500 to £1,000.

Reviews of the film were very favourable. *The Times* (25 March 1943) wrote: 'The film follows the tradition of the Crown Unit in telling of heroic events in a matter-of-fact manner. . . . The Crown Film Unit completes yet another film which shows its genius for interpreting the services to the world without undue emotionalism, vainglory, or false modesty. The idiom is difficult, but the Unit is its master.' The *Daily Express* (27 March 1943) was quite ecstatic: 'This picture will thrill millions of people whose minds are still scorched by the blitz of 1940–41 and the blazing times we lived through then. . . . You must certainly see this picture. You will never forget it.' There were also enthusiastic reviews in the *News Chronicle* (27 March 1943), *Reynolds News* (28 March 1943) and the *Sunday Chronicle* (28 March 1943). The *News of the World* (28 March 1943) noted that Fred Griffiths 'combines the toughness and humour of James Cagney with the quiet strength of Spencer Tracy.' Indeed, the reviews commented very favourably on the amateur actors. William Whitebait, in the *New Statesman and Nation* (3 April 1943), wrote: 'Humphrey Jennings builds up, without either hurry or failure, a drama that could not well be surpassed in excitement and intensity.' The *Manchester Guardian* (9 April 1943) said: 'the terms of the document are always modest, and spectacular only in the sense that any fire is spectacular. There is no striving after effect, no big heroics by famous stars (or their "doubles"); the camera records a straight tale in a straight way.' If the *Daily Telegraph* (24 March 1943) was less enthusiastic, finding the beginning far too slow and wanting more emphasis placed on the ship, the *Birmingham Post* (14 April 1943) was more positive: 'Strange as it might seem, Humphrey Jennings, of the Crown Film Unit, has produced

an epic of the fire-fighting service with entirely non-professional actors. . . .
The film has even gained in realism from this absence of professional-
ism.'[125]

The reputation of the film has continued to grow. Of course, it takes some
time for critical opinion to sort itself out. The *Documentary News Letter*,
which had generally taken a somewhat hostile view of Jennings' work,
acknowledged: 'Now it is the great merit of *Fires Were Started* that it does
take sides, that it is not afraid to come out with a confession of faith. Of
course there is a certain amount (too much in fact) of people answering
telephones, writing things on blackboards and moving little coloured discs
about, but that's not what the film is really about, it's about men, how they
live and how they die, how they work together on the job and how they live
together off the job.' The reviewer, differing from the *Telegraph*, felt that too
much was made of the ship and that at times the film was too 'arty', but 'what
is the real strength of the film – the best handling of people on and off the job
that we've seen in any British film. . . . Maybe for the first time we have
proper middle class dialogue on the screen. . . . At a guess, [Jennings']
success comes from keeping his people together for days on end, watching
them like a lynx and listening to them like a Mass-observer, and building up
the dialogue by rehearsing them for hours on end.'[126] The *Bulletin of the
British Film Institute*, however, was quite negative: 'With a more imaginative
reach, however, much more could have been made of the material. This film
fails to exploit the dramatic fury of acre upon acre of raging flames.'[127] So
much, then, for the immediate response: a fuller appreciation and
recognition of what Jennings had achieved lay in the future.

Jennings himself went on to make further films. First, *The Silent Village*;
then, in 1944, three more films for the Crown Film Unit: *The True Story of
Lili Marlene*, about the song as used by the Allies and the Axis during the
war (Marius Goring, Jennings' younger contemporary from the Perse
School, was in the cast); *The 80 Days*; and *V1*, about the German flying
bombs. In 1944–5 he directed the third of his best-known films, *A Diary for
Timothy*, which is a celebration of the new world in Britain that awaits
Timothy James Jenkins, born on 3 September 1944, as well as of the events
of the war that went into the shaping of his immediate past.

After the war Jennings made four more films before his fatal accident in
1950: *A Defeated People, The Cumberland Story, Dim Little Island* and *Family
Portrait* (for the Festival of Britain). All are now largely forgotten. *Fires*

Were Started, however, was on its way to being recognized as his undoubted masterpiece. In 1969 *Sight and Sound* described it as 'the highest achievement of British cinema; and Jennings is not only the greatest documentarist but also, counting Chaplin and Hitchcock as American, the greatest film maker this country had produced. *Fires Were Started* is the only British film which looks and sounds as if it came from the land of Shakespeare.'[128] This may be a touch of hyperbole, but seeing *Fires Were Started* long after the war one recognizes it as a film of extraordinary power, a combination of poetry, heroism and the ordinariness of the individuals involved, their specific human nature. Jennings achieved, as George Orwell did in *The Lion and the Unicorn*, a high form of patriotism without being soft and without betraying his commitment to the Left; he expressed his belief that some sort of revolutionary change was necessary in England. Like Orwell, few individuals could possibly be more intensely English than Jennings; and again like Orwell, Jennings was, despite his comparative poverty (he probably only earned about £8 a week at the Crown Film Unit and he had no private income), by birth and education a member of the 'lower-upper-middle class'. In the Spanish Civil War Orwell had seen what lies could come out of war, and yet he remarked about this war: 'I believe that this is the most truthful war that has been fought in modern times.' It was at this truth that Jennings was aiming.

Jennings could be both revolutionary and Churchillian in his film statements. As Roland Penrose remarked of him: 'he was certainly committed in that he felt that his activities must have some bearing, revolutionary bearing on the social situation.' But as his wife remarked in the same programme: 'I think if anybody had the spirit of Churchill Humphrey had, you know.'[129] Like so many other English radical thinkers, he combined a fascination with industrialization – his great affection for railways and his great project on the Industrial Revolution – with an abiding love of country life, of the horse, of Suffolk. He was personally austere and hard to get to know, and yet, again like Orwell and other English intellectuals of his class, he was almost desperate to get to know 'ordinary' people. They were the subject of his films. In a talk he gave about documentaries he commented:

It is well known that one of the most remarkable things that has come to everybody out of the war has been the breakdown of partitions and

prejudices, and barriers of one sort and another between individuals. To that extent war conditions have definitely helped us because it is precisely the breaking down of prejudices and partitions that documentary producers have always aimed at, and it is one of the basic aims and ideas of the documentary. That is one of the reasons for presenting people to people – that people in the audience should see people who are like themselves and that the documentary film should make clear that the people are like themselves. I have found people extra helpful and extra charming in wartime. They are living in a more heightened existence, and are much more prepared to open their arms and fall into somebody else's.[130]

At the same time, Jennings recognized the paradox of the English, that they remained intensely private and were not quite the lovable figures that they may have seemed to some during the war. In 1948 he wrote that, although the English like to think of themselves as sheep, they 'are in fact a violent, savage race; passionately artistic, enormously addicted to pattern, with a faculty beyond all other people of ignoring their neighbours, their surroundings, or in the last resort, themselves'.[131] He cited as extreme examples of the English love of pattern their affection for bell-ringing and the conversion of train carriages into a row of cottages. He also pointed out their love of the countryside and an ability to will their surroundings to be what they wish. 'The English live in cities but they are not citified. . . . They can dwell in the midst of twenty miles of paving stones and pretend, with the aid of a back green or a flower pot, that they are in a hamlet on the Downs.'[132]

Fires Were Started, unlike most documentaries, told a story and so did more than simply inform its viewers. It had its own subdued romanticism, but it certainly depicted ordinary people as they were, a fusion not found in most feature films. Jennings' genius lay in his ability to achieve the quality of ordinariness while imbuing his film with a feeling of epic and myth, perhaps because he could build upon a kind of nostalgia for the Blitz now that it was over. There is a very little feeling of enmity in the film, no signposting that the fire and Jacko's death are caused by the Germans' bombing.[133] His is almost an English national style. He had an extraordinarily detached commitment, or a committed detachment. As Gerald Noxon has remarked, he was a man of deep sentiment, but he was not sentimental.[134]

In 1954, during a Humphrey Jennings film season at the National Film Theatre in London, the reviewer in *The Times* was very perceptive about *Fires Were Started*, pin-pointing the characteristic style of this film dedicated to unheroic heroism: 'Conceived on the plane of realism, determined to show heroism without heroics, it is nevertheless alight from beginning to end with the flame of imagination. . . . It is a tribute, full of the most exact observation, to human courage not as the recruiting poster presents it but as the poet, yes the poet, understands it.'[135]

Lindsay Anderson also wrote about Jennings in 1954. He too emphasized Jennings as poet: 'It might reasonably be contended that Humphrey Jennings is the only real poet the British cinema has yet produced.' About *Fires Were Started* in particular, Anderson said: 'In outline it is the simplest of pictures – in treatment it is of the greatest subtlety, richly poetic in feeling, intense with tenderness and admiration for the unassuming heroes whom it honours. . . . No other British film made during the war, documentary or feature, achieved such a continuous and poignant truthfulness, or treated the subject of men at war with such a sense of incidental glories and its essential tragedy.'[136]

The war provided an occasion for Jennings to release his deepest feelings, but in a characteristically restrained English way. Later, in his review of Ernest Barker's *The Character of England*, he noted that the English subdue violence through a love of pattern, order and significance. In the film there is the orderliness of fighting the fire with water, two great primal elements; in effect, the firemen are subduing chaos. In the process the old hand dies and the new one becomes part of the group. The story is one of initiation, of the new man, Barrett, and the ultimate symbolism lies in his replacing Jacko. War provided a means to express a humane love for one's fellows and also to move beyond class barriers.

Philip Strick has pointed out that 'Humphrey Jennings could not operate a camera, had little experience of dramatic direction, was hopeless with technicalities. Yet his brilliant intellect, his searing intensity, his sense for visual composition, and his love for the genuine and basic emotions of the human nature, these qualities burst from him when he made a film and were embedded in it in fantastic profusion.'[137] In *Fires Were Started* Jennings was able to make a film that conveyed the humanity of, and a

compassion for, humankind under great trial. Although it was intended as no more than a routine film about one of the defence services on the Home Front – the kind of documentary propaganda asked of the Crown Film Unit – it transcended its moment and its mission. It became a great work of art, and it endures.

PART 3

❖ ❖ ❖

Benjamin Britten

|❖| 1 |❖|

MOORE'S shelter drawings, Jennings' *Fires Were Started*, Nash's paintings of the war in the air, and Sutherland's of the devastation on the ground – in each case the circumstances of wartime were essential to their creation. So too, in a very different, more complex and less specific way, was this true of Benjamin Britten's opera *Peter Grimes*, which had its first performance on 7 June 1945 at the Sadler's Wells Theatre on Rosebery Avenue, London, a month to the day after the German envoys had signed the peace agreement.

None of these works was patriotic in any obvious sense, but all were deeply English and all were intimately concerned with the country they were depicting – except in Britten's case, a country in a state of war. These particular artists, like many others, may have had doubts about their society, but in their own work they turned deeply inward, and took the English world, not necessarily without criticism, as their subject. On account of the Blitz and its continuing sequel – to 1945 – years of the flying bombs, the V1s and V2s – those on the Home Front were almost as deeply exposed to the risk of injury and death as were the soldiers on the battlefield. Since the danger was more random, not restricted to the young and able, and far less a matter of choice or obligation imposed upon certain members of the population by the state, civilians felt an intensity of experience close to that of front-line soldiers in both the First and the Second World War.

Peter Grimes does not declare itself as a work of wartime. Unlike the other works we have discussed, it is not set in the present, but rather in the early nineteenth century, the period of romanticism. Britten transposed the action from the late eighteenth century, the time depicted in George Crabbe's original poem, the opera's source. England in the early romantic

period was suffering from the turmoils of a post-French Revolutionary, post-Napoleonic World. Politics are certainly not directly reflected in the opera, but the story of an isolated fishing village takes place at a time when the country was experiencing upsets similar to those of more than a hundred years later. The changes in English society in the years when *Peter Grimes* was written and performed were as dramatic, as important and as decisive as those that occurred in the first half of the nineteenth century.

|❖| 2 |❖|

Benjamin Britten was born on 22 November* 1913 in Lowestoft, Suffolk – the East Anglian county of Constable and Gainsborough on the English coast facing the North Sea that would mean so much to Britten throughout his life. He was the youngest of four children. His parents were intensely musical, particularly his mother, who gave him his first music lessons. His father, a successful dental surgeon, believed in performing and listening to music, but not in its reproduction by radio or phonograph, a feeling that persisted in his son's dislike of mechanical music. At an extraordinarily young age Benjamin seemed destined to be a composer. He was already writing music in early childhood; in 1920 or 1921, in a play of his own devising, *The Royal Falily* (*sic*), he included a line of music, and he had made attempts at composition while taking lessons with his mother two years before.

Although Britten was in many ways an ordinary child, it was not ordinary that a musical genius should be born into the East Anglian middle class. In 1927, at the age of 14, he began composition lessons with Frank Bridge, an important composer of the time, a pacifist and a man whom Britten revered all his life. (There was a possibility that he might go on from Bridge to study with Alban Berg in Vienna, but his family would not allow it. As Britten remarked years later, 'It might have taught me how to unlock gates I did in fact have to climb over.')[1] In 1928 he entered Gresham's School, Holt, nearby in Norfolk. It was a distinguished public

*St Cecilia's Day – she is the patron saint of music.

school, if not as famous as Eton or Winchester, was known to be progressive and counted W. H. Auden among its former pupils. After two not particularly happy years there, he went on at the age of 16 to the Royal College of Music. He was in the early stages of making his mark as a composer to be watched, and he plunged into the musical and fevered political world of London in the 1930s.

It is not our purpose here to provide a biographical sketch of Benjamin Britten, but rather to dwell on those aspects of his life that went into the making of *Peter Grimes*. During the early years in London he became involved with contemporary developments in English artistic circles and was part of a group of emerging, gifted and promising figures, most notably W. H. Auden, all of whom were highly critical of English life in the 1930s.[2] After the formation of the National Government in 1931, coinciding with the dark years of the Depression, it seemed to many that it was not possible to create a satisfactory society in England. Yet this was the country where Britten was launching his precocious career. Like so many other young artists and intellectuals of the 1930s, he was unhappy with the world he discovered about him. However, he had his own sense of independence, which may be characteristic of the firmness, the tradition of disagreeing with the main social currents, historically associated with East Anglia. For quite a few of the alienated young of the 1930s this period of dissent was brief, and was perhaps more symptomatic of rebellious youth than of anything more deep-rooted. Britten, however, steadfastly held to his principles, most notably his pacifism, which in his case was not motivated by religious belief. In his quiet manner he held to his dissident views in a firmer and longer-lasting way than did many of his contemporaries. His beliefs, his music, his operas are marked by a highly attractive combination of poetry and realism. Catching this element of his character, John Evans has written of 'Britten's personal brand of verismo in which the extremes of poetic and prosaic utterance co-exist'.[3] After precocious beginnings he developed surely and strongly, establishing himself by the time he was in his early thirties as one of the dominant figures of his age and perhaps the greatest English composer of the modern period.

The young composer entered into the musical life of London; even while he was still at the Royal College of Music his works began to be performed, although, with the single exception of his *Sinfonietta*, none of his early performances were given at the College itself. He was extraordinarily

productive, not only in the traditional forms one would expect of a serious and ambitious young composer – to these years belong the *Simple Symphony, Variations on a Theme of Frank Bridge*, the Piano Concerto and the song-cycle *Our Hunting Fathers* – but also in the realm of young man's 'to-order' music. As Donald Mitchell astutely summarizes: 'It was the thirties that provided him [Britten] with just the training that quite peculiarly fitted him for the bold dramatic ventures of his later life. Seen in this context, the assurance, expertise and confidence, the sheer dramatic knack and flair, that marked *Peter Grimes* must strike one not as qualities conjured out of the air but as manifestations of techniques that had been prepared over a long period in the often gruelling environment of a film studio, cutting-room or theatre pit.'[4]

In 1934 he met the tenor Peter Pears, a member of the BBC Singers who were performing Britten's *A Boy was Born*, and the two began a life-long association. Britten was intensely individualistic, and in his vocal music he wrote for particular people; there can be no question of the great importance of this partnership with Pears for both Britten's emotional and his musical life. Many of his works, from *Peter Grimes* to *Death in Venice*, were written with central roles for Pears. One may ask to what degree this relationship, which lasted until Britten's death in 1976, affected his life and his music. As homosexuals, Britten and Pears had something of an outsider relationship to English society, since they were, strictly speaking, breaking the law. This is undoubtedly a factor in Britten's music but it should not be exaggerated. Although Britten was very much influenced by W. H. Auden for a time – Auden helped him to come to terms with his homosexuality – he did not wish to live the poet's sort of life, and he had little use for the bohemian option. In many ways Britten and Pears led an ordinary domestic existence. And yet, because the majority of the population is heterosexual, and because homosexuality was actually illegal in England at that time, their personal situation could not but have an important influence upon their lives and their work. Britten and Pears were far from being crusaders and gay liberationists, but in their own lives (and their great musical accomplishments) they may have done more for public acceptance of homosexuality (without the patronizing overtone of 'tolerance') than the more flamboyant actions of others.

It has been argued that, with his conventional background, Britten in fact felt guilty about his sexual nature, and that some of this guilt is reflected in *Peter Grimes*. That is a possible interpretation, but Ronald

Duncan, the librettist for Britten's opera *The Rape of Lucretia*, is certainly excessive to the point of melodrama when he writes in his memoir, *Working with Britten*: 'He remained a reluctant homosexual, a man in flight from himself, who often punished others for the sin he felt he had committed himself. He was a man on a rack.'[5] Britten was unlike those creators who happen to be homosexual and whose sexuality seemingly has little to do with their work, but as Hans Keller, more judicious than Duncan, observes, 'Britten's homosexuality had a beneficial influence on his art because it gave him insight into areas of the psyche that he might not have had access to without it. Thus his so-called abnormality was in fact useful to him as a composer: it enabled him to chart territory he would not have otherwise approached.'[6] In his music, notably in the operas, and particularly in the first, the middle and the last (the three 'grand', non-chamber operas) – *Peter Grimes, Billy Budd* and *Death in Venice* – the theme of being an outsider and implicit homosexual elements (the relationship between an older and a younger man) are present and cannot be simply ignored. There is a progression in the homosexual theme: it is possible in *Peter Grimes*, probable in *Billy Budd* and unmistakable in *Death in Venice*. Britten's attitude towards his homosexuality may well have been a factor in his vision – so important in *Peter Grimes* – of society as persecuting, intolerant of the deviant. It may also account in part for the extraordinary transformation of Peter Grimes from the undoubted villain of Crabbe's poem into the ambivalent 'hero' of the opera.

Although he was not a Quaker, there was almost a Quakerish quality to Britten's pacifism, an element of quietism. (Probably the greatest influences in shaping his pacificism were Frank Bridge and the commitment to pacificism of many of Britten's friends of the 1930s.) At the same time, however – and this is very clear in *Peter Grimes* – there is the theme of violence, the 'fear within us all'.[7] Certainly the 1930s, when he was at his most political and was coming to terms with his sexuality, were troubling times for Britten. They climaxed in his long visit with Pears to the United States between 1939 and 1942.

However, before a further consideration of Britten's pacifism and his trip to the United States – both crucial aspects in the making of *Peter Grimes* – the composer's highly varied musical activities during the 1930s should be mentioned. They help to account for the extraordinary versatility of his music, his willingness to turn his hand to almost any style. These works of

his twenties are now being reassessed, or in some cases made available for the first time, and are astonishing in their fertility, variety and richness.

The two crucial events in bringing Britten out of himself and introducing him to a wider world were his work for the GPO Film Unit (then under the direction of John Grierson) and his meeting with W. H. Auden, who was to remain an important influence until the early 1940s. Britten began to work for the GPO Film Unit in 1935, scoring such films as *Coal Face* and *Night Mail* (with a text by Auden), and more than twenty other documentaries. He also wrote the score for a feature film, the thriller *Love from a Stranger*, in 1936; incidental music for J. B. Priestley's *Johnson over Jordan* in 1939; and music for radio programmes, including one on Chartism and another on the legend of King Arthur. As he declared in 1946, 'I maintain strongly that it is the duty of every young composer to be able to write every kind of music – except bad music.'[8]

In the spirit of the left-wing 1930s Britten was also closely connected with the Group Theatre, providing music for several productions, among them the Auden and Isherwood plays *The Ascent of F6* and *On the Frontier*. In his memoir, *Drawn from the Life*, Robert Medley, one of the founding members of the Group, has given a lively picture of Britten at this time:

> The first music Britten composed for the theatre was for Nugent Monck's production of *Timon of Athens*, given at the Westminster Theatre as part of our new season in December 1935. Thereafter Ben became composer extraordinary for the Group Theatre, creating music for the subsequent Auden–Isherwood plays as well as for Louis MacNeice's *The Agamemnon of Aeschylus* and *Out of the Picture*. Ben was always generous with his time and his talents. Like Wystan [Auden] he could produce brilliant things at short notice, and he was always willing to give advice and help out; for *On the Frontier* he not only wrote the music and conducted the choir, but personally found the two first-rate horn-players that his music required, and played the piano: all this for no payment whatsoever. . . . He gained invaluable experience in working for a living theatre, improvising and making things in close collaboration with other artists within the limitations of a given script and production schedule.[9]

The Group Theatre was rather mildly left-wing; Britten was also involved in more strongly left-wing activities with Montagu Slater, the poet, playwright and editor of *Left Review*, who was then a member of 'the

Communist Party and was also working for the GPO Film Unit. (He would be the librettist for *Peter Grimes*.) Britten wrote the incidental music for a play by Slater *Stay Down, Miner*, performed at the Left Theatre; and for a three-minute pacifist propaganda film made by Paul Rotha in 1936, *Peace of Britain*, which the Board of Censors made an abortive attempt to block, giving it a great deal of publicity. (Rotha regarded the music as 'perhaps the best thing in the film.')[10] In 1937 Britten composed *Pacifist March* for the Peace Pledge Union; and in 1938, music for chorus, *Advance Democracy*, to a text by Randall Swingler, who was also an editor of *Left Review*. In April 1939, the month before he left for North America, he composed *Ballad for Heroes* to Swingler's text for a festival of Music for the People at the Queen's Hall. As Donald Mitchell has written: 'One might interpret *Ballad for Heroes* ... as Britten's farewell to more than his native land. *Ballad for Heroes* was the last politically engaged work of its kind he was to write.'[11]

He was to turn away from his more explicit form of political expression, so much a matter of the times in the 1930s when politics seemed simpler. It appeared essential then to Britten, Auden and their friends to be committed to the Left. If anything, Britten was probably more serious and more left-wing in his political views than Auden, but in an interview in 1963 Britten demonstrated that he had changed his political stance – he was no longer as specifically engaged as in the 1930s, although his basic concerns remained the same, and he was always to remain moderately left-wing in his politics. The interviewer asked him, 'At one time your political sympathies were quite clear. There was no mistaking your position during the Spanish Civil War. Are your political persuasions unchanged today or would you describe yourself as a-political as far as practical politics go?' Britten replied: 'Politicians are so ghastly, aren't they? After all, the job of politics is to organize the world and resolve its tensions. What we really need is more international technicians, artists, doctors. Political institutions ought to have shown signs of withering away by now. My social feelings are the same as they have always been. I disbelieve profoundly in power and violence.'[12]

Probably the most vivid collaboration between Auden and Britten in the 1930s was the grimly brilliant symphonic cycle for voice and orchestra *Our Hunting Fathers* (1936). It deserves a landmark place – although even now its significance is not fully recognized – in the music of that ill-fated decade. The cycle, consisting of five poems – two by Auden himself, a rather enigmatic prologue and an epilogue, and three others chosen by him, among

them the astonishing 'Hawks Away' by the sixteenth-century poet T. Ravenscroft – has as its overt unifying theme man's relationship with animals. But, as the composer Colin Matthews points out, 'What is evident at once is that here is no animal-loving sweetness, rather the poems are chosen to demonstrate man's inhumanity to the animal world, and by transference, man's inhumanity to man.' Yet, Matthews adds, 'the texts are not in themselves particularly provocative; it is the way Britten sets them, deliberately exaggerating or understating the surface meaning that is so disconcerting. Audiences and critics alike at the first performance felt themselves under direct attack – the critic of *The Times* hoped that it represented a stage which the composer would "safely and quickly get through".'[13]

The failure of the first performance of *Our Hunting Fathers* – there was a BBC broadcast of the work in April 1937, no other performance until 1950, and inexplicably few since then – was a great blow to Britten. He had been justly pleased with what he had accomplished and thought it was truly his Opus 1 (in fact it is listed as Opus 8); hence the pain of its rejection was all the greater. However, he heeded the consolatory advice of Frank Bridge, who had attended the first performance and heard the 1937 broadcast: 'It is extremely hard to bear, but one *must* & I suppose *does*, anyway.'[14] Immersed as he was in the breadth of a journeyman-craftsman's work, he allowed this extraordinary achievement to fade into oblivion. It is possible, however, that the act of forgetting burdened him more than he recognized. The three years before he left England for America include five works to which he assigned opus numbers. Outstanding among them are Opus 10, *Variations on a Theme of Frank Bridge for String Orchestra*, and Opus 13, Piano Concerto No. 1. Yet one senses a pause, the kind of adventurous glow that inspires *Our Hunting Fathers* waiting to be rekindled. Whether explained as a consequence of his leaving England or of his coming to America, there was to be a renewal of creative energy that would reach a climax in 1945.

|❖| 3 |❖|

Peter Pears and Benjamin Britten gave their first recital together in 1937 in Cambridge in aid of medical relief for the Spanish Loyalists. It

marked the beginning of one of the great collaborations in musical history.

Pears was born in 1910 in Farnham, Surrey, to a professional family that moved around a lot – they never actually owned a home – and he did not have Britten's identification with one county. He, like Britten, was the youngest child in his family. His father, a civil engineer, designed railways around the world and had spent a great deal of time in India. Pears attended Lancing, a distinguished High-Church public school, and spent a year as an organ scholar at Hertford College, Oxford. Afterwards he taught at his preparatory school for a few years before joining the BBC Singers.

Pears, like Britten, was a pacifist. In the early 1930s anti-war feeling in England was in full spate, but after Hitler came to power in January 1933 a strong and opposite sentiment gradually arose. On the one hand, there was the prospect of war, the unthinkable; on the other, Fascism was threatening all of democracy's most cherished values. Many on the Left were caught in the dilemma of hating both war and Fascism. Particularly at the time of the Spanish Civil War, when Hitler sent squadrons of bombers to support Franco in his rebellion against the Republic, it seemed clear that the Nazi movement could only be stopped by force. As we have seen, Britten, like so many of the Left in England, wanted to help the Republican cause. Nevertheless, he remained a dedicated pacifist and it was logical therefore that he should aid medical relief, not the actual military effort.

Attempting to resolve the dilemma – how to be against war *and* Fascism – may have been one of the cluster of reasons why Britten and Pears left for the United States. On 12 March 1938 Britten wrote in his diary: 'Hitler marches into Austria, rumour has it that Czecho.S. & Russia have mobilised – so what! War within a month at least, I suppose & end to all this pleasure – end of Snape, end of concerto, friends, work, love – oh blast, blast, damn.'[15]

The shameful Munich agreement between Hitler and Chamberlain in September 1938 was at least a delaying tactic. While peace lasted, however, it did not seem unreasonable to Britten and Pears to follow their friends Auden and Isherwood, who had left some months before, to America. With Nazi Germany looming as an ever more menacing threat to civilized values and democracy, believers in pacifism would find it increasingly difficult to hold to their pacifist position. The anti-war/anti-Fascist dilemma carried with it a damaging question: if England went to war, then what?

It could be argued that the pacifist commitment was a crucial element for Britten and Pears in their attraction to Peter Grimes as an outcast from his society. The community – the Borough in the opera – like Middlemarch in George Eliot's novel, has the power to impose its own values on those anxious to go their own way. As Britten would later write:

> A central feeling for us [himself and Pears] was that of the individual against the crowd, with ironic overtones for our own situation. As conscientious objectors we were out of it. We couldn't say we suffered physically, but naturally we experienced tremendous tension. I think it was partly this feeling which led us to make Grimes a character of vision and conflict, the tortured idealist he is, rather than the villain he was in Crabbe.[16]

The influence of Auden was immense, particularly in drawing Britten to America, so much so that when Britten outgrew him he turned somewhat against him, as if Auden represented a father figure who had been extremely important but then needed to be rejected. Towards Britten, Auden was an odd mixture of intellectual bully and firm-minded nanny. He had come to the conclusion that the roots of England – dead for him – were suffocating his art (although some have argued that the change in his poetry once he had emigrated to America was not entirely to its advantage). In order to realize himself as a poet he needed to be an exile, to live in the comparative anonymity of America, and ultimately he became an American citizen, though not anonymous. Britten would come to the directly opposite conclusion: that he needed his English roots in order to fulfil himself as a composer.

Britten and Pears left for the United States in May 1939. At first America proved to be exciting – an important break from things English, a place that would put England in perspective. Originally, their plan was to return home in August, but in the event they stayed for three years. When war was declared in September 1939 Britten's sister Barbara sent a cable reassuring him that all was well and advising him that he need not return. He replied immediately:

> You can't tell how glad I was to get your wire and to know that you are well. . . . So far I am taking your advice because (a) I hear that we are not

wanted back (b) if I come I should only be put in prison – which seems silly, just to do nothing and eat up food. I am staying with friends of Peter's near New York and as far as possible am having a good time. Thinking of you simply all the time, too; the papers & radio are hysterical of course and one feels chronically sick about the whole thing. I've seen & am seeing Auden a lot, & our immediate future is locked with his, it seems.[17]

The question of whether or not to return to England was not urgent in the protracted months of the phoney war, but it was quiescently and obstinately under the surface of his crowded American life. After the fall of France in May 1940 and the subsequent Battle of Britain, it came closer to the surface. In an interview in the *New York Sun* in December 1940, Britten was depicted as anxious to return when needed but also as being courageous in his way by staying in America:

He's been told he will be sent for when and if he is needed. Apparently England has taken to heart the lesson of the last war, in which so many of her musicians were lost, and it is encouraging to know that even nations fighting for their existence are thinking of their cultural and artistic futures. Certainly a man like Britten is of far greater value as a composer than he could possibly be as a soldier; and to go on doing his work in the comparative safety of this country, when natural emotions of patriotism urge toward physical participation in the fight for his homeland, requires a very high order of courage.[18]

This story did not take into account Britten's pacifism.

Britten and Pears did eventually return to the homeland in 1942, but their stay in the United States helped them to enter the most creative phase of their careers. It also gave Britten time to come to terms with being an outsider, out of step with his society both as a conscientious objector and as a homosexual. While in America he was frequently unwell, subject to bouts of illness that were no doubt partially or perhaps almost entirely psychosomatic in origin, much in keeping with Auden's belief that illness was induced by the state of one's mind and emotions.

At first Britten felt that America might be a more congenial place to work; it might prove more welcoming of contemporary music than

Britain. This was another reason that had prompted him to come to America. 'I was immensely depressed about Europe. I'd been vaguely political, as we all were. . . . Europe looked finished. . . . Another thing was that it had been very hard to get started as a composer in England. My works had made a small impact, but there were never any number of performances. There had been some in New York and there were plans for more.'[19]

|❖| 4 |❖|

Britten and Pears actually began their visit in Canada. Rather oddly, given their expectation of furthering their careers – surely they intended to work in the United States? – they had only acquired visitors' visas. It meant they had to return to Canada and re-enter the United States with a new sort of visa that would permit them to work there. Merely to be in North America was stimulus in itself. While waiting in Canada, Britten composed a number of new works, most notably his Violin Concerto, which was first performed by Antonio Brosa with the New York Philharmonic under John Barbirolli in March 1940. This was not, however, a Philharmonic debut for Britten the composer. In August, when he and Pears, equipped with suitable visas, finally re-entered the United States, they arrived in New York in time to hear the Philharmonic give the first American performance of his *Variations on a Theme of Frank Bridge*.

A serendipitous moment, that, and a harbinger of good things to come. Their ultimate plans, however, still remained unclear – in this early phase they gave the impression, when writing to friends and family in England, that they were likely to be returning quite soon. But, perhaps not surprisingly, to their American friends they seemed to indicate an inclination to remain, and even after they returned to England in 1942 they were writing of an intention to return to the States.

Pears had already been in the United States twice before, on tour with the New English Singers. On shipboard, sailing to America in 1936, he had established a warm friendship with a German-Jewish refugee, Elizabeth Mayer, on her way with her children to join her husband, William, a

psychiatrist who had been forced to abandon his practice in Munich and was now on the staff of the Long Island Home, a private hospital for the mentally ill.

Although Britten and Pears would live in several places in the East, their most important base was unquestionably with the Mayers in Amityville, in Suffolk County on Long Island. (Britten, already nostalgic for the land and seascapes of East Anglia, was immensely cheered by the coincidence that he should be staying in Suffolk County by the sea.) The Mayers lived in a tiny house in the grounds of the Long Island Home. Elizabeth Mayer, very much an intellectual, with a passion for music and an ingrained belief in European cultural values, was immensely important as a sustaining force, and she provided a 'family' for Britten, who loved to be mothered. (She also became a great friend of Auden's, but he sometimes grew restive under her vast maternal attention.) It was while he was living in Amityville that Britten served briefly as conductor for the Suffolk Friends of Music orchestra.

Their other major residence in the East, to which they moved in 1940, was much more bohemian, though given a sort of mad order by the dictatorial manner of Auden, who was in charge of the household, sitting at the head of the table and handing out tasks and bills. This was a house in Brooklyn Heights, 7 Middagh Street – now torn down to make way for the Brooklyn–Queens expressway. It belonged to George Davis, the fiction editor at *Harper's Bazaar*, to whom Lincoln Kirstein had supplied money so that he could provide a home for artists and writers. Among those who were residents at various times, besides Britten and Pears, and Auden and Chester Kallman, were Gypsy Rose Lee (who wrote the *G-String Murders* there), Richard Wright (at work on *Native Son*), Jane and Paul Bowles, Golo Mann (a son of Thomas, and hence a brother-in-law of Auden's), Colin McPhee (who awakened Britten's interest in Balinese music) and Carson McCullers. Paul Bowles remembered Middagh Street as well heated and quiet 'when Benjamin Britten was working in the first-floor parlor, where he had installed a big black Steinway'.[20] But in spite of the warmth and quiet, and even the dominating presence of Auden, the style of life was a bit too raffish and unconventional for Britten and Pears, and presently they moved on.

Auden's importance for Britten should not be underestimated – an opinion reinforced by Pears[21] – and it is summed up in a letter that Auden

wrote to Britten in January 1942, close to the end of the American stay, when Britten and Pears had decided to return to England. Auden begins affectionately: 'Very guilty about not having written. Perhaps I can't make myself believe that you are really leaving us. I need scarcely say, my dear, how much I shall miss you and Peter, or how much I love you both.' Then he moves on to more serious matters:

> I think of you as the white hope of music; for this very reason I am more critical of you than anybody else; and I think I know something about the dangers that beset you as a man and an artist because they are my own.
>
> Goodness and [Beauty] are the results of a perfect balance between Order and Chaos, Bohemianism and Bourgeois Convention. Bohemian chaos alone ends in a mad jumble of beautiful scraps; Bourgeois convention alone ends in large unfeeling corpses. Every artist except the supreme masters has a bias one way or the other.... For middle-class Englishmen like you and me, the danger is of course the second.... I am certain too that it is your denial and evasion of the demands of disorder that is responsible for your attack of ill-health, i.e. sickness is your substitute for the Bohemian.

Donald Mitchell recalls how 'Peter Pears, on re-reading this letter almost 40 years on, remarked that [it reflected] . . . the actual state of the house that he and Britten shared with the poet for some months in 1940–41 and from which they – the self-confessed representatives of Bourgeois Convention – were driven by the conditions of Bohemian chaos amid which Auden chose to live at 7 Middagh Street'.[22] Britten himself replied to Auden in January 1942. That letter is lost.

Cutting loose from Auden may have been difficult, and it certainly left Britten and Pears a little anchorless. Auden, with his strong personality and decided views, had been a major reason for their taking the dramatic step of coming to the United States at all, and for their giving serious consideration at that time to the thought of becoming American citizens. Besides living with him in Middagh Street, they also visited him in September 1940 at the farm where he was staying in Williamsburg, Massachusetts; from there Britten wrote to his publisher Ralph Hawkes that he was finding it possible to work and was planning to live in New

York. He also indicated that Auden was making arrangements for him to write music for Hollywood films, a prospect that was never realized.[23]

Despite his illness, an acute streptococcus infection, throughout 1940, and his movements about the country, Britten managed to compose a number of works while in America that are now recognized to have been both important in themselves and significant preliminaries for *Peter Grimes*. Notable were *Les Illuminations* – a song-cycle using poems by Rimbaud, begun in England, completed in the United States and first performed in its entirety in London in January 1940 – and the *Seven Sonnets of Michelangelo*, written expressly for Peter Pears in 1940. (Was there any significance in his choice of Rimbaud and Michelangelo? Both men were great foreign artists, in a sense standing for the international nature of art, and both were, like Britten, outsiders on account of their homosexuality.)

Perhaps the most impressive work of this period is the *Sinfonia da Requiem* (1940), which had been commissioned by the Japanese government to mark the 2,600th anniversary of the founding of the Japanese Empire (an interesting irony considering the international situation); the piece was rejected by the Japanese because of what they considered its Christian and non-festive nature. Perhaps the Japanese, expecting a celebration, had discerned in the *Sinfonia* both an anticipation of war to come and a pacifist protest. If they had, they would not have been far off the mark. For the requiem, while dedicated to the memory of Britten's parents, who had died in the recent past, is also a requiem for lost peace and civility, and an apprehension of disasters yet to come. Rejected by the Japanese, who graciously paid the commission fee none the less, the *Sinfonia da Requiem* received its first performance on 29 March 1941 in Carnegie Hall; it was played by the New York Philharmonic Orchestra conducted by John Barbirolli. Unlike the unhappy première of *Our Hunting Fathers*, the audience was enthusiastic and the critics approving.

There was during this time another disappointing collaboration with Auden: *Paul Bunyan* (1941), variously described as an opera, an operetta or even a musical aimed at Broadway. This was Auden's first attempt at writing an opera libretto – later, in collaboration with Chester Kallman, he mastered that difficult art – and although Britten, still under the spell of Auden, set uncomplainingly and brilliantly to work, the joint result was not the success they had hoped for. The text was burdened with far too

much talk from the mythical and invisible Paul Bunyan. Although the eponymous hero, he is not allowed a physical presence in the piece, only an omnipresent disembodied speaking voice. He never sings, and in the speeches Auden devised for him he is less the giant lumberjack of folklore than a cross between a kindly Rotarian, a priggish clergyman and a confident analyst of the American character. It was probably too early in their stay for these two quintessential middle-class Englishmen, however critical of England they might be, to attempt to write about an American folk legend – one might almost say that it was presumptuous, certainly American critics did not hesitate to say so. *Paul Bunyan* ran for a week in May 1941 at the Brander Matthews Theater at Columbia University; the reviews were unfavourable – the one by the composer Virgil Thompson was especially hurtful. Britten withdrew the work and virtually ignored it for the next thirty years. But the experience, however disappointing, was stimulating enough to leave him with a desire to write a true, even a grand, opera, albeit with a different librettist.*

The next move, after the failure of *Paul Bunyan*, was to try the West Coast. Britten and Pears drove across the country in a Ford V8 to stay with Ethel Bartlett and Rae Robertson, the English husband-and-wife two-piano team for whom Britten wrote a number of works. They had a house in California at Escondido, near San Diego, and Britten found he was able to compose there. He wrote to his publisher: 'The place is very lovely – just the place for work. Not too hot (nice & high up) but plenty of sun.'24 They remained *chez* Robertson for most of the summer. In Escondido Britten wrote his first string quartet, No. 1 in D, which had been commissioned by Elizabeth Sprague Coolidge, the very wealthy patroness of new music. First performed in September 1941 in Los Angeles, the quartet presently

*Donald Mitchell writes: 'Britten actually began revising the operetta in 1974, having been persuaded to explore the possibility of reviving this early work. He only very reluctantly agreed! He only agreed in fact if he were able to have the opportunity to hear the operetta again, not in the first instance in the theatre, but on the radio; and for that reason the BBC helped us all out by mounting a radio production which went out on Radio 3 in February 1976. As a result of that – and on hearing it Britten said to me "Donald, I had quite forgotten what a strong piece it was" – he agreed to the work being published and to it going back into the theatre; a production followed at the Aldeburgh Festival in the summer of 1976, at Snape, which was the last summer of Britten's life and the last time (I think I am right in saying) that he was to see a production of one of his own operas. In every sense the wheel turned full circle on that occasion' (Letter from Donald Mitchell to the authors, 5 April 1993).

won for Britten the Library of Congress Medal for services to chamber music. Yet the stay in California was not ideal – there were emotional tensions with the Robertsons – and the discomfort of the situation may have made Britten and Pears a little more interested in returning home than they otherwise would have been. By now they were pursuing the idea of American citizenship and were actively involved in applying for their first papers. At first, they thought they would make the necessary re-entry into the country via Mexico; later it looked more likely that they might return via Canada in the autumn. One way or another, they were certainly anticipating returning to the East at the end of the summer.

On the other hand, their thoughts about a long, possibly even permanent, absence from the homeland might have been influenced by a continuing dispute centred around Britten in the *Musical Times* in England. That June the composer had been attacked, though not by name, in a letter by Pilot Officer E. R. Lewis to the *Musical Times*. Under the heading 'English Composer Goes West', he wrote: 'It is not encouraging to see others thriving on a culture which they have not the courage to defend.' In reply, Gerald Cockshott defended Britten, but the editors chose to be very severe: 'Mr. Britten is only one of many thousands of young men who 'wished to continue their work undisturbed'; and if they had all followed him to America Hitler would have had a walk-over.... After all, there are even worse fates than being unable to go on living and 'composing in America' and one of them may be the consciousness of having saved one's art and skin at the cost of failure to do one's duty.'

The dispute in the *Musical Times* continued into the autumn. Earlier, Ernest Newman, the eminent critic of the *Sunday Times*, had found himself in a similar dispute. In May he had praised Britten's Violin Concerto, and he was attacked for having called him a 'thoroughbred'. In reply, he wrote: 'I did not mean to lay it down that Mr. Britten is certain to turn out a world-beater. He may or may not.... By thoroughbred I mean simply that combination of good pedigree, good build, and clean running and jumping that is the mark of the finely bred horse.' But clearly the war was in the minds of those who defended and attacked Britten, as is made evident by Newman's easy pun: 'A few weeks ago I used the word thoroughbred in connection with Benjamin Britten's new violin concerto and ever since then I have been fighting single-handed the battle of Britten.'[25] As Britten wrote in the summer of 1941 to his publisher: 'Ernest Newman's second

defence of me in the Sunday Times has just been sent me (the Battle of Britten!!) and I feel really grateful to the old boy for his support.'[26]

|❖| 5 |❖|

It was in California that the crucial event happened, now hallowed in musical history, that led both to the gestation of *Peter Grimes* and to Britten and Pears taking the final decision to return to England. It has been compared to the moment in the history of impressionism when Boudin suggested to Monet that he paint outside! 'Britten had to go overseas in order to find England.'[27] The moment took place during that summer – it is unclear whether it was in Los Angeles or San Diego – when Pears discovered a copy of the *Collected Poems* of George Crabbe. Although Crabbe was an important Suffolk poet, apparently Britten had not known much about him before. (It is particularly fitting that there should be a monument to Crabbe – 'The Poet of Nature and Truth 1754–1832' – in the Aldeburgh Parish Church now opposite the John Piper memorial window to Britten with its representations of *Curlew River, The Burning Fiery Furnace* and *The Prodigal Son*. It is in the churchyard there that Britten and Pears are buried.) But for Pears to find a book by a Suffolk man on a coast so dissimilar to Britten's native North Sea was little short of miraculous.

The book itself is now in the Britten–Pears Library in Aldeburgh, and Pears has written into it: 'I bought this book at a ? San Diego/Los Angeles book-seller in 1941 and from this we started work on the plans for making an opera out of "Peter Grimes." Peter Pears Aldeburgh 1978 (rewritten 1982).' An edition of 1851, the copy includes marked passages in 'The Borough', a sequence of several poems about the inhabitants of a fishing village on the North Sea; one of them relates the story of the fisherman Peter Grimes, another that of the schoolteacher Ellen Orford.*

The serendipitous event was to lead Britten into the major phase of his musical career. He had already done so much that it is hard to remember

*The Crabbe edition's full title is *The Life and Poetical Works of the Revd George Crabbe*, edited by his son in one volume (London, 1851). It had been purchased by Charles Forbes on 9 May 1851, and he had presented it to the Reverend Varnon Page on 11 May 1852. Its history over the next 90 years is unknown.

that he was still only in his twenties, and had received a good deal more recognition – deserved recognition – than many other composers of the day. However, his genius had not reached its full expression as yet. In our view, his absence from England during the first years of the war and then his return there in 1942 were crucial for this development. As Britten said when he received the first Aspen Award:

> I first came to the United States twenty-five years ago, at the time when I was a discouraged young composer – muddled, fed-up and looking for work, longing to be used.... But the thing I am *most* grateful to your country for is this: it was in California, in the unhappy summer of 1941, that, coming across a copy of the Poetical Works of George Crabbe, in a Los Angeles bookshop, I first read his poem, *Peter Grimes*; and, at the same time, reading a most perceptive and revealing article about it by E. M. Forster, I suddenly realised where I belonged and what I lacked. I had become without roots, and when I got back to England six months later I was ready to put them down. I have lived since then in the small corner of East Anglia, near where I was born.... I believe in roots, in associations, in backgrounds, in personal relationships.... My music now has its roots, in where I live and work. And I only came to realise that in California in 1941.[28]

Receiving the freedom of Lowestoft, where he was born, in 1951, he said: 'I am firmly rooted in this glorious county [Suffolk]. And I proved this to myself when I once tried to live somewhere else.'[29]

The event, and Britten's memory of it, became somewhat schematic in retrospect. He discovered Crabbe in July and immediately started to think about an opera, but he was still worrying about the questions of his and Peter's visas and the problems of remaining in America. One might also ask to what degree their decision was hastened by the fact that they were not happy in California and did not enjoy being with Bartlett and Robertson. Amityville and the Mayers had been far more congenial.

As Britten indicated in his Aspen speech, his interest in Crabbe had been stimulated just before he acquired the book itself by reading a talk by E. M. Forster published in the *Listener* on 29 May 1941. The subject was Crabbe. Indeed, the piece created the desire to read the poems of Crabbe, which Britten and Pears had not known before; doing so would lead to their decision ultimately to return to Suffolk. From its first line, Forster's piece

was powerful in its appeal to them: 'To talk about Crabbe is to talk about England.' His evocative sentences were bound to summon up the county of Suffolk as Britten read them in the relentless if benign sun of a southern Californian summer:

> [Crabbe] never left our shores and he only once ventured to cross the border into Scotland. He did not even go to London much, but lived in villages and small country towns. . . . Aldeburgh . . . is a bleak little place: not beautiful. It huddles round a flint-towered church and sprawls down to the North Sea – and what a wallop the sea makes as it pounds at the shingle! Near by is a quay, at the side of an estuary, and here the scenery becomes melancholy and flat; expanses of mud, saltish commons, the marsh birds crying . . . [Crabbe] escaped from Aldeburgh as soon as he could. His fortunes improved, he took orders, married well, and ended his life in a comfortable west country parsonage. He did well for himself, in fact. Yet he never escaped from Aldeburgh in the spirit, and it was the making of him as a poet. . . . So remember Aldeburgh when you read this rather odd poet, for he belongs to the grim little place, and through it to England. . . . A famous [poem] is 'Peter Grimes': he was a savage fisherman who murdered his apprentices and was haunted by their ghosts; there was an actual original for Grimes.

Forster came to agree with Britten and Pears's interpretation of Grimes, and the difference between the poem and the opera prompted him to observe in a later lecture in 1948: 'In a properly constituted community, he [Grimes] would be happy, but he is far ahead of his surroundings. . . . The community is to blame. . . . I knew the poem well, and I missed [in the opera] its horizontality, its mud. I was puzzled at being asked by Grimes to lift up my eyes to the stars [the magnificent aria "The Great Bear and Pleiades"]. At the second hearing my difficulty disappeared, and I accepted the opera as an independent masterpiece, with a life of its own.'[30]

Crabbe and Forster represent testimony to the inadvertent power of literature to affect lives. The conjuction of the eighteenth-century clergyman-poet and the twentieth-century novelist was the major factor in leading Britten and Pears to conclude eventually that, whatever the consequences of their being conscientious objectors, they needed to return to England, that they could not, for the sake of their art and their lives, cut themselves off from their roots. As Britten wrote in 1946: 'Once having

tried the American Way of Life, I feel, in spite of its silly muddles, really a part of Europe.'[31] Crabbe and Forster made both Britten and Pears realize their homelessness and isolation in America. Before coming to America, Britten had bought the Old Mill at Snape near Aldeburgh (where the main concert hall for the Aldeburgh Festival – the Maltings – is now located). He and Pears began to make plans to return there.

On their way back from California they met Isherwood in Philadelphia, where he was working in a Quaker hostel. They raised with him the possibility of his writing the libretto for *Grimes* (which he declined) and told him of their decision to return to England; Isherwood himself had decided to stay permanently in America, but he felt that Britten and Pears were making the right choice for themselves.[32] Returning to England was fine as an aspiration; to accomplish it during wartime, however, proved difficult. They would have to wait six months to secure passage on a Swedish freighter, the *Axel Johnson*, and the journey, starting from New York on 16 March, would take five weeks, the most dangerous part of which would be the twelve days crossing the Atlantic. Most of their remaining time in America was spent in Amityville with the Mayers, ending, as they indicated in the guest book, the 'weekend' that had started almost two years before.

The long wait imposed by wartime conditions before they could obtain passages on a freighter had one distinct advantage from the point of view of writing the opera: Britten secured a grant of $1,000 from the Koussevitsky Music Foundation. In November 1941 Serge Koussevitzky had conducted the Boston Symphony Orchestra in a performance of the *Sinfonia da Requiem* that Britten was able to attend. In December Britten wrote to Koussevitzky: 'I did so very much enjoy meeting you and talking with you in Boston last month; I felt it a great experience. At the present moment my plans for the future are still rather vague, but I expect to leave for England in the middle of January. I do hope that I shall carry back with me the thrilling memory of, what I consider, my best piece played by you and your glorious orchestra.'[33]

While in Boston Britten met Koussevitzky, and in the course of a conversation told him that he wanted his first full-scale opera to be based on Crabbe's work, but he added that he could not afford to devote the necessary time to it: 'the construction of a scenario, discussions with a librettist, planning the musical architecture, composing preliminary

sketches, and writing nearly a thousand pages of orchestral score, demanded a freedom from other work which was an economic impossibility for most young composers.'[34]

The Foundation had just come into existence, celebrating the memory of Koussevitzky's wife, who had died the previous January. Koussevitzky responded in a decisive and memorable way. He chose Benjamin Britten as the recipient of the Foundation's first grant for the composition of *Peter Grimes*; his only stipulation was that the work have its première by the Boston Symphony and be dedicated to the memory of his wife, Natalie. Koussevitzky was distressed when he realized that Britten was going back to England rather than writing the opera in America, and he almost cancelled the commission. However, he reconciled himself to the idea that it might not be first performed by his beloved orchestra. Given wartime conditions, and that it would have been very difficult to arrange performances in America when the opera was finished, Koussevitzky generously and sensibly gave permission for it to be staged in England first.

The story of Peter Grimes, such as it is in Crabbe's original poem, was grim. Britten and Pears kept that grimness, but they did dramatically transform the character of the sadistic Grimes from a crazed hater of his father and an abuser of his apprentices into a misunderstood figure, certainly not mentally stable but with elements of poetry and heroism that might, at one level, make him akin to a Byronic individualist hero defying his society. On another level, however, the Grimes of the opera is anxious to prove himself to the community – just as Britten and Pears may have been anxious to show their willingness to serve England during wartime, but in their own way. As Britten has said, 'A central feeling for us was that of the individual against the crowd, with ironic overtones for our situation. As conscientious objectors we were out of it. We couldn't say we suffered physically, but naturally we experienced tremendous tension. I think it was partly this feeling which led us to make Grimes a character of vision and conflict, the tortured idealist he is, rather than the villain he was in Crabbe.'[35]

The transformation, maladjustment and ambivalence of the character of Grimes are of course also indicated musically. Originally the title role was conceived as a baritone – not as a tenor, the traditional hero's voice; nor as a bass, the traditional villain's – suggesting that Grimes would be neither

entirely heroic nor villainous but, as it were, a mix of both. Ultimately the role was written for a tenor but 'to a certain extent this ambivalence still exists in the finished work: it gives symbolic power to the character, endows the opera with universal appeal – and causes critical discomfort'.[36] As Desmond Shawe-Taylor asked in his review of the first performance:

> Who is Peter Grimes? In Crabbe he is a mere brute, guilty of the manslaughter (if not the murder) of his father, and of no less than three poor workhouse boys whom he has bought as his apprentices with the deliberate intention of ill-treating them; 'untouched by pity, unstung by remorse, and uncorrected by shame . . . a mind depraved and flinty': in fact the perfect S.S. Camp Commandant. In the opera . . . Grimes himself wears a very different aura. He is not presented as a worthy character (that would be too much), but as an outcast: romantic, Byronic and misunderstood.[37]

It could be said that Britten and Pears over-identified with Grimes, for even in their version he seems far more neurotic than the character they later wrote about – in contrast to the musical character – as someone merely out of step with his own society. In 1946 Pears wrote:

> If he had lived in a city, Grimes might have been a revolutionary or gone to join one of Robert Owen's settlements. But there were no politics in the Borough – only the many and the few, the conventional and those outside the pub. . . . Grimes is not a hero nor is he an operatic villain. He is not a sadist nor a demonic character and the music quite clearly shows that. He is very much of an ordinary weak person who, being at odds with the society in which he finds himself, tries to overcome it and, in doing so, offends against the conventional code, is classed by society as a criminal, and destroyed as such. There are plenty of Grimeses around still, I think![38]

There is something disingenuous about this statement, as if Pears were trying to present himself and Britten, political and sexual outsiders, as not being very unconventional. As is so frequently true in England of those in the arts and also of those who are in their private lives unconventional sexually, their actual style of life was that of the English middle classes, and

all the more comfortable and supporting for that very reason. In a way, too, Britten and Pears almost overdramatized themselves. They were hardly as strange and unconventional as Grimes comes across even in the opera. This lack of congruence is reflected in Grimes's desire to be accepted by the philistine community, a drive that would not ring true if he were also a Byronic romantic. Perhaps because of their middle-class background Britten and Pears appeared to be more concerned with acceptance by their society than one might have expected. It may well have been a particularly intense issue for them during the war, when they were unwilling to fight. Grimes appears in two ways, both as an ordinary person and as an idealist and outsider suffering for his beliefs.

The decision to return to England released a flood-tide of creativity. On the return journey, even though he was in a cabin next to a smelly and noisy refrigeration plant, Britten 'couldn't stop the flow'.[39] Britten had not been inactive before, but on the freighter, hardly with congenial working conditions, he completed the music for Auden's *Hymn to St Cecilia*, which had the doubly rich significance of marking his own birthday and also celebrating music and its making. He also composed aboard ship *A Ceremony of Carols*, using modern music for a most traditional purpose, a foreshadowing of the various ways in which he would bring contemporary music into the Church. Christopher Palmer has remarked of this song sequence: 'All the familiar and much-loved associations of Britten's childhood – English poetry, plainsong, boys' voices, church bells, Christmas– contribute to the piece, but all refracted at a new angle.'[40] Some of his manuscripts were confiscated, both by the American and the British customs authorities, perhaps in the belief that the musical notes were some sort of code. In both cases the manuscripts were returned, among them a never completed project for a clarinet concerto for Benny Goodman.[41]

However, the most important work that Britten and Pears did on the freighter was to continue to outline the scenario for *Peter Grimes*. Some thought had already gone into it; there are some notations by Britten for Act I and by Pears for Acts I, II and III, probably done at the Mayers' in Amityville, on the back of the programme for the Elizabethan Singers, a group they were involved with in late 1941 who gave concerts at schools and universities. These notes indicate the animosity between the sea, representing the uncontrolled power of war and violence, and the earth,

representing stability of peace. Britten's notes reveal how far the opera had already progressed:

> Act I, Sc. I Aldeburgh, Sea Shore fisherman's hut to [the] sea diagonally centre back to ... breakwater. A fishing boat is hauled in by men's chorus. Women comment anxiously. Storm is brewing. Enters character with story of rising tide or damage from North. Ellen enters. song, about Grimes. He is drinking and not working. no apprentice since last one died. Chorus suggest suicide. Ellen denies it; (Probably fell off mast) Asserts Grimes was innocent, misunderstood. Blames sea as cause of all disaster – women all agree. Men disagree, Climax. Enter a man hurriedly – strange foreign boat sighted in difficulties off Southwold. Man jumps to top of hut and sights ship.[42]

There also exist at the Britten–Pears Library outlines and notes by Pears written on the freighter stationery, with a list of musical numbers and indeed further fragments of a draft scenario in Pears's hand and a summarized version by Britten. One wonders how much of this was written during the most dangerous part of the journey, when the *Axel Johnson* was crossing the Atlantic in convoy. The Britten–Pears Library also contains a list of the characters in Britten's hand, written on the back of a letter from Elizabeth Mayer dated 1 June 1942.

It would, in our opinion, be difficult to exaggerate the importance of the war in the creation of what many consider Britten's greatest work, with the possible exception of the *War Requiem*, and what was undoubtedly his greatest success in the eyes of the world. Britten and Pears were not in England during the Blitz; yet because they had been exiles, and then made a deliberate decision to return, they may have been more influenced by the war than many for whom it was a daily reality to which they had hardened themselves. At the least, they were more self-conscious about the war they returned to.

Being in America provided Britten with fresh perspectives on his own country as well as a fresh start. The character of Grimes in both the opera and George Crabbe's poem hardly stands for the humane values at stake in the war, yet Britten and Pears transformed him into a man who stood against the crowd – a recognizable if warped version of the romantic individualist. Rather oddly perhaps, Grimes represents the importance of personal rights in which Britten and Pears profoundly believed and which,

it was claimed, the war was being fought to preserve. The war provided a relentless pressure upon Britten, and as such was a major cause of the breakthrough that he was to achieve in *Peter Grimes*.

The fall of France in June 1940 had disconcerted them. As Britten later said: 'All my thoughts and interests were in Europe and yet to return to the maelstrom seemed madness – my views on pacifism still held, so I couldn't do anything practical about the situation. At least in the States I could work, could be of some use to people. I got extremely ill and was in and out of bed for a year. I couldn't solve the situation for myself intellectually – as Auden didn't fail to point out.'[43] Shortly after the phoney war ended, with the beginning of the Blitz in September 1940, Britten and Pears began to consider the question of coming back, but it was not until the discovery of Crabbe and Forster in the summer of 1941 that they were actually led towards their decision. The war, even at such a great distance, had deeply affected Britten, but America too had had its influence: 'I think the effect of America was to broaden one, encourage one and to shake one.'[44]

|❖| 6 |❖|

By 1942 Britten and Pears had missed the worst of the Blitz. Back in England, they were still interested in returning eventually to America, or so they wrote to Elizabeth Mayer.[45] In some ways they found England drab and sad, but the countryside was beautiful, their friends had not turned from them, Britten's music was being performed, and Pears had developed his voice through his work in America and was consequently much in demand. They both felt that on many levels they had done the right thing in returning to England.

They had also made a deliberate decision to face the war and whatever might be the consequences of their conscientious objection to it. Once the United States had entered the war in December 1941 their position concerning the draft there, or conscription in England, had probably become more ambiguous. At the end of May 1942 Britten went before a local tribunal of the Military Recruitment Department of the Ministry of Labour for the registration of conscientious objectors. Earlier that month

he had submitted a statement pointing out that as a creative person he could not participate in destruction, and that Fascism needed to be fought with passive resistance. He felt he could serve best in a musical fashion, such as working for the Ministry of Information, the BBC or CEMA, and he was willing to do other work if so directed on the condition that it was not connected with the Armed Forces.[46] The tribunal excused him from combatant duty but without freeing him from working within the Armed Forces, which was not acceptable to him.

At the appellate tribunal in July William Walton testified on his behalf, pointing out what a crime it would be if Britten could not continue with his music.[47] Britten had written some incidental music for radio commentaries by Louis MacNeice on wartime England that were broadcast to America, and the BBC producer of those broadcasts submitted a testimonial. Impressed and sympathetic, the tribunal agreed to exempt Britten unconditionally, a very rare decision. Such exemption was only given to 4.7 per cent of objectors.[48] The tribunals could be somewhat inconsistent, presumably in part depending on the willingness of the applicants to co-operate. Michael Tippett, for instance, was ordered to work on the land, and when he refused he was sentenced to prison for three months.

Unlike Britten, Pears did not have to appear before an appeal tribunal. With witnesses to his sincerity as a pacifist, and to his refusal to join the Officers' Training Corps at school or to go into the Navy, he was granted full exemption at his first appearance.[49] Britten was sufficiently grateful for the help he had received in his appeal to write a letter of congratulations to the *Bulletin* of the Central Board for Conscientious Objectors on its fiftieth-anniversary issue; in it he stated how much the organization meant for those 'who will not goose-step like the rest of the world'.[50]

As we have already indicated, great efforts were made to preserve and disseminate culture throughout Britain during the war. Audiences were very receptive to serious music, even if it tended to be at the more popular end of the scale, and that interest increased not only in London but in the provinces as well. Britten and Pears ended up touring extensively for CEMA, which was helping to spread serious music more broadly than had ever been done before:

Indeed, one of the most remarkable features of musical life in Britain during the war was the quite phenomenal rise in popularity of

symphonic music, which was made accessible to and enjoyed by sections of the community, – soldiers, sailors, airmen, factory workers, etc. – who up till then had shown little signs [*sic*] of appreciating classical music – perhaps from lack of opportunities. The phenomenon was especially noticeable among the inhabitants of some of the smaller provincial towns.... Symphonic music henceforth was accepted by the workers and ceased from then on to be the prerogative of a musical *élite*.[51]

A similar statement could be made on a somewhat reduced scale for chamber music of the sort performed by Britten and Pears. Their concerts around the country were given under the auspices of CEMA. Such concerts gave musicians a greater sense of 'ordinary' people, who would come for the music itself, with less concern for the particular fame of the performers than a London audience might have. But apart, and very different, from the CEMA tours, there were important concerts in London at the National Gallery and the Wigmore Hall where the *Seven Sonnets of Michelangelo* was first performed. In May 1942 Pears made his debut in the *Tales of Hoffman*, and in January 1943 he became a leading member of the Sadler's Wells opera company. As a result Britten found himself listening to far more opera than he had previously.

Between his tours for CEMA and the other concerts with Pears, Britten was at work, notably at his *Serenade for Tenor, Horn and Strings*, spending what time he could in Suffolk at the Old Mill at Snape, which he had bought in 1937 after the death of his mother. It was close to Aldeburgh with a wonderful view of the estuary, and it was there that he worked on *Peter Grimes*. The libretto, at least a very early version of it, was finished as early as September 1942.

From 1943 to 1946 Britten and Pears also had a flat over the Home & Colonial store in St John's Wood High Street, a welcome base for their many musical commitments in London. They shared the flat with Erwin Stein (Britten's editor at the music publisher Boosey & Hawkes), Stein's wife and his daughter, Marion; they had moved there when their previous flat was bombed. It was a congenial arrangement, the Steins and Britten and Pears became close friends, and Britten had the pleasure of an editor at hand who had been a prominent conductor in the 1920s and also served as the editor of Stravinsky, Bartók, Berg and Webern.

On 22 July 1942 the first performance in England of *Sinfonia da Requiem* was given at the Proms at the Royal Albert Hall. The *Seven Sonnets of Michelangelo*, the first song-cycle written by Britten specifically for Pears, also served as part of their reintroduction to the British musical scene on 23 September 1942. (Walter Legge of EMI arranged for them to record the work, their first major recording.)[52] Again at Wigmore Hall, on 22 November (St. Cecilia's Day and Britten's birthday), the BBC Singers, a group of which Pears had been a member, gave the first public performance of *Hymn to St Cecilia*, written on the transatlantic journey home in March. And the *Sonnets*, along with the Schumann song-cycle *Dichterliebe*, were part of a recital given by Pears and Britten on 22 October 1942 in the famous lunch-time series in the National Gallery.[53]

They also gave concerts in prisons, most memorably on 11 July 1943, when their page turner proved to be an inmate, the composer Michael Tippett. As described in Tippett's own words: 'Ben and I met first in the war, when we were both conscientious objectors.... On my side I am ashamed to mention the untruthful wrangling by which I convinced the authorities that the recital was impossible unless I turned the pages for the pianist.'[54]

Britten tended to find the war more disconcerting and frightening than did Pears, who was more fatalistic and therefore, paradoxically, less worried about its consequences and dangers. To Pears the war was hateful, but it also provided a sense of the need for creative efforts to counteract its destructiveness.[55] Britten's major artistic commitment in these months was to *Peter Grimes*, but there was still time for other compositions such as the *Serenade* and *Rejoice in the Lamb* (completed in July 1943). The music of the latter and the text he had chosen for it, Christopher Smart's 'Song from Bedlam', emphasized Britten's sense of alienation from his society – alienation that was to be expressed so much more strongly in *Peter Grimes* – 'to discover anew how from private pain the great artist can fashion something that transcends his own individual experience and touches all humanity'.[56]

After the *Serenade*, which was first performed in Wigmore Hall on 15 October 1943 by Pears and Dennis Brain – the great horn player (then in his early twenties) for whom the horn part had been written – Britten's energies were concentrated on the completion of *Peter Grimes*. With the Rimbaud and Michelangelo cycles behind him he was ready to come back

to an essentially English theme and setting. It is striking that Britten would achieve the extraordinary accomplishment of *Grimes* in the international sphere of opera where the British had been so notably unsuccessful since Purcell, with the possible exceptions of Handel and Gilbert and Sullivan. The only contemporary British operas that had any reputation at all were Ralph Vaughan Williams' *Hugh the Drover* (1924) and Ethel Smyth's *The Wreckers* (1906). That these two operas, despite their worthiness, were the only real contributions to the form indicates what a comparatively low state English opera was in. Even in comparison with the notable achievements of Elgar, Britten stands out in a far more distinguished way, so that it hardly seems enough to say, as does Alun Davies: 'What Elgar had achieved for British orchestral music at the turn of the 20th century, Britten would accomplish for British opera – hitherto the crustless orphan of British music.'[57]

As with the concerts at the National Gallery, Britten was in his composition maintaining the international character of his style or musical language; his operas were in the great tradition of Mozart, Verdi and Berg. '"Wozzeck" had, for about ten years, played a great part in my life, not only I may say musically, but also psychologically and emotionally', he said in an interview in 1966. 'Particularly as war approached us, of course, the figure of the lonely incredible soldier, trapped in the great machine of war was something I thought about and felt for deeply; in many ways I am aware now that I was strongly influenced by "Wozzeck" when I wrote "Grimes" ... the influence of Mozart and Verdi, of course, is more obvious. The wonderful stagecraft and wit and aptness of Mozart's, Verdi's trust in melody and his sense of form.'[58]

In 1942 Britten had asked Montagu Slater to undertake the libretto, a task that was to take eighteen months. The music was written largely after the completion of the libretto, from January 1944 to February 1945, although it had been simmering in Britten's mind since California, and he and Pears had already blocked out its shape. Britten liked Slater, but the collaboration was somewhat difficult and tense, as Slater had to accustom himself to changes in the libretto made necessary by musical requirements. At one meeting Slater banged on the table, defending his work, and argued it was not to be changed. But Britten had learned a particular lesson from his collaboration with Auden on *Paul Bunyan*: although opera is a co-operative venture, it is one in which the composer is chief.

Hc had selected Slater, who at the time was working at the Films Division of the Ministry of Information, to write the libretto after Isherwood had declined the earlier invitation. Britten knew him quite well; they had done quite a bit of work together in the 1930s: one of Britten's *Two Ballads* for two voices and piano in 1937 was a setting of a poem by Slater, 'Mother Comfort', the other was of Auden's poem 'Underneath the Abject Willow'. Britten had also provided incidental music for two of Slater's one-act puppet plays, as well as for his play *Stay Down, Miner*. Although Slater was more dogmatically committed to the Left than Britten, there are no overt traces of politics in the opera; however, it does contain an intense sense of the antagonism between the individual and society. As Donald Mitchell has written:

> Slater was a prolific writer and active in many spheres, as novelist, poet, propagandist, journalist, dramatist, film-scripter, critic and editor.... '*Realism* as a style' might be said adequately and fairly to sum up an over-riding trend in Slater's aesthetic, a trend he believed in and helped to create in his own literary environment. It wasn't an aesthetic that belonged particularly to the thirties. *Grimes*, of course, belongs to the post-war forties, and the music, self-evidently, transformed – or transcended – the work and the aesthetic of the librettist. Nonetheless, '*realism* as a style' remained, I am convinced, a potent and influential force, a legacy – in the very person of Slater – from the thirties and one that made its own powerful appeal to the realistically minded composer of *Peter Grimes*.[59]

From the first the opera aims at a certain form of social realism: elements of ordinary life and problems that go beyond the immediate environment of the village. Much of the original poem by Crabbe was let go, as was Slater's first version, in the protracted discussions between composer and librettist. Slater eventually published his own version, written in 'four-beat half-rhymed verse, as conversational as possible and not too regular',[60] and in very many ways significantly different from the text of the opera, although he claimed he had only 'omitted some of the repetitions and inversions required by the music'.[61]

The transformation of the libretto can be followed in the long article by the musicologist Philip Brett in the collection of essays he edited on *Grimes*,

drawing on the various versions in the Britten–Pears Library in Aldeburgh, where records of the changes made by Slater and Britten are to be found. (The library also contains the preliminary sketches in pencil and water-colour for the sets, designed by Britten's old friend Kenneth Green, an art master at Wellington College, who stayed at the Old Mill at Snape while Britten was working on the score. There had been some talk of Henry Moore or Graham Sutherland designing them but Britten wished for his old friend Green.)[62] Britten worked well with others, but at the end of the day he was in charge, of that there was no doubt.

We do not propose to enter into a detailed analysis of the libretto or music of *Grimes*. As a frequently performed opera in the international repertoire, and probably the most regularly performed modern opera, the story is surely well known. It tells of a Suffolk fisherman, Peter Grimes, who has lost one apprentice through death under suspicious circumstances and who is strongly suspected by the community of mistreating his apprentices. His only friends are a schoolmistress, Ellen Orford, whom he hopes to marry, and a retired skipper, Captain Balstrode. Grimes, who acquires another apprentice from the poorhouse, cannot help reacting violently to the world that he finds himself in, as we see when he strikes his main defender, Ellen; yet he hopes to do better. Then the death of the second apprentice through misadventure (and Grimes's roughness) brings about his madness. He finally accepts Balstrode's advice to take his boat out and sink both it and himself. At the end of the opera the life of the town is shown to go on as usual, while on the horizon can be seen the sinking boat. Ordinary society triumphs over the misfit. Britten was intensely aware of the parallels: he, like Grimes, was living out of step with his own society at war.

Britten took the decision to change the nature of Grimes in the original poem, endowing him with much more inward motivation, hating the community but painfully determined to be accepted by it. This change was significantly helped by transposing the action of Crabbe's poem from the late eighteenth to the early nineteenth century, when romanticism was in full flood, and Grimes could be transformed from the grim, unreflective brute of the original poem into someone who is almost a hero – perhaps a rather surprising one to be found in a fishing village on the Suffolk coast. In the opera he is 'something of a Borough Byron, too proud and self-willed to come to terms with society, and yet sufficiently imaginative to be fully

conscious of his loss.... The rift ... between, on the one hand, the comparatively modern type of the psychopathic introvert, divided against himself and against the world, and, on the other, reactionary extrovert society.... This intensity of vision helps to raise to the tragic plane what might otherwise have been merely a sordid drama of realism.'[63]

The opera is certainly told from Grimes's point of view, and of course this increases the thematic conflict in the story. Grimes wishes both to be his own man, to go his own way, and at the same time to earn the Borough's approbation, to show his worth and to be a solid enough citizen to win Ellen's hand in marriage. He attempts to hold both values. (Without being too reductive, it is possible to see this as the tension in Britten's own life: to lead his own artistic and sexual life, and yet be a respected figure in the middle-class English world.) This contradiction is a bothersome weakness in the transformation in the story.

Homosexuality is suggested in the oppressive relationship between Grimes and the boy apprentices, and in that relationship of adult and child there is also the inevitable tension between knowledge and innocence, the theme of lost innocence that was so important to Britten. An artist, a conscientious objector and a homosexual – Britten was claiming his right to be all three – although he did not necessarily avoid guilt about the latter two – in wartime England, when society was much more likely to be demandingly conformist. No doubt there were many who were unwilling to grant such freedoms, but it is an impressive testimony to the freedom of the artist during the war that Britten was able to create his masterpiece, and to bring to realization his own magnificent conception. In the opera Grimes is defeated, as he drowns himself at sea; and the narrow, purblind, ordinary conformist life of the Borough goes on. Yet there is the greatness of Britten's music, witness to the freedom permitted the individual in England, even in wartime.

Crabbe's Grimes does seem to be present in the opera as well, although the only direct quotations from the original poem are a few quatrains at the beginning and the end of the libretto and the deeply memorable phrase referring to Grimes's beating of the boy: 'Grimes is at his exercise.' There is, however, a strength and appropriateness in the last lines of the opera that come directly from Crabbe, reasserting the power of the sea: 'In ceaseless motion comes and goes the tide / Flowing it fills the channel vast and wide / Then back to sea and strong majestic sweep / It rolls in ebb, yet

terrible and deep.' However one may respond to the unrelenting story set forth in the opera, there can be no question that it is redolent of humanity, and it is human values that are being extolled while they are under attack, as in a war. In that, the tale is very different from Crabbe's, important as the Suffolk poet was as an inspiration.

The Grimes of the opera is perhaps somewhat less a misfit and more a psychopath than the composer intended. At least this is the case in the text, without an actor realizing the part on stage. It is hard to tell how self-aware we are supposed to believe Grimes is – is he consciously accepting the standards of the Borough and rejecting his role as a visionary, captured in the overwhelming Great Bear and Pleiades aria?[64] It is true that he is a far more complex character than is common in opera, which tends to deal in blacks and whites: heroes and villains, basses and tenors. Not only musically, but also in the conception of character, Grimes shares the damned grandeur of Verdi's Otello as well as the humanity of his Falstaff. Is the Borough as consciously destructive, is Grimes as heroic as Philip Brett believes?

[Grimes's] difference of nature – proud, aloof, rough and visionary – poses some sort of threat to the narrow ordered life of society struggling for existence against the sea, and therefore he is subjected to persecution, which is part of the ritual societies devise, whether subtly or in this case brutally, to maintain the bounds of what is socially acceptable. . . . Once we hear Peter falling under the spell of the Borough's values, we know that he embraces his own oppression and sets his soul on that slippery path towards self-hatred that causes the destruction of the individual.[65]

There is an illuminating difference in the two great contemporary interpreters of the character of Grimes: Peter Pears and Jon Vickers. There is no question that Pears came closer to what Britten wanted: Grimes as a more ordinary person who suffers, who has longings and who despairs, a figure with whom the audience can identify. Yet he must also be a hero who is destroyed by events that, in effect, he has set in motion. In the Vickers version it is as if the violence of Crabbe's Grimes is somewhat more dominant; yet, again, Vickers may well have had more of the Byronic element in his portrayal.

It is the music, as Joseph Kerman has pointed out, that must have the

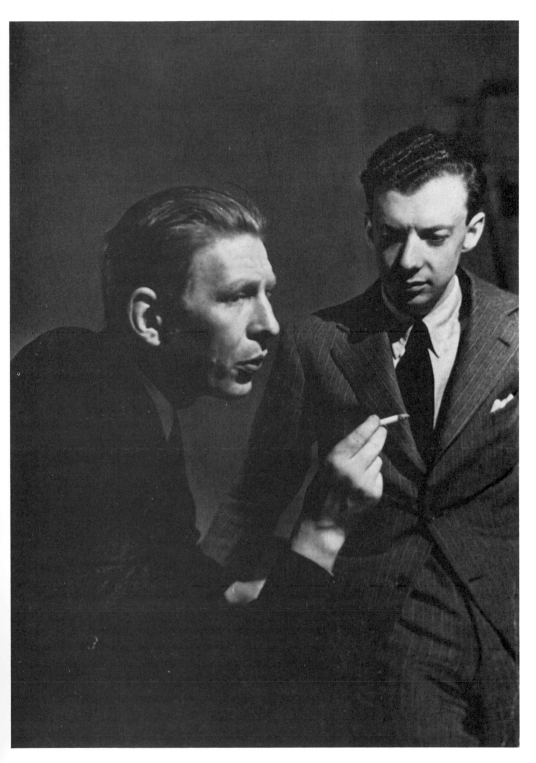

Auden and Britten, New York 1941, at the time of the rehearsals
for Paul Bunyan

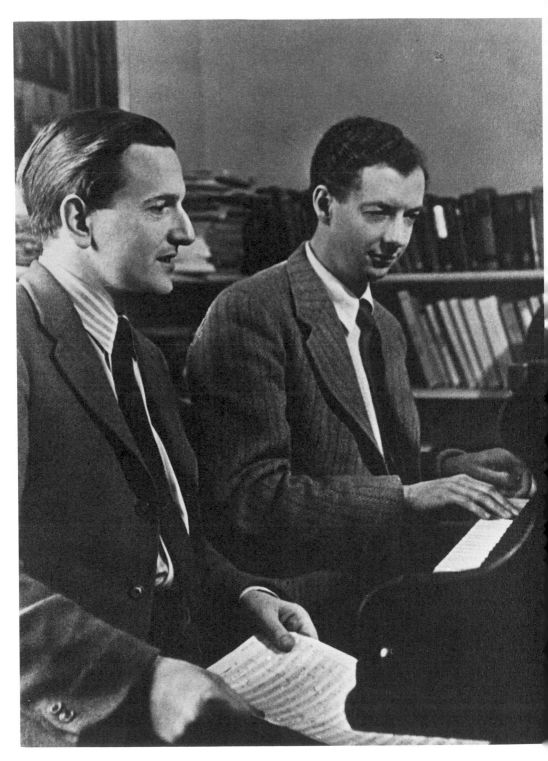

Pears and Britten, Stanton Cottage December 1941

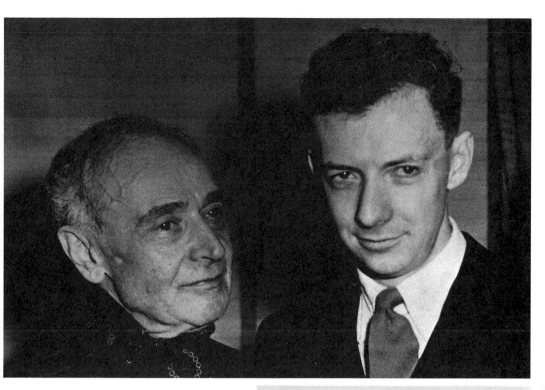

Britten with Serge Koussevitzky, Boston 1942

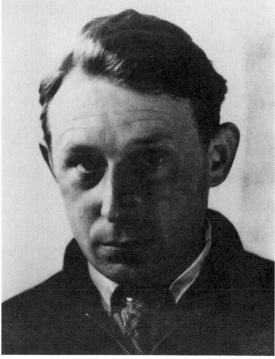

Montagu Slater

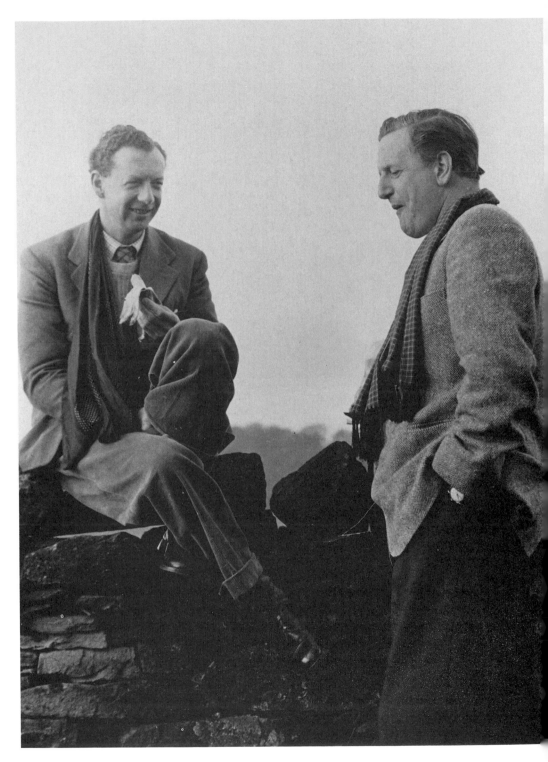

Britten and Pears at Old Mill, Snape

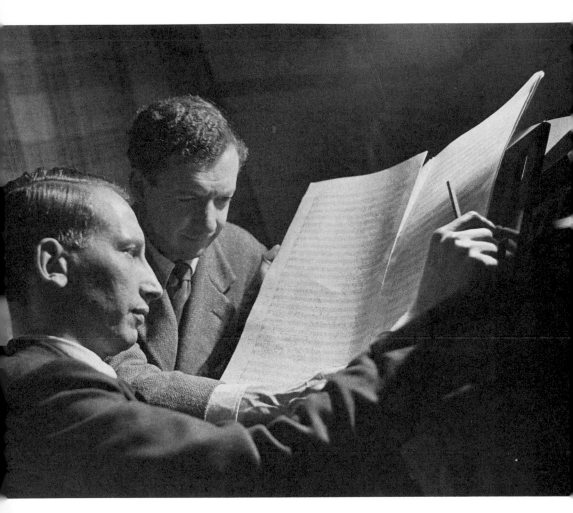
Britten with Eric Crozier

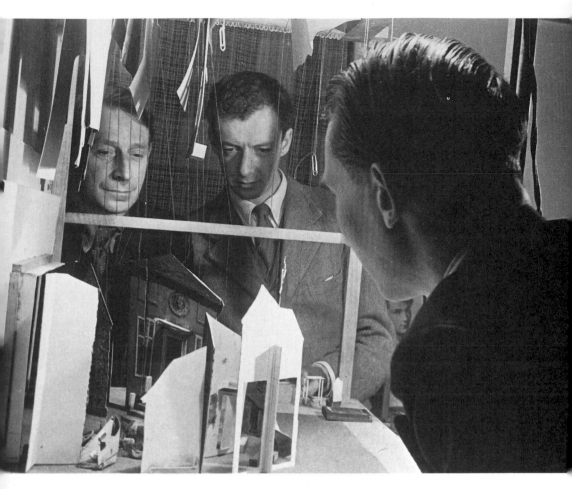

Britten, Montagu Slater and Eric Crozier with a model of part of the set
for Peter Grimes

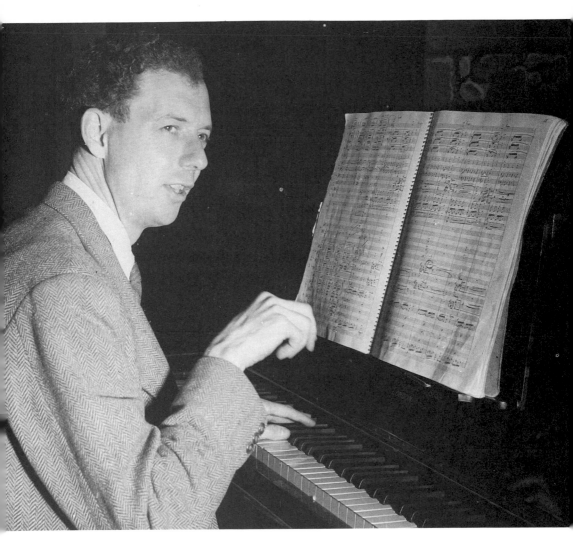

Britten working on Peter Grimes

SADLER'S WELLS

ROSEBERY AVENUE, E.C.1

BOX OFFICE: TER. 1672

LICENSEE: TYRONE GUTHRIE MANAGER: GERALD SEYMOUR

THE GOVERNORS OF SADLER'S WELLS
IN ASSOCIATION WITH C.E.M.A.

PRESENT

SADLER'S WELLS OPERA

MADAM BUTTERFLY LA BOHEME

THE BARTERED BRIDE COSI FAN TUTTE

RIGOLETTO

AND FIRST PRODUCTION OF

PETER GRIMES

BY BENJAMIN BRITTEN

ADMINISTRATORS OF THE OLD VIC AND SADLER'S WELLS COMPANIES
TYRONE GUTHRIE

The action of the opera takes place in THE BOROUGH, a small East Coast Fishing-town, early in the nineteenth century

ACT I —Prologue A Court Room in the Moot Hall
 Scene 1 The High Street. A few days later
 Scene 2 Inside "The Boar." The same evening

ACT II —Scene 1 The High Street. Some weeks later
 Scene 2 Peter Grimes' hut

ACT III—Scene 1 The High Street. Three days later
 Scene 2 The same. Early the following morning

(NOTE.—The Management would be grateful if applause were reserved until after the final scene of each act, as the musical action is continuous.

Produced by ERIC CROZIER

Scenery and Costumes by KENNETH GREEN

Scenery made in Sadler's Wells Workshops and painted by Henry Bird. Costumes made in the Sadler's Wells Workrooms under the direction of Maria Garde ; and by H. Sparrow
Properties by Harry Adams (Old Vic Workshops) Joan Cross's Wig by Gustave
 Wigs by "Bert"

THURSDAY EVE., JUNE 7TH SATURDAY EVE., JUNE 9TH

PETER GRIMES

An Opera by BENJAMIN BRITTEN

Libretto by MONTAGU SLATER, based on the poem of George Crabbe

Conductor—REGINALD GOODALL

Peter Grimes (a Fisherman) PETER PEARS
Ellen Orford (the Borough Schoolmistress) ... JOAN CROSS
Auntie (Landlady of "The Boar") EDITH COATES
Her "Nieces" BLANCHE TURNER, MINNIA BOWER
Balstrode (a retired Sea-Captain) RODERICK JONES
Mrs. Sedley (a Widow) VALETTA IACOPI
Swallow (Lawyer and Magistrate) OWEN BRANNIGAN
Ned Keene (Apothecary) EDMUND DONLEVY
Bob Boles (a Methodist Fisherman) MORGAN JONES
The Rector TOM CULBERT
Hobson (The Village Carrier) FRANK VAUGHAN
Doctor Thorp SASA MACHOV
A Boy (Grimes' new apprentice) LEONARD THOMPSON

The People of the Borough : Maude Boughton, Muriel Burnett, Peggy Butler, Rose Carlson, Myfanwy Edwards, Pauline Guy, Hilda Hanson, Netta Legsat, Jean Mountford, Winifred Newnham, Olwen Price, Keturah Sorrell, Molly Wilkinson ; Howard Allport, Gilbert Bailey, William Benn, William Booth, Albert Digney, George Gorst, Eldon Guller, Leonard Hanks, John Havard, Leonard Hodgkinson, Ivor Ingham, Cecil Lloyd, Haydn Meredith, Charles Miller, Arthur Perrow, Erin Tosi, Herbert Tree, Rhys Williams, Vaughan Williams ; Margaret Aspin, Romayne Austin, Barbara Fewster, Fiona Moore

THE STORY OF THE OPERA

In the life of his Suffolk fishing-town Peter Grimes fits uneasily. He lives alone, visionary, ambitious, impetuous, poaching and fishing without caution or care for consequences, and with only one friend in the town—the widowed schoolmistress, Ellen Orford. He is determined to make enough money to ask her to marry him, though too proud to ask her till he has lived down his unpopularity and remedied his poverty.

He fishes with the aid of an apprentice, bought, according to the custom of the time, from the work-house. In the Prologue he is chief witness in an inquest on his first apprentice and the verdict is accidental death. In Act I he is boycotted but obtains a second apprentice, whom Ellen goes to fetch for him and promises to care for. In Act II she discovers he has been using the boy cruelly. Led by the Rector, the landslide under which he moors his boat, and the boy falls down the cliff. When it is discovered that the boy is dead, a hue-and-cry from the Borough sets out to find Peter, who commits suicide by scuttling his boat just out of sight of the town. This is in the small hours of the morning. The Borough wakes up and goes on with its life as usual.

Musical Director LAWRANCE COLLINGWOOD
General Manager BRUCE WORSLEY

Stage Director ERIC BASS
Stage Manager JOHN GREENWOOD
Chorus Master ALAN MELVILLE
Secretary SHEILA FERGUSSON

General Manager ... (for Old Vic and Sadler's Wells) ... GEORGE CHAMBERLAIN

SMOKING IS NOT PERMITTED

In accordance with the requirements of the Lord Chamberlain—

1.—The public may leave at the end of the performance by all exit doors and such doors must at that time be open.

2.—All gangways, passages and staircases must be kept entirely free from chairs or any other obstruction.

3.—Persons shall not in any circumstances be permitted to stand or sit in any of the gangways intersecting the seating, or to sit in any of the other gangways. If standing be permitted in the gangways at the sides and rear of the seating, it shall be strictly limited to the number indicated in the notices exhibited in those positions.

4.—The safety curtain must be lowered and raised in the presence of each audience.

Programme for the opening night of Peter Grimes, at Sadlers Wells, 7 June 1945

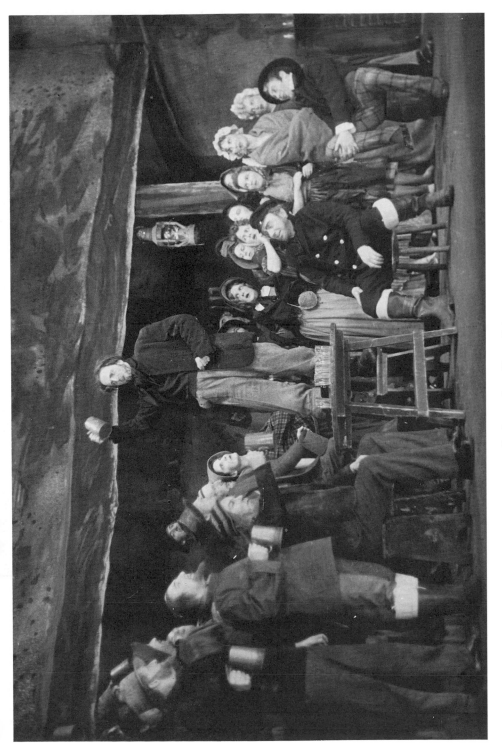

Prologue from Peter Grimes

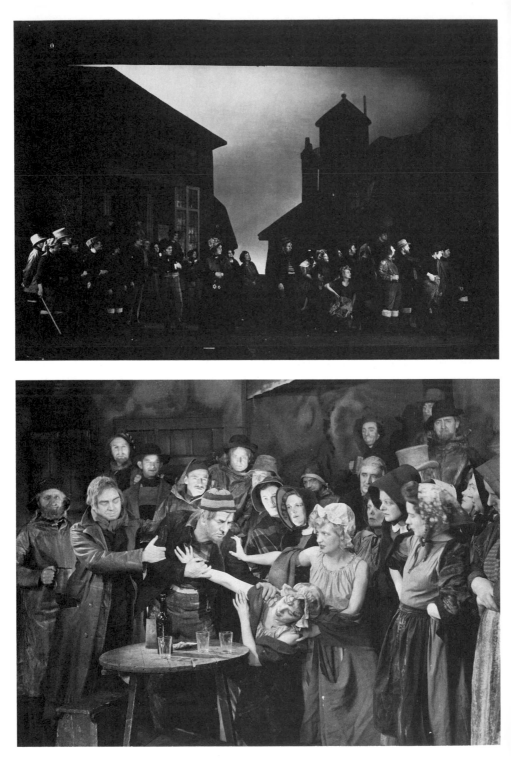

Peter Grimes Act I, Sadlers Wells 1945 (above)
The pub scene in Peter Grimes (below)

Peter Pears as Grimes

Peter Pears as Grimes

'final credibility'; it makes us believe in Grimes as Britten wishes us to. But Kerman hesitates to assent: 'In opera the final credibility is in the music, and Britten can almost make us believe in Grimes though Slater hardly can – Grimes as a man, not a predicament. . . . *Grimes* then must be relegated to that extensive class of operas which fail to meet the standard of an ideal synthesis of music and drama and philosophy that Wagner envisioned; he is in good company there, along with everything that Wagner wrote.'[66] The music tells us what is right and wrong, through the three elements of the opera: the Borough as the overarching power of conformity, Grimes as the rebel, and the sea, standing perhaps for the everlasting forces of the world, in this instance the destructive power of war and violence. The sea determines Peter's life, and it is omnipresent in the opera. In the first production the sea was imagined as being in front of the stage, with the audience as it were forming part of it. Subsequently the sea was placed backstage, with the audience identified with the land, with the Borough.

|❖| 7 |❖|

It was an extraordinary and appropriate coincidence that *Peter Grimes* reopened the Sadler's Wells opera company on 7 June 1945, as both the climax of the company's wartime experience and the beginning of the new world of peace. The story of Sadler's Wells during the war, like the opera itself, testifies to the need to preserve the values of the civilization for which the war was being fought. At the outbreak of war Sadler's Wells included within itself what have subsequently become three of the leading cultural institutions of post-war Britain: the National Theatre, the Royal Opera and the Royal Ballet. The decision to reopen the theatre after the war with *Peter Grimes* had been taken early in the writing of the opera, when Britten had played the Prologue and Act I to the directors of Sadler's Wells.

The theatre, in Rosebery Avenue, London, had closed down with the beginning of the Blitz, on 6 September 1940. It became the London headquarters for the three touring companies (they also played in the New Theatre in London) as well as a home for local people bombed out of their

houses, until the theatre itself suffered minor damage in 1941. The opera touring company performed popular works, keeping opera alive and bringing performances to the provinces.

Tyrone Guthrie, a brilliant director, was the crucial figure in the preservation of this significant part of the cultural life of Britain during the war. After the death of Lilian Baylis he had become head of what might be called a unified public arts programme that included opera, theatre and ballet. The success of that enterprise, and then its disintegration at the end of the war, partially because of one of its greatest successes, *Peter Grimes*, was both a high and low point in Guthrie's career. As he wrote in his autobiography, there was 'a great and necessary clearance of rubbish. Under the stress of war there is an intense liberation of feeling and thought which only such a violent stimulus seems able to achieve.... Public taste [in wartime] was serious. Libraries all over the country reported a rise in the demand for serious and classical books. Sadler's Wells Opera met with enthusiasm in cities not hitherto renowned for musical cultivation. ... The fact that it was during my regime that their [opera, ballet and theatre] courses began to diverge I count the most serious failure of my professional life.'[67]

The opera company had been amazingly successful in continuing its commitment to performing opera in English. Under the leadership of its artistic administrator Joan Cross, who was, in Guthrie's opinion, the greatest British singer of her time, and Lawrance Collingwood as director and musical director, 'the Opera Company went out on provincial tours and delighted thousands who had never seen opera before. It was a tightly knit team with two pianos and Constant Lambert very active on one of them.'[68] It offered the standard repertoire, as well as operas by British composers such as Stanford, Smyth, Holst and Vaughan Williams. The company grew somewhat during the war, as did the orchestra (beyond the two pianos). It toured Oldham, Burnley, Accrington, Stockport and sixty-four other towns, performing *La Traviata, The Marriage of Figaro, Rigoletto, The Magic Flute* and *The Queen of Spades*, the last as 'a gesture toward the Russians'.[69]

As the only opera company really functioning, and also because Pears was a leading member, Sadler's Wells was an obvious choice for *Grimes*. Britten particularly admired Joan Cross, and thought of her as singing Ellen, but it was potentially awkward for Cross, as director of the company, to assign to herself the leading female role. When the company

was performing in Liverpool Britten came there to play the score. As Joan Cross remembers:

> I have a curious recollection of that day that it was one of those dazzling Northern English days, when there was a brilliant sky with scudding clouds. I dimly recollect walking through Liverpool to the funny little studio with an upright piano where he played through it. Of course it was an extaordinary occasion, extraordinary. I can still see those enormously long fingers just simply ripping through that score, absolutely fantastic.[70]

The decision was taken to do the opera, and Guthrie appointed a production team consisting of Eric Crozier as stage director and Reginald Goodall as conductor.

It was a dramatic decision that this new British opera by a composer whose only earlier semi-operatic attempt, *Paul Bunyan*, had been a failure should reopen Sadler's Wells in London. Considering how unsuccessful British operas had been in the past, it was a brave thing to do. Even braver in that Britten was not yet 30; he had done extremely well for one so young, but with his first full-scale operatic venture he was far from being a safe or predictable choice.

Producing *Peter Grimes* was a triumph of the values that the war had professedly been fought for – a great artistic moment. But it was as if, with the coming of peace, the wartime spirit of solidarity began to evaporate. The decision to stage Britten's opera caused great rifts in the company. Certainly it was a factor in the breaking up of the Sadler's Wells group. That singers should rebel against the *status quo* might be thought a function of the growth of the 'democracy' promised in the course of the war. The 'troops' of the company, who had worked extremely hard during the years on the road, were miffed by the turn of events. They would have preferred, and were sure the London audience would have preferred, a more traditional opera to reopen the house. Even those who admired the music of *Grimes* felt that it would hardly appeal to their audience, who, they believed would have liked to hear *Madama Butterfly* or *Faust*.[71] Some even thought that Joan Cross had chosen the opera to provide herself with a leading role. Eric Crozier remembers: 'Various principal singers, for whom there were no parts in the new work, were showing increasing

hostility to the idea of staging *Grimes* at all and had begun a serious agitation to get rid of the director and run the company by committee.'[72] There were murmurs that it was not really appropriate at the end of the war to perform an opera written by a conscientious objector, with a conscientious objector in the title role and another conscientious objector, Crozier himself, as the stage director. Some may even have known of Britten and Pears's relationship and felt that it was favouritism that Pears should have been assigned the leading role.

The singers wanted more control and to be appointed to an executive committee – perhaps almost a 'soviet' – that would take charge of the company. With the end of the war in sight they felt the time was at hand for them to be more generously rewarded, and they were being tempted by talk of a new company to be formed at Covent Garden. In fact, the great triumph of the opera would be followed by mass resignations, and the dissolution of the company that had kept itself together on a shoe-string budget throughout the war.

Rehearsals, which began in February, proved difficult. They began under Crozier's direction while the opera was on tour (giving eight performances weekly), and took place in a Methodist church hall in Sheffield, a gymnasium in Birmingham and a civic hall in Wolverhampton with no time off to celebrate VE Day on 8 May. Britten, characteristically, had kept the abilities of the group in mind, but he was particularly worried about the quality of the orchestra. The company as a whole was not too happy with what it regarded as the modernism of the piece, some referring to it as a 'piece of cacophony'. Eric Crozier recalled an 'unhappy, divided atmosphere':

> Six days before the opening performance at Sadler's Wells, a committee of leading singers met a representative of the Vic–Wells governing body to announce they would not perform at all during the forthcoming season – for which they had already refused to sign contracts – unless the governors appointed them to the executive committee in charge of the company . . . [with power to] hire and fire and decide what operas should be performed. The governors had accepted this ultimatum, and even before the first performance of *Grimes* it was plain that there would be no place at the Wells in future for Britten and his colleagues.[73]

It was a sad irony that the members of the company should have chosen this opera, dealing as it did with the relation of the individual to society, to

launch their claim for majority rule. The unity, perhaps at times rather false, that the war had imposed was rapidly dissipating. Even before the opening of *Grimes* took place, it was known that the company was on the verge of breaking up. (To avoid such situations in the future, and to keep control in his hands, Britten would form, with Crozier, the English Opera Group in 1946, and two years later with Crozier and Pears, the Aldeburgh Festival.)

The opening of *Peter Grimes* was a triumph. There was an extraordinary excitement in the house as the realization dawned that an operatic career of great richness was beginning. 'Not since the time of Purcell and Handel had the country heard such a brilliant new work in the theatre from one of its own composers. After two dull centuries, it signalled a turn of events in which music, in particular opera, would flourish as never before in the land. As Britten himself said later, "I think it broke the ice for British opera."'[74]

On Thursday, 31 May, at Wigmore Hall there was a concert introduction to the work with excerpts sung by Peter Pears and Joan Cross, among others, with Britten at the piano. There had been the rehearsals 'on the road' – taking place at the same time as the company was giving regular performances, and some singers even going off to give concerts on their own – but time only for a fortnight's intense preparation in London.

The concert preview was a hint of glories to come, far different from the real performance a few days later. On the opening night Tyrone Guthrie was in a state of nervous anxiety, fearful that the great chandelier, newly reinstalled in the theatre, would come crashing down. He was aware of Britten's extraordinary achievement, but dismayed at the psychic price it was costing the company. As Joan Cross remembers, '"Good luck! Whatever happens we were right to do this piece," was Tyrone Guthrie's not overenthusiastic encouragement to me just before the curtain went up on the first night. He reflected the doubts and anxieties current in the company. The overwhelming success of that first night is now operatic history.'[75] In a different version of the story Cross remembers 'Guthrie coming into my dressing room, looking me straight in the eye and saying whatever happens it was absolutely right to do this piece. I did not know what he was talking about; it had never occurred to me really and truly that we should have done anything else.'[76]

Beverley Baxter, present at the opening night to cover the event for the *Evening Standard*, took note that 'the audience included almost every eminent musician in London from the veteran Vaughan Williams to the still youthful Willie Walton, as well as that most welcome visitor, Yehudi Menuhin'. But he struck a more serious note when he said that *Peter Grimes* represented the possibility that London might 'become the artistic centre of the world if we avoid insularity and welcome the stranger in our midst'.[77] Along with all the eminent musicians, many young people in uniform attended as well as those figures of fashion who somehow always make it to a major première. For some, no doubt, the opera was too 'modern' to be acceptable and it took a while for Britten to become a deeply loved and 'popular' composer, but it was not hindsight for the majority of those who were at those first performances (though some boos and hisses were heard among the applause) to feel that they were present at something deeply memorable. Leonard Thompson, who played the mute role of the apprentice, remembered that 'when the curtain came down there seemed to be an interminably long silence, then wave upon wave of applause'.[78]

E. M. Forster, who had played a role, although indirectly, in bringing the opera into being, included a discussion of the première in a broadcast he made to India on 5 July 1945: 'I have just been for the second time to an opera by a young English composer, Benjamin Britten. It seems to me a great work, both musically and emotionally. . . . one of the greatest things I have ever seen on the operatic stage.'[79]

Ironically, the opera was the precipitating factor in the closing of the Sadler's Wells company as it had existed up to that time. The eternal friction between society and the independent and innovative individual was being reproduced in the theatre. Many of the singers, playing the residents of the Borough, were unhappy with this new opera, although they were professional enough to give good performances. But when a recording of *Grimes* was scheduled for the British Council the singers instead opted to go on a tour for ENSA, an organization established to entertain the troops. The governors, yielding to the pressures exerted by the company, said that they would close the theatre and form a new company, promising to rehire all the singers. Eric Crozier believes that the governors too distrusted '*Peter Grimes* and Britten's music as something alien to their own tastes and experience'. After the brave moment of

decision the more conventional forces would gain their end. 'The *coup-de-grâce* was given', Crozier wrote, 'in an ingenious and totally unexpected manner. At the end of the last performance of *Grimes*, when a widely enthusiastic audience was cheering the cast and the composer, the iron safety-curtain was suddenly lowered – presumably in case the audience's excitement should lead to a demonstration. (This last performance of *Grimes* was, incidentally, Joan Cross's farewell performance after 21 years at the Old Vic and Sadler's Wells.) . . . A theatre dominated by its singers, as the Wells unhappily appears to be now, will not risk experiment.'[80]

Peter Grimes was performed several times during that season and rapidly established itself as part of the international repertoire. In August 1946 it was given its American première in a not very adequate student production conducted by Leonard Bernstein at Tanglewood. Koussevitzky urged Britten to come to Tanglewood for the performance, and he did, as did Eric Crozier to help out with the production. In the next few years it was performed in New York, Stanford and San Francisco (by the Stanford Players) in May and June 1948, and in Stockholm, Basle, Antwerp, Zurich, Milan and Budapest.[81]

Eric Walter White remarked about the opening performance:

> The orchestra might be too small to do full justice to the interludes, the stage space too cramped for the full sweep of the action, the idiom of the music unfamiliar, the principals and chorus under-rehearsed, yet the impact of the work was so powerful that when the final chorus reached its climax and the curtain began to fall slowly, signifying not only the end of the opera but also the beginning of another day in the life of the Borough, all who were present realized that *Peter Grimes*, as well as being a masterpiece of its kind, marked the beginning of an operatic career of great promise and perhaps also the dawn of a new period when English opera would flourish in its own right.[82]

Not all the reviews were enthusiastic – initial reactions to what are later established as masterpieces are rarely uniformly praising – but there can be no question that the opera was an immediate popular success. Preston Benson wrote in the *Star* that Grimes's suicide made him think 'of a tortured victim of Hitler left in his cell with a loaded revolver'. *The Times*

remarked, 'It is a good omen for English opera that this first-fruit of peace should declare decisively that opera on the grand scale and in the grand manner can still be written.'

Grimes represented a new cultural flowering and power. The special national significance of the occasion was suggested in the highly popular magazine *Picture Post* in its issue of 30 June. Its reviewer announced that the arrival of *Grimes* 'will be remembered as the reinstatement of opera in the musical life of this country. The absence of opera in British music was a void which could be filled only by a national work in the true sense. Without a truly British production opera remained an exotic bird which never nested here.'

Peter Grimes was both an intense reaction to the human condition and a particular statement about the preservation of values – even if not conventional – on behalf of the individual against the rest of society. The importance of the willingness to allow nonconformity is particularly significant when a society is under siege. Britain was fighting for humane values, but it is frequently true that an endangered society tends to be far less tolerant, even though it may wage war in the name of freedom. One does not wish to blame those who were against putting on *Peter Grimes* – they too were claiming their right to think as they wished – but their resistance made even more vivid the point in the opera about the power of the Borough to demand conformity.

In the 1930s, when Britten was at his most overtly political, he had written music for a pacifist march with agitprop text by Ronald Duncan, which began: 'March, / Strike to resist / Strong with force / Not with fist / Against all war / We shan't cease / To construct for peace.' In a far subtler way Britten was still fighting in his music against the power of violence, even when his central figure was so full of it. Though in many ways a happy man, Britten also had a strain of melancholy and suffered black moods.

Grimes, the character, represented the individual struggling to be free, but also demonstrated the dangers that lurked in the human personality. Violence is all about us, and within us, as is suggested, inevitably, by a state at war. In the opera Britten 'strengthened what was for him the major theme – the individual against the crowd – by emphasising more consistently the isolation of Grimes implicit in Act I, where it is symbolised musically by the rising minor ninth of his first aria'.[83] Andrew Porter also

dwells on the use of the minor ninth and its symbolic importance as an image of inner emotion – in *Grimes* for the individual against society, and, by implication, the need to preserve humane values in time of war. 'When I first visited Aldeburgh,' Porter writes:

> Benjamin Britten lived on the edge of the sea. A flag flew before his house, and on it was blazoned the musical theme heard in the second scene of *Peter Grimes* to the words 'We strained into the wind.'

We strained in - to the wind

One of the principal themes of the opera, it finds its major statement [and the introduction of the rising minor ninth motif] at Grimes's questions 'What harbour shelters peace? . . . What harbour can embrace terrors and tragedies?'

What har - bour shel-ters peace?

Those questions, and attempted answers to them, have been the main theme of many of Britten's works.

Porter points out that the minor ninth is heard at the time of Tarquin's death in *Lucretia* and in Billy Budd's lullaby on the eve of his execution. And at the end of Britten's last opera, *Death in Venice*, 'the vibraphone plays a final, shimmering transformation of the "What harbour shelters peace?" motif from *Grimes*.'[84] For Britten the answer was in his music. He had within himself a sense of a persecuting society, and he responded to it with the terror and tragedy of Peter Grimes, 'destroyed by the forces of convention ranged against him and by his inability either to come to terms with or to conquer them.'[85]

One way in which the opera was connected with the war was vividly captured by the great American critic Edmund Wilson. He had come to London in June 1945 and was taken to an early performance of the opera. He had heard some Britten earlier, the *Sinfonia da Requiem*, and hadn't liked

it very much, but *Peter Grimes* made a powerful impression, in a London still devastated by the war in the very first days of European peace:

> I do not remember ever to have seen, at any performance of opera, an audience so steadily intent, so petrified and held in suspense, as the audience of *Peter Grimes*. This is due partly to the dramatic skill of Britten, but is due also to his having succeeded in harmonizing, through *Peter Grimes*, the harsh, helpless emotions of wartime. This opera could have been written in no other age, and it is one of the very few works of art that have seemed to me, so far, to have spoken for the blind anguish, the hateful rancors and the will to destruction of these horrible years. Its grip on its London audiences is clearly of the same special kind as the grip of the recent productions of *Richard III* and *The Duchess of Malfi*. . . . By the time you are done with the opera – or by the time it is done with you – you have decided that *Peter Grimes* is the whole of bombing, machine-gunning, mining, torpedoing, ambushing humanity, which talks about a guaranteed standard of living yet does nothing but wreck its own works, degrade or pervert its own moral life and reduce itself to starvation. You feel, during the final scenes, that the indignant shouting trampling mob which comes to punish Peter Grimes is just as sadistic as he. And when Balstrode gets to him and sends him out to sink himself in his boat, you feel that you are in the same boat as Grimes.[86]

|❖| 8 |❖|

'This opera could have been written in no other age.' So, too, Moore's shelter drawings and Jennings' *Fires Were Started*. These works belong inseparably, despite all their differences, to the age that called them into being, the seven years of the Second World War.

Arriving at the end of our study, we return to its starting point: 'Our theme is the relation between art and war, or war and art – the question of precedence is not negligible.' War, as we have seen, provides the artist with a particular subject; what is made of it is the work of art. Obviously, had it not been for the war, there would have been no shelterers in the London

Underground waiting for Moore, no fire raids on London waiting for Jennings. In each case, however, the artist brought to the subject those elusive and significant elements: his own vision, his own sensibility. The artless reality that confronted him was realized in the work of art as we know it, in ways that he may not have initially recognized or consciously intended.

Moore chose the shelters as they came into being after the year of the phoney war ended and the Blitz began. He was working in the present tense, so to speak, as a witness to the event and the phenomenon that inspired him. Jennings, also a witness, chose to make his film about the Auxiliary Fire Service just after the Blitz ended, wanting to record a kind of plain-speaking civilian heroism that was becoming 'historical' and which he felt deserved to be remembered. The crowds who streamed down into the Underground night after night for shelter against the air raids were a collective subject for Moore. In *Fires Were Started* we share the day and night experience of a group of ordinary Londoners, more individualized than Moore's shelterers, but of interest chiefly in their collective identity as a company of volunteer firemen and women.

The focus changes dramatically in *Peter Grimes*, closing in on the individual against a hostile (or indifferent) society, the people of the Borough, that in the end will bring about Grimes's destruction. After the stoic endurance of Moore's shelterers, and the understated courage and heroism of Jennings' firemen, it comes as a shock to encounter the passion, anger and despair of Britten's *Grimes* at the darkling end of the spectrum of war art.

Moore and Jennings were, as we have said, witnesses. They were there, in London, during the most dangerous and pulverizing time of the war. Their art was essentially externalized: because they were there, in the public and universal thick of it, they could generalize; they felt no need to immerse themselves in the depths and complexities of the individual tragedy. For Britten it was very different. He was not a witness, he was not there, he was an exile. Which is not to say that he was unaware of the war or did not suffer inwardly because of it. Indeed, the complex of feelings within him – not simply because he was a homosexual or a pacifist – may have been even more painful because, as an artist, he had yet to find an objective correlative to that tumult of inward feeling. Ultimately he would find it – in the summer of 1942 in Crabbe's 'Peter Grimes'. The libretto for *Paul*

Bunyan, written in America in the latter months of the Blitz, though a diverting challenge to Britten, had inevitably left untapped his deepest feelings. The transformation of Crabbe's 'Peter Grimes' into Britten's *Peter Grimes*, which he began on his way back to England in 1942 and brought to a triumphant conclusion there in 1945, would prove a landmark in his own art, in the art of the Second World War, in the art of this century.

NOTES
❖ | ❖ | ❖ |

PART 1: MOORE, NASH AND SUTHERLAND

1 Alan G. Wilkinson, *The Drawings of Henry Moore* (London, 1977), p. 103. The exhibition began in Ontario in 1977, went on to three cities in Japan, and ended at the Tate Gallery, London, in June 1978.

2 Donald Hall, *Henry Moore* (London, 1966), p. 32.

3 Roger Berthoud, *The Life of Henry Moore* (New York, 1987), pp. 42–3.

4 Vera Russell and John Russell, 'Conversation with Henry Moore', *Sunday Times*, 17 December 1961, pp. 17 18.

5 Ibid.

6 Susan Compton, *Henry Moore* (London, 1988), p. 171.

7 Quoted in William Packer, *Henry Moore* (London, 1985), p. 69.

8 Henry Moore, *Heads Figures and Ideas* (London, 1958), no pagination.

9 Quoted in Joseph Darracott, *Henry Moore War Drawings* (n.p., n.d.), no pagination.

10 Herbert Read, *The Meaning of Art* (London, 1931), pp. 250–7; quoted in *Henry Moore: The Reclining Figure* (Columbus, Ohio, 1984), p. 130.

11 David Baxendall, *Art Then: Eight English Artists, 1924–40* (n.p., 1974), no pagination.

12 Moore to Clark, 1 October 1939, Sir Kenneth (Lord) Clark Papers, Tate Gallery Archives.

13 Moore to Clark, 23 December 1939, Clark Papers.

14 Quoted in James Johnson Sweeney, *Henry Moore* (New York, 1946), pp. 64–7.

15 John Hedgecoe and Henry Moore, *Henry Moore* (London, 1968), pp. 132–3.

16 Kenneth Clark, *The Other Half* (London, 1977), pp. 9–16.

17 Imperial War Museum, War Artists Archives, GP/72/A, fo. 2.

18 Clark, *The Other Half*, p. 43.

19 Julian Andrews, interview, 26 July 1984. For two recent studies of war artists see Meirion Harries and Susie Harries, *The War Artists: British Official War Art of the Twentieth Century* (London, 1983), and Alan Ross, *Colours of War: War Art 1939–45* (London, 1983).

20 Details from Andrew Causey, *Paul Nash* (Oxford, 1970).

21 *Paul Nash: Paintings, Watercolours and Graphic Work* (London, 1980), p. 5.

22 Nash to Robert Byron, 8 September 1939, transcript by A. Bertram, Tate Gallery Archives, Tan 38 26 35/2, fo. 14.

23 Paul Nash, 'Letter from Oxford', *Listener*, 30 November 1939, pp. 1065–7. See Lionel Esher, 'The Plot to Save the Artists', *Times Literary Supplement*, 2 January 1987, pp. 12–13, for a discussion of another scheme along similar lines attempted by the author's father, Lord Esher, with the co-operation, among others, of John Betjeman.

24 Clark to Nash, 28 September 1939, Microfilm, Tate 7050 12/14, fos. 357–8.

25 Clark to Betjeman, 9 September 1939, Tate 7050 12/15, fo. 408.

26 Clark, *The Other Half*, p. 21.

27 Tate 7050/4, fo. 2.

28 Tate 7050/24, fo. 27.

29 Clark to Crossley, n.d., IWM GP/55/13(1), fo. 103.

30 IWM GP/72/D(1), fo. 72.

31 IWM GP/72/D(1), fo. 115.

32 Nash to Dickey, 22 October 1940, IWM GP/55/13, fo. 42.

33 Reprinted in Paul Nash, *Outline: An Autobiography* (London, 1949), p. 26.

34 Ibid., p. 263; originally published in *Counterpoint* (1945).

35 Peake to Nash, 10 November 1940, Tate 7050/47, fo. 57.

36 War Artists' Advisory Committee minutes, 3 July 1941, IWM.

37 Clark to Nash, 3 March 1941, copy, IWM GP/55/13(1), fo. 114.

38 Dickey to Clark, 4 July 1941, copy, IWM GP/72/E1, fo. 154.

39 Clark to Nash, 31 October 1940, Tate 7050/45, fo. 55.

40 Nash to Clark, 21 November 1941, Clark Papers.

41 Clark to Nash, 22 November 1940, copy, IWM GP/55/13(C1), fo. 68.

42 Lillian Browse to Nash, n.d., Tate 7050 12/11, fo. 87.

43 Nash to Barbara Bertram, n.d., Stanford University Libraries.

44 Nash to Seddon, 4 April 1941, Tate Tam 38 35/2.

45 See pls. 92–4 in Andrew Causey, *Paul Nash's Photographs: Document and Image* (London, 1973).

46 Clark to Nash, 27 August 1940, copy, IWM GP/55/13, fo. 27.

47 Piper to Nash, 3 September 1940, Tate 7050 12/33.

48 Eric Newton, *Paul Nash Memorial Exhibition* (London, 1948), pp. 7–8.

49 *Spectator*, 6 September 1940.

50 Nash to Clark, 11 March 1941; Nash to Dickey, 20 March 1941, IWM GP/55/13(1), fos. 127, 129.

51 Nash to Dudley Tooth, November 1943, carbon, Tate 8127.6, fos. 4–5.

52 Dickey to Nash, 13 March 1941; Clark to Nash, 15 March 1941, Tate 7050 12/13.

53 Tate 7050 12/34, fos. 157–8.

54 IWM GP/55/13(1), copy, fo. 175.

55 Dickey to Nash, 17 July 1941, copy, IWM GP/55/13, fo. 176.

56 Clark to Nash, 22 October 1941, Tate 7050 12/32.

57 Nash to Clark, 23 October 1941, Clark Papers.

58 Clark, *The Other Half*, p. 21.

59 Kenneth Clark, 'The Artist in Wartime', *Listener*, 26 October 1939.

60 See Sarah Griffiths, 'War Painting: A No-Man's Land Between History and Reportage', *Leeds Art Calendar*, 78 (1976), pp. 24–32.

61 Clark, *The Other Half*, pp. 23–4.

62 Clark to Rothenstein, 14 October 1941, Rothenstein Papers, Houghton Library, Harvard University.

63 Henry Moore, interview with the authors, 13 April 1983.

64 Constantine FitzGibbon, *The Blitz* (London, 1957), p. 15.

65 *Picture Post*, 19:19, 5 October 1940.

66 See Joanna Mack and Steve Humphries, *London at War* (London, 1985), p. 53.

67 Attlee Papers, Bodleian Library, Oxford.

68 Euan Wallace, diary entry, 24 September 1940, Euan Wallace Papers, Bodleian Library, Oxford.

69 Angus Calder, *The People's War: Britain 1939–45* (London, 1969), p. 568. Life in the shelters was closely examined by Mass-Observation, and its records can be found in the archives at the University of Sussex. There is a small selection of these reports in Tom Harrisson (one of the founders of Mass-Observation), *Living Through the Blitz* (London, 1977), and Angus Calder and Dorothy Sheridan, *Speak for Yourself: A Mass-Observation Anthology 1937–49* (London, 1984).

70 FitzGibbon, *The Blitz*, p. 157. The book uses as illustrations eight shelter drawings by Moore.

71 Figures from Susan Briggs, *Keep Smiling Through* (London, 1975), p. 64.

72 See Richard M. Titmuss, *Problems of Social Policy* (London, 1950), pp. 343, 559, 589.

73 Henry Pelling, *Britain and the Second World War* (London, 1970), p. 28.

74 Darracott, *Moore*, no pagination.

75 Charles Graves, *London Transport at War* (London, 1978), p. 43.

76 Quoted in Calder, *People's War*, p. 154.

77 See Pelling, *Britain*, pp. 94–5.

78 Henry Moore, *Shelter Sketch-Book with 80 Facsimile Collotypes* (Berlin, 1967), no pagination.

79 Mass-Observation Archives, University of Sussex.

80 FitzGibbon, *The Blitz*, p. 151. The fashionable sought more elegant shelter in hotel basements.

81 Mack and Humphries, *London at War*, p. 63.

82 Henry Moore, *80th Anniversary Exhibition* (Bradford, 1978), no pagination.

83 Philip James (ed.), *Henry Moore on Sculpture* (London, 1966), p. 212.

84 Robert Melville, *Henry Moore Shelter Sketch-Book 1940–42* (London, 1972), p. 95.

85 Wilkinson, *The Drawings*, p. 31.

86 Gemma Levine, *Henry Moore: The Artist at Work* (London, 1978), p. 25.

87 Wilkinson, *The Drawings*, p. 32.

88 FitzGibbon, *The Blitz*, p. 149.

89 Quotations from contemporary accounts given in Harrisson, *Living Through the Blitz*, pp. 117–18.

90 Sweeney, *Moore*, p. 68. In appreciation, Moore eventually gave this notebook to Clark's wife, Jane, and she bequeathed it to the Department of Prints and Drawings in the British Museum. It has now been published: Henry Moore, *A Shelter Sketch Book*, with a commentary by Frances Carey (London, 1988).

91 Kenneth Clark, *Henry Moore Drawings* (London, 1974), p. 83.

92 Clark, *The Other Half*, p. 42.

93 Kenneth Clark, 'Hindsight', in Tom Hopkinson (ed.), *Picture Post* (London, 1984), p. 140.

94 Robert Melville, *Henry Moore* (Madrid, 1981), p. 20.

95 Dickey to Burke, 19 December 1940, copy, War Artists' Advisory Committee Papers, IWM GP/72/D(2), fo. 307.

96 Dickey to Moore, 4 January 1941, copy, IWM GP/55/104, fo. 2. Also see Moore to Clark, 5 January 1941, Clark Papers.

97 Dickey to Moore, 13 January 1941, copy, IWM GP/55/104, fo. 4.

98 Moore to Clark, 30 March 1941, Clark Papers.

99 WAAC minutes, 23 April, 7 May 1941, IWM GP/72/E1, fos. 67, 83.

100 Wilkinson, *The Drawings*, p. 32.

101 IWM GP/55/104, 14 August 1941, fo. 20.

102 IWM GP/55/104, 14, 19 August 1941, fos. 21, 23.

103 Levine, *Moore*, p. 25.

104 Moore, *Shelter Sketch-Book* (1967), no pagination.

105 Ibid.

106 Gordon Onslow-Ford, 'The Wooden Giantess of Henry Moore', *London Bulletin* (June 1940), p. 10.

107 Hedgecoe and Moore, *Moore*, p. 140.

108 Alan G. Wilkinson, 'The Drawings of Henry Moore' (Ph.D. thesis, Courtauld Institute of Art, University of London, 1974), p. 305.

109 *Moore* (1981), p. 18.

110 Hedgecoe and Moore, *Moore*, p. 140.

111 Moore, *Shelter Sketch-Book* (1967), no pagination.

112 Wilkinson, 'The Drawings of Henry Moore', p. 309.

113 Ibid., p. 304.

114 Tom Hopkinson, *Of This Our Time* (London, 1982), p. 227.

115 Ibid., p. 229.

116 Paul Overy, 'Looking Back on Henry Moore', *The Times*, 16 May 1978.

117 *Lilliput*, 66:6 (December 1942), pp. 473–82.

118 Clark, *Moore Drawings*, p. 150.

119 Information from the Henry Moore Foundation. See Moore, *Shelter Sketch-Book* (1967).

120 Clark, *Moore Drawings*, p. 150.

121 Clark, Ibid., p. 227.

122 A. D. B. Sylvestre, 'The Shelter Drawings', *Graphis*, 16 (April 1946).

123 Keith Roberts, 'War Drawings', *Burlington Magazine*, 118 (July 1976), p. 539.

124 Quoted in Darracott, *War Drawings*, no pagination.

125 Ibid.

126 Herbert Read, introduction to Sylvester, *Henry Moore*, vol. 1, p. xxvii.

127 Moore, *Shelter Sketch Book* (1967), no pagination.

128 IWM GP/55/104, fo. 31.

129 Sweeney, *Moore*, p. 68.

130 IWM GP/55/104, fo. 58.

131 See Monroe Wheeler (ed.), *Britain at War* (New York, 1941).

132 Stephen Spender, introduction to *War Pictures by British Artists*, 2nd ser., Air Raids (Oxford, 1943), pp. 5–6.

133 Moore, interview.

134 Lillian Browse, interview, 17 October 1983.

135 Kenneth Clark, *More Details from Pictures in the National Gallery* (London, 1941), p. iv.

136 Clark, *Moore Drawings*, p. 149.

137 Herbert Read, 'The Drawing of Henry Moore', *Art in Australia* (September–November 1941).

138 See Ronald Alley, *Graham Sutherland* (London, 1982), p. 65.

139 Clark to K. Sutherland, 5 September 1939; Clark to G. Sutherland, 13 September 1939, Picton Castle Trust microfiche, Tate Tam 67/3, fos. 161–2, 163.

140 Graham Sutherland, 'Images Wrought from Destruction', *Daily Telegraph*, 1 September 1971; reprinted in Roberto Tassi (ed.), *Sutherland: The Wartime Drawings* (London, 1980), p. 20.

141 Sutherland to Dickey, 7 August 1940, IWM GP/55/57, fo. 9.

142 Dickey to Sutherland, 3 August 1940, copy, IWM GP/55/57, fo. 6.

143 Dickey to Sutherland, n.d., IWM GP/55/57, fo. 10.

144 Clark to Sutherland, 9 July 1943, Picton microfiche, Tate Tam 67/4, fo. 176.

145 Minutes, 1 January 1941, IWM GP/72/D(2), fo. 327.

146 Tassi (ed.), *Sutherland*, p. 19.

147 Ibid.

148 V. S. Pritchett, Graham Sutherland, Sir Kenneth Clark and Henry Moore, 'Art and Life', *Listener*, 13 November 1941, pp. 657–9.

149 Sutherland to Eric Newton, n.d., Picton, Tate.

150 Roger Berthoud, *Graham Sutherland* (London, 1982), p. 87.

151 Julian Andrews, 'Graham Sutherland and the War Artists' Advisory Committee', in Tassi (ed.), *Sutherland*, p. 167.

152 IWM GP/72/D(2), 9 April 1941, fo. 54. In July the committee acquired a further three pictures, and in September a further four (IWM GP/72/E(2), 30 July, 10 September 1941, fos. 173, 217).

153 Douglas Cooper, *The Work of Graham Sutherland* (New York, 1961), pp. 25, 63.

154 Hendy to Clark, 30 April 1941, copy, Leeds City Art Gallery Archives.

155 Jane Clark to Hendy, 5 May 1941, Leeds Archives.

156 Clark to Hendy, 30 June 1941, Leeds Archives.

157 Moore to Hendy, 29 June 1941, Leeds Archives.

158 Clark to Hendy, 29 July 1941, Leeds Archives. He also noted in the letter that, if there were a second edition of the catalogue, Moore wanted all of Clark's Moores to be listed as belonging to him.

159 *Henry Moore, John Piper, Graham Sutherland* (Leeds, 1941), p. 2.

160 Hendy to Clark, 4 February 1941, Leeds Archives.

161 Moore to Hendy, 25 July 1941, Leeds Archives.

162 Sutherland to Hendy, 29 August 1941, Leeds Archives.

163 *Moore, Piper, Sutherland*, p. 4.

164 Hendy to Clark, 7 November 1941, copy, Leeds Archives.

165 Kenneth Clark, 'Dean Walter Hussey', in *Chichester 900* (Chichester, 1975), p. 72.

166 *Peter Pears: A Tribute on His 75th Birthday* (London, 1985), p. 48.

167 Sutherland to Hussey, 30 May 1945, in Joan Kinneir (ed.), *The Artist by Himself* (New York, 1980), p. 145.

168 See Michael Nicholas, *Muse at St. Matthew's* (Northampton, n.d.).

169 Sweeney, *Moore*, p. 77.

170 Williamson to Hussey, 16 December 1942, in Walter Hussey, *Patron of Art* (London, 1985), p. 25.

171 Moore to Hussey, 23 June 1943, in Hussey, *Patron*, p. 28.

172 Clark to Hussey, 26 July 1943, in Hussey, *Patron*, p. 30.

173 Hussey to Clark, 28 July 1943, Clark Papers.

174 Moore to Hussey, 26 August 1943, Hussey, *Patron*, pp. 32–3.

175 Moore to Hussey, 11 September 1943, in Hussey, *Patron*, p. 33.

176 Hussey, *Patron*, pp. 37–9.

177 Ibid., pp. 40–2.

178 Nicholas, *Muse*, no pagination.

179 Moore to Juliette Huxley, 14 April 1944, Julian Huxley Archives, Rice University, Houston, Texas.

180 Wilkinson, *The Drawings*, p. 311.

181 John Russell, *The Henry Moore Gift* (London, 1978), p. 12.

182 Melville, *Moore*, p. 22.

183 John Russell, 'Henry Moore at 80', *Smithsonian* (August 1978), p. 80.

184 Melville, *Moore*, p. 53.

185 Clark, *The Other Half*, p. 24.

PART 2: HUMPHREY JENNINGS

1 Robert Vas (ed.), *The Heart of Britain*, 1969, transcript of television interviews on Jennings, British Film Institute Archives, London, p. 5.

2 Mary-Lou Jennings, *Humphrey Jennings* (London, 1982), p. 6.

3 *Two Plays from the Perse School with a Preface by Dr W. H. D. Rouse and an Introduction on Dramatic Teaching in Schools by F. C. Happold* (Cambridge, 1921).

4 For bibliographical material about Jennings see Mary-Lou Jennings, 'Humphrey Jennings and This Book', in Humphrey Jennings, *Pandemonium*, ed. Charles Madge and Mary-Lou Jennings (London, 1985).

5 Vas (ed.), *Heart of Britain*, p. 5.

6 See Roland Penrose, *Scrap Book 1900–1981* (London, 1981), p. 78.

7 M.-L. Jennings, *Jennings*, p. 11.

8 Rachel Low, *Documentary and Educational Films of the 1930s* (London, 1979), p. 86.

9 Lindsay Anderson, 'Only Connect', originally published in 1954, postscript to M.-L. Jennings, *Jennings*, p. 59.

10 Ian Dalrymple, 'Humphrey Jennings OBE', *British Film Academy Quarterly* (January 1951), pp. 2–3.

11 Humphrey Jennings and J. B. Holmes, 'The Documentary Film', n.d., BFI Archives, pp. 2–5.

12 Quoted in Donald Mitchell, *Britten and Auden in the 1930s* (Seattle, 1981), p. 61.

13 Mitchell, *Britten and Auden*, p. 86.

14 Clive Coultass, 'British Feature Films and the Second World War', *Journal of Contemporary History*, 19:1 (January 1984), p. 9.

15 See Charles Harrison, *English Art and Modernism 1900–1939* (London, 1981); Dennis Farr, *English Art 1870–1940* (Oxford, 1978); and Paul C. Ray, *The*

Surrealist Movement in England (Ithaca, NY, 1971), for a discussion of surrealism in Britain.

16 Humphrey Jennings, 'In Magritte's Paintings', *London Bulletin* (April 1938).

17 Quoted in Philip Strick, 'Fires Were Started', *Films and Filming* (May 1961), p. 15.

18 Humphrey Jennings, 'The Iron Horse', *London Bulletin*, 3 (June 1938), p. 22.

19 Ibid., p. 23.

20 Humphrey Jennings, 'Do Not Lean out of the Window!', *London Bulletin* 4–5, (July 1938), pp. 13–14.

21 See M.-L. Jennings, *Jennings*, p. 14.

22 Julian Trevelyan, *Indigo Days* (London, 1957), p. 82.

23 M.-L. Jennings, *Jennings*, pp. 16–17.

24 Humphrey Jennings *et al.* (eds.), *May the Twelfth: Mass-Observation Day-Survey 1937 by over Two Hundred Observers* (London, 1937), p. ix.

25 For information on the founding of Mass-Observation see Angus Calder and Dorothy Sheridan (eds.), *Speak for Yourself: A Mass-Observation Anthology, 1937–49* (London, 1984); see p. 62 for Jennings' involvement with *May the Twelfth*.

26 Anthony W. Hodgkinson, 'Humphrey Jennings and Mass-Observation: A Conversation with Tom Harrisson', *Journal of the University Film Association*, 27:4 (Fall 1975), p. 32.

27 Ibid., p. 33.

28 Dalrymple, 'Jennings', p. 3

29 Evelyn Waugh, *Put Out More Flags* (London, 1961; first published 1942), pp. 31, 109.

30 Public Record Office, Ministry of Information, INF 1/81.

31 Gerald Noxon, 'How Humphrey Jennings Came to Film', *Film Quarterly*, 15:2 (Winter 1961–2), p. 25.

32 PRO, INF 1/81.

33 See Frances Thorpe and Nicholas Pronay with Clive Coultass, *British Official Films in the Second World War: A Descriptive Catalogue* (Oxford, 1980), p. ix.

34 Philip M. Taylor, Introduction to Philip M. Taylor (ed.), *Britain and the Cinema in the Second World War* (New York, 1988), p. 7.

35 See Michael Balfour, *Propaganda in War 1939–1945* (London, 1979), p. 71.

36 Ibid., p. 53.

37 Alfred Duff Cooper, one time Minister of Information, quoted in Thorpe and Pronay, *British Official Films*, p. 19.

38 Ibid., pp. 28–30.

39 Ibid., p. 30.

40 R. J. Minney, *Puffin Asquith* (London, 1973), pp. 102–3.

41 Ian McLaine, *Ministry of Morale* (London, 1979), p. 178. Also see pp. 82 and 93.

42 Thorpe and Pronay, *British Officials Films*, pp. 34–5.

43 Clark to Ian McLaine, 30 May 1974, in McLaine, *Ministry*, p. 217.

44 Kenneth Clark, *The Other Half* (London, 1977), p. 14.

45 Thorpe and Pronay, *British Official Films*, pp. 36–7.

46 Roger Manvell, foreword to Anthony W. Hodgkinson and Rodney E. Sheratsky, *Humphrey Jennings: More Than A Maker of Films* (Hanover, 1982), pp. xii–xiii.

47 Helen Forman, 'The Non-Theatrical Distribution of Films by the Ministry of Information', in Nicholas Pronay and D. W. Spring (eds.) *Propaganda, Politics and Film 1918–1945* (London, 1982), p. 224.

48 Basil Wright, *The Long View* (London), p. 200.

49 See Dilys Powell, *Films since 1939* (London, 1948), p. 63.

50 Ian Dalrymple, 'The Crown Film Unit, 1940–43', in Pronay and Spring (eds.), *Propaganda*, p. 212.

51 Thorpe and Pronay, *British Official Films*, pp. 38–9.

52 Alfred Duff Cooper, *Old Men Forget* (London, 1953), pp. 285–8.

53 Clark, *The Other Half*, p. 18.

54 Clark to James Lees-Milne, 27 May 1978, in James Lees-Milne, *Harold Nicolson* (London, 1981), vol. 2, p. 145.

55 Harold Nicolson, diary entry, 22 September 1940, Diaries, Balliol College, Oxford.

56 Lees-Milne, *Nicolson*, p. 130.

57 Diary entry, 18 July 1941. The text, a quotation from Tacitus, reads: 'By everyone's consent he was capable of governing, had he never governed.'

58 Ministry of Information, INF 1/58.

59 Wright, *The Long View*, pp. 199–200.

60 M.-L. Jennings, *Jennings*, p. 27.

61 Hodgkinson and Sheratsky, *Jennings*, p. 132. There are detailed accounts of all of Jennings' films in app. A, pp. 111–73. The same film was shown in the US under the title *This is England*, with the narration by Ed Murrow (Thorpe and Pronay, *British Official Films*, p. 81).

62 Jennings to Cicely Jennings, March 1941, in M.-L. Jennings, *Jennings*, p. 27. In the text the film is confused with *Words for Battle*.

63 Roy Armes, *A Critical History of the British Cinema* (New York, 1978), p. 153. The exact passages quoted are listed in M.-L. Jennings, *Jennings*, p. 28.

64 Jennings to Cicely Jennings, March 1941, in M.-L. Jennings, *Jennings*, p. 27.

65 Jennings to Cicely Jennings, 13 September 1941 (courtesy of Mary-Lou Jennings).

66 William Feaver, *Observer*, 17 January 1982.

67 Kenneth Clark, 'Concerts in the National Gallery', *Listener*, 2 November 1939.

68 Clark, *The Other Half*, p. 28.

69 See Howard Ferguson (ed.), *Myra Hess by her Friends* (London, 1966), particularly Joyce Grenfell, 'Julia M.'; Howard Ferguson, 'The National Gallery Concerts and After' (p. 99 for the figures); and 'Works played by Myra Hess at the National Gallery Concerts'(pp. 111–13).

70 Armes, *British Cinema*, p. 154.

71 Point made in Dai Vaughan, *Portrait of an Invisible Man: The Working Life of Stewart McAllister, Film Editor* (London, 1983), p. 99.

72 Gavin Lambert, 'Jennings' Britain', *Sight and Sound*, (May 1951), p. 25.

73 Manuscripts courtesy of M.-L. Jennings.

74 Jennings to Cicely Jennings, 20 October 1940, M.-L. Jennings, *Jennings*, p. 25.

75 Jennings to Cicely Jennings, Easter Monday, 14 April 1941 (courtesy M.-L. Jennings).

76 Jennings to Cicely Jennings, 10 May 1941 (courtesy of M.-L. Jennings).

77 Dalrymple, 'The Crown Film Unit', p. 217.

78 Coultass, 'British Feature Films', p. 15.

79 See PRO, Ministry of Information Co-ordination Committee, February 1940, INF 1/867.

80 PRO, INF 1/985. The film cost £13,612 8 s 1od to make, which was only £396 over budget.

81 See A. J. P. Taylor, *English History 1914–1945* (Oxford, 1965), pp. 501–2.

82 See Aylmer Firebrace, *Fire Service Memories* (London, n.d.), pp. 177, 188, 193.

83 See Angus Calder, *The People's War: Britain 1939–1945* (London, 1969), pp. 61, 77.

84 Neil Wallington, *Fireman at War* (Newton Abbot, 1981), p. 209. The book is useful for a general history of the fire service.

85 Jennings Archives, BFI, no. 6, p. 2.

86 Ibid., p. 18.

87 Jennings to Cicely Jennings, 11 January 1942, BFI Archives.

88 Vas (ed.), *Heart of Britain*, p. 9.

89 William Sansom, '*Fires Were Started*', n.d, William Sansom Collection, Brigham Young University, p. 1; published as 'The Making of *Fires Were Started*', *Film Quarterly*, 15.2 (Winter 1961–2), pp. 27–9.

90 Sansom, '*Fires Were Started*', p. 3.

91 See *Picture Post*, 1 February 1941, pp. 9–15, and Michael Wassey, *Ordeal by Fire: The Story and Lesson of Fire over Britain and the Battle of the Flames* (London, 1941).

92 Sansom, '*Fires Were Started*', p. 2.

93 *Fires Were Started*, Take 93, reel 1.

94 Ibid., take 88, reel 2.

95 Ibid., take 14, reel 4.

96 *Omnibus*, 1969, transcript, roll 20/6.

97 Lambert, 'Jennings' Britain', p. 25.

98 *Fires Were Started*, take 26, reel 4.

99 Ibid., take 34, reel 6.

100 Hodgkinson and Sheratsky, *Jennings*, p. 146.

101 Jennings to Cicely Jennings, 12 April 1942 (courtesy of M.-L. Jennings); published in part in M.-L. Jennings, *Jennings*, p. 31.

102 Jennings to Cicely Jennings, 29 May 1942 (courtesy of M.-L. Jennings).

103 Jennings to Cicely Jennings, 28 July 1942 (courtesy of M.-L. Jennings); quoted in part in M.-L. Jennings, *Jennings*, p. 29.

104 Sansom, '*Fires Were Started*', p. 7.

105 Ibid., p. 7.

106 *Omnibus*, roll 18/8.

107 Strick, '*Fires Were Started*', p. 35.

108 *Omnibus*, roll 19/1.

109 PRO, INF 5/88.

110 Ibid., 1/211.

111 *Omnibus*, roll 20/7.

112 Sansom, '*Fires Were Started*', p. 2.

113 *Omnibus*, roll 19/9.

114 PRO, INF 5/88.

115 PRO, INF 1/212.

116 Beddington to Dalrymple, 26 November 1942, PRO, INF 1/212.

117 Dalrymple to Mr Weait (?), 22 October 1942, PRO, INF 1/985.

118 J. A. Bradley to Jarratt, 7 December 1942, PRO, INF 1/212.

119 Lejeune to Beddington, n.d., copy, PRO, INF 1/112.

120 Harman to Jennings, 4 December 1942, copy, PRO, INF 6/985.

121 Leslie to Beddington, 15 December 1942; Beddington to Leslie, 16 December 1942 PRO, INF 1/212.

122 Jennings to Cicely Jennings, 29 January 1943, quoted in part in M.-L. Jennings, *Jennings*, p. 35; D. D. Evans to Jennings, 25 December 1942 (courtesy of M.-L. Jennings). A shortened version of *Pandemonium* was finally published in 1985, edited by Charles Madge and Mary-Lou Jennings.

123 A copy survives in the William Sansom Archives, Brigham Young University.

124 Press release, n. d., PRO, INF 6/985.

125 BFI Archives.

126 *Documentary News Letter*, 4 (1943), p. 200.

127 *Monthly Film Bulletin of the British Film Institute,* 10:112 (30 April 1943).

128 Daniel Millar, '*Fires Were Started*', *Sight and Sound* (Spring 1969).

129 Vas (ed.), *Heart of Britain*.

130 Jennings and Holmes, 'The Documentary Film', p. 5.

131 Humphrey Jennings, review of *The Character of England* by Ernest Barker, *Times Literary Supplement*, 7 August 1948, pp. 47–8.

132 Quoted in M.-L. Jennings, *Jennings*, pp. 42–3.

133 See Alan Lovell and Jim Hillier, *Studies in Documentary* (London, 1972), pp. 62–98.

134 Noxon, 'How Humphrey Jennings Came to Film', p. 26.

135 *The Times*, 28 April 1954.

136 In M.-L. Jennings, *Jennings*, pp. 56–7.

137 Strick, *'Fires Were Started'*, p. 35.

PART 3: BENJAMIN BRITTEN

1 Quoted by the Earl of Harewood in Donald Mitchell and Hans Keller (eds.), *Benjamin Britten* (London, 1952), p. 3.

2 This period of Britten's early life has been brilliantly discussed by Donald Mitchell, *Britten and Auden in the Thirties: The Year 1936* (Seattle, 1981).

3 John Evans, 'The Creative Treatment of Actuality: Cinematic Realism in *Peter Grimes*', Welsh National Opera Programme, 2 September 1983, p. 17.

4 Mitchell, *Britten and Auden*, p. 30.

5 Ronald Duncan, *Working with Britten* (Welcombe, 1981), p. 28.

6 Interview with Hans Keller in Alan Blyth (ed.), *Remembering Britten* (London, 1981), pp. 89–90.

7 Point made at a symposium in San Francisco on Benjamin Britten, 16 March 1983; the participants were Philip Brett and Richard Bradshaw. The quotation is from Britten's second opera, *The Rape of Lucretia*.

8 *Listener*, 7 November 1946, p. 624.

9 Robert Medley, *Drawn from the Life* (London, 1983), p. 163.

10 Paul Rotha, *Documentary Diary* (London, 1973), p. 165.

11 Mitchell, *Britten and Auden*, p. 143.

12 Murray Schaefer, *British Composers in Interview* (London, 1963), p. 117.

13 Colin Matthews, sleeve note to *Our Hunting Fathers*, sound disc, 1983.

14 Bridge to Britten, 30 April 1937, in Donald Mitchell and Philip Reed (eds.), *Letters from a Life: The Selected Letters and Diaries of Benjamin Britten (1913–1976)* (Berkeley, Calif., 1991), vol. 1, p. 433.

15 Donald Mitchell (ed.), 'Benjamin Britten: From his Personal Diaries for 1937 and 1938', in Marion Thorpe (ed.), *Peter Pears: A Tribute on his 75th Birthday* (London, 1985), p. 112.

16 Quoted by Philip Brett, 'Postscript', in Philip Brett (ed.), *Benjamin Britten: Peter Grimes* (Cambridge, 1983), p. 190.

17 Britten to Barbara Britten, 3 September 1939, in Mitchell and Reed (eds.), *Letters from a Life*, vol. 2, p. 696.

18 William King, *New York Sun*, 9 December 1940.

19 John Warrack, 'Conversation with Benjamin Britten', *Musical America*, 84 (December 1964), p. 20.

20 Quoted from Paul Bowles, *Without Stopping*, in Millicent Dillon, *A Little Original Sin: The Life and Work of Jane Bowles* (New York, 1981), p. 94.

21 In a television interview in August 1985 Pears remarked that Auden 'woke Ben up'.

22 Letter and comment in Mitchell, *Auden and Britten*, pp. 161–3.

23 Britten to Hawkes, 2 September 1940, Mitchell and Reed (eds.), *Letters from a Life*, vol. 2, p. 855.

24 Britten to Hawkes, 12 June 1941, in Mitchell and Reed (eds.), *Letters from a Life*, vol. 2, p. 937.

25 *Musical Times* (June 1941), p. 234; (August 1941), p. 308; (October 1941), pp. 376–7; *Sunday Times*, 4 May, 8 June 1941.

26 Britten to Hawkes, 23 July 1941, in Mitchell and Reed (eds.), *Letters from a Life*, vol. 2, p. 957.

27 *Caradoc's Music Information Folios* (n.p., n.d.).

28 Benjamin Britten, *On Receiving the First Aspen Award* (London, 1964), pp. 20–2. (But it may have been Pears who discovered the book on his own; see Pears to Elizabeth Mayer, 5 July 1941, in Mitchell and Reed (eds.), *Letters from a Life*, vol. 2, p. 951.)

29 Quoted by Brett, 'Postscript', p. 180.

30 E. M. Forster, 'George Crabbe and Peter Grimes', in *Two Cheers for Democracy* (New York, 1951), pp. 186–7.

31 Britten to Hawkes, 4 February 1946, Bodleian Library, Oxford, MS Don d.162, fo. 18.

32 Caroline Seebohm, 'Conscripts to an Age: British Expatriates 1939–1945', unpublished paper, p. 30. Isherwood definitely declined to write the libretto the following February (Mitchell in Brett (ed.), *Britten*, p. 35).

33 Britten to Koussevitsky, 18 November 1941, in Mitchell and Reed (eds.), *Letters from a Life*, vol. 2, p. 100.

34 Britten in Brett (ed.), *Britten*, p. 148.

35 Quoted by Brett, 'Postscript', p. 190.

36 Brett in Brett (ed.), *Britten*, p. 56.

37 Desmond Shawe-Taylor in Brett (ed.), *Britten*, p. 154.

38 Pears in Brett (ed.), *Britten*, p. 152.

39 Warrack, 'Conversation', p. 272.

40 Christopher Palmer, sleeve note to *A Ceremony of Carols*, sound disc, Musical Heritage Society, New York, 1982.

41 Donald Mitchell and John Evans, *Benjamin Britten: Pictures from a Life* (New York, 1978), pl. 159. See also the notes to Mitchell and Reed (eds.), *Letters from a Life*, vol. 2, pp. 1026–7.

42 Manuscript reproduced in Brett (ed.), *Britten*, p. 49.

43 Warrack, 'Conversation', p. 20.

44 Ibid., p. 272.

45 See, for instance, Britten to Elizabeth Mayer, 17 May 1942, in Mitchell and Reed (eds.), *Letters from a Life*, vol. 2, p. 1049.

46 Statement to the Local Tribunal for the Registration of Conscientious Objectors, 4 May 1942. The hearing was on 28 May. See Mitchell and Reed (ed.), *Letters from a Life*, vol. 2, p. 1046.

47 Susan Walton, *William Walton: Behind the Façade* (Oxford, 1988). p. 125.

48 Martin Ceadal, *Pacifism in Britain 1914–1945* (Oxford, 1980), p. 302.

49 Copy of appeal form, Friends House, London; Denis Hayes, *Challenge of Conscience* (London, 1900), p. 46; letter from S. M. Healy, PRO, to the authors, 18 April 1985.

50 Central Board for Conscientious Objectors, *Bulletin*, 52 (June 1944), p. 10.

51 Rollo Myers, *Music since 1939* (London, 1948; first published in 1946/7), pp. 108–9.

52 Blyth (ed.), *Remembering*, p. 17.

53 Mitchell and Evans, *Britten*, pl. 161.

54 Blyth (ed.), *Remembering*, p. 64.

55 Interview with Sir Peter Pears,9 October 1983.

56 Brett in Brett (ed.), *Britten*, pp. 195–6.

57 Alun Davies, 'Britten and Grimes', *Sadler's Wells Newspaper* (October–November 1963).

58 Edward Tracey, 'Benjamin Britten Talks', *Sadler's Wells Opera Magazine* (1966).

59 Mitchell in Brett (ed.), *Britten*, pp. 22–3. The phrase *'realism as a style'* is a quotation from Stephen Spender.

60 Montagu Slater, *The Story of the Opera 'Peter Grimes'* (London, 1945), p. 19.

61 Montagu Slater, *Peter Grimes and Other Poems* (London, 1946), p. 7.

62 Interview with Eric Crozier, 8 June 1985.

63 Eric Walter White, *Benjamin Britten: His Life and Operas* (London, 1983), pp. 122–4.

64 See Garbutt in Brett (ed.), *Britten*, p. 168.

65 Brett in Brett (ed.), *Britten*, p. 185.

66 Joseph Kerman, 'Grimes and Lucretia', *Hudson Review* (1949), pp. 280–1.

67 Tyrone Guthrie, *A Life in the Theatre* (New York, 1959), pp. 216–27.

68 James Forsyth, *Tyrone Guthrie* (London, 1976), p. 176.

69 Joan Cross, 'An Experiment in Opera, 1940–45', in Eric Crozier (ed.), *Opera in English* (London, 1945), pp. 18–24.

70 Joan Cross, 'Recalling *Peter Grimes*', *Opera*, 28:2 (February 1977), pp. 137–9.

71 See Tyrone Guthrie, 'Out of Touch', *Opera News*, 31 (11 February 1967), p. 11.

72 Eric Crozier, 'Staging First Productions', in David Herbert (ed.), *The Operas of Benjamin Britten* (London, 1979), p. 26.

73 Crozier, 'Staging', pp. 25–6.

74 Brett in Brett (ed.), *Britten*, p. 95.

75 Blyth (ed.), *Remembering*, pp. 72–3.

76 Cross, 'Recalling', p. 139.

77 Mitchell and Reed (eds.), *Letters from a Life*, vol. 2, pp. 1253–65, has a selection of the reviews.

78 In Mark Archer, 'Silence, Then Grave Waves of Applause', *Sunday Telegraph*, 7 April 1991.

79 E. M. Forster, 'We Speak to India: Some Books', Forster MSS, King's College, Cambridge.

80 Eric Crozier, '"*Peter Grimes*": An Unpublished Article of 1946', *Opera*, 16:1 (1965), p. 416.

81 Peter Stansky, '*Peter Grimes*, Jan Popper and Stanford', *Sandstone and Tile*, 12:2–3 (Winter/Spring 1988), pp. 8–11.

82 Eric Walter White, *Benjamin Britten* (Berkeley, Calif., 1970), pp. 42–3.

83 Brett in Brett (ed.), *Britten*, p. 86.

84 Andrew Porter, 'Notes on *Peter Grimes*', Metropolitan Opera programme, November 1983, no pagination.

85 Andrew Porter, *Music of Three More Seasons* (New York, 1981), p. 207.

86 Edmund Wilson, *Europe without Baedeker* (New York, 1947), pp. 222–4.

INDEX
|❖|❖|❖|